Goya

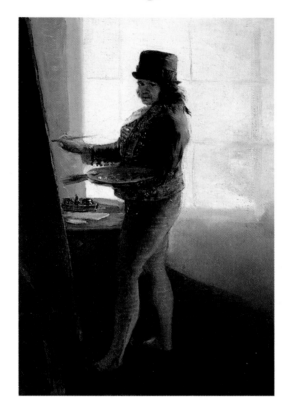

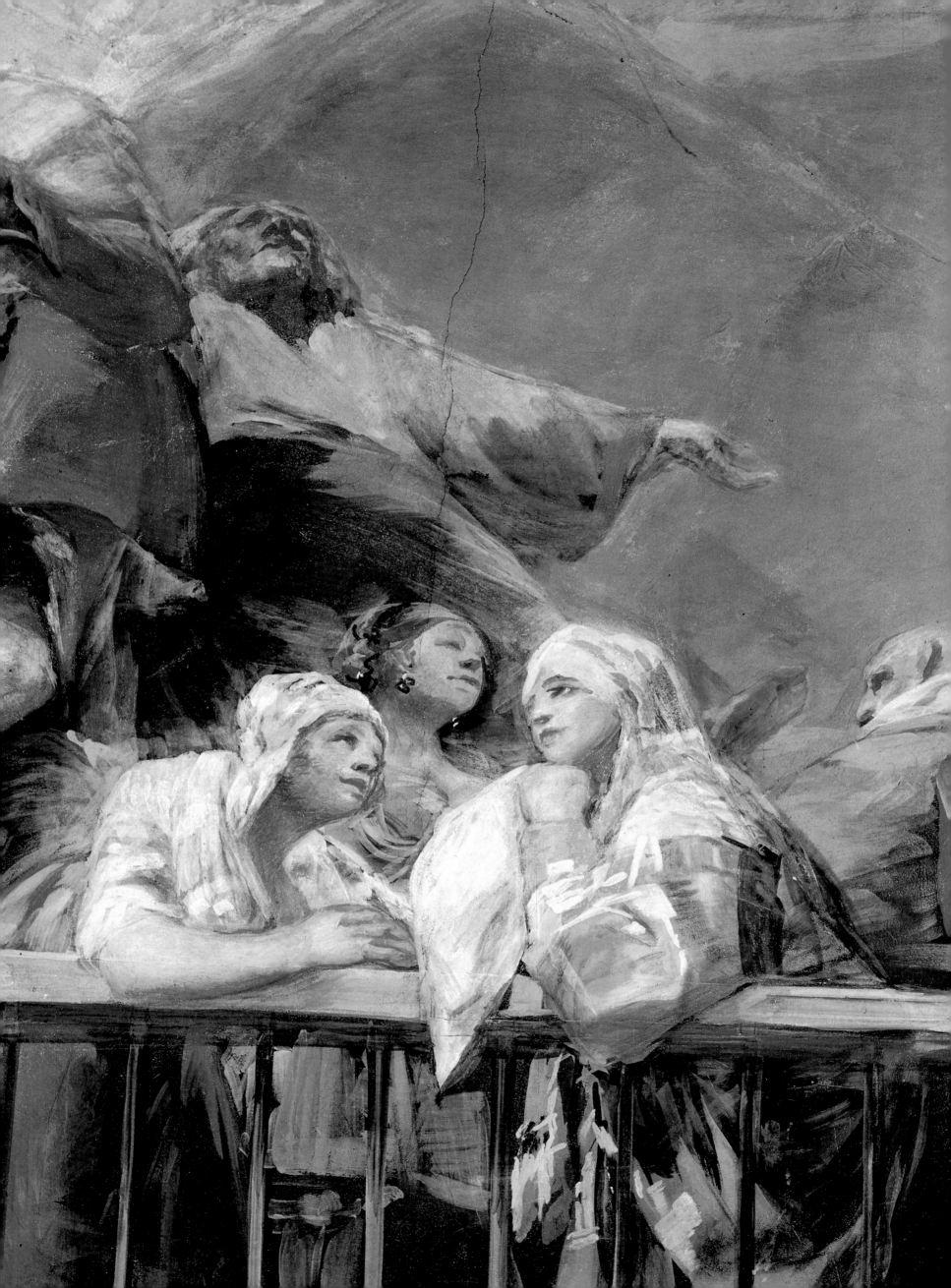

Goya

Frank Milner

BISON GROUP

First published in 1995 by
Bison Books Ltd
Kimbolton House
117A Fulham Road
London SW3 6RL

ISBN 1-85841-079-7

Printed in Spain

FOR JAMES HAWORTH

PAGE 1:
Goya in his Studio, 1792
Oil on canvas, 16½ × 11 inches (42 × 28 cm)
Real Academia de Bellas Artes de San Fernando,
Madrid

PAGE 2:
The Miracle of Saint Antony (detail), 1798
Frescoed dome, 236 inches (600 cm) diameter
San Antonio de la Florida, Madrid

Contents and List of Plates

Introduction

There have been many Goyas. "Wild genius, half angel, half Satan," was how Yriarte, one of his earliest biographers, described him. For Baudelaire, he was the conjuror of "*le monstrueux vraisemblable*," a demonic nightmare world of the unknown where witches gathered together to roast fetuses. Others cast him in Byronic mold: "a broth of a boy – quarrelling, fighting, bullfighting and of course a great one for the girls," wrote Kenneth Clark, reiterating Romantic notions about Goya's youth that had first been propounded by writers such as Théophile Gautier. For Manet he was the touchstone of Naturalism – the first truly modern painter. More recently there has been a Marxist Goya, whose class-solidarity lay with the dispossessed in their anti-imperialist struggle against the French. Under Franco there was even an attempt to promote a quintessentially Nationalist Goya. There has certainly been more than one variant of the Freudian Goya, fed by interpretations of his life and the psychoanalysis of his art. With the emphasis also on dream, it perhaps comes as no surprise to discover a Surrealist Goya, invoked by Salvador Dalí and by Luis Buñuel. The magnificent 1989 Goya exhibition at New York's Metropolitan Museum set out to fix Goya in the intellectual milieu of late eighteenth-century Spain, but somehow he would not quite fit into the suggested form of the Enlightenment Goya.

Despite this great range of interpretations, and despite his enormously fertile influence, Goya was not an intellectual artist, notwithstanding the philosophical and theological subtleties that have been ascribed at times to certain of his prints. He left no large body of writ-

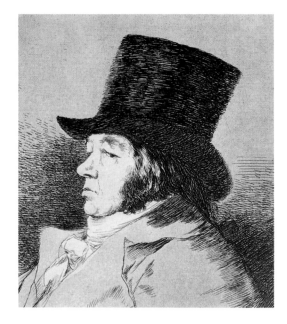

ing. The bulk of his surviving correspondence is to a childhood friend, the businessman and banker, Martín Zapater: "the letters of a cabinet maker," was how Ortega y Gasset, the twentieth-century Spanish philosopher, described them. Although Goya held office over many years at the Royal Academy of San Fernando, including for a while having responsibility for the teaching of students, there are only a few paragraphs written in a 1792 report to suggest any artistic principles that Goya might have wished to pass on. While he studied past painters and sculpture when he visited Rome, Goya did not return from Italy, as did for example his contemporaries Reynolds in England or David in France, with any mission to preach the merits of antique or classical exemplars. In his 1792 report his strongest criticisms were reserved for those "tyrants of taste" who wished to include exercises in the mathematically-grounded proportions of Greek statuary

as part of the curriculum of the Academy, and thereby restrict students from access to drawing directly from nature. (On the basis of this brief report the myth of the anti-academic Goya was grounded.) Although Goya did have a library, no list survives of its several hundred volumes, but it was large enough to attract a tax of 1500 reales ($25) in 1812, and he also collected pictures and prints. He kept company with some of the most progressive intellectuals of his day, but unfortunately no Spanish Boswell stood by taking notes.

Francisco José de Goya y Lucientes was born on March 30, 1746 in Fuendetodos, a small village 25 miles south-west of the Aragonese capital of Zaragoza. His father was an artisan, a master-gilder, good enough to work on large parts of the enormous, newly-built basilica in Zaragoza dedicated to Our Lady of the Pillar (El Pilar). Goya's paternal grandfather had been a notary. His mother, Gracia Lucientes, was a *hidalgo*, one of the thousands of minor aristocrats whose fastidiousness prevented them from taking manual occupations and whose unproductive poverty was becoming a serious social problem. At Goya's birth his family appear to have been attempting the more genteel business of farming inherited land within his mother's village. Later his father removed the household to Zaragoza, where better opportunities existed for earning money by his own trade and for providing an education for his six children.

Goya's artistic training started in about 1760, when, aged 13 or 14, he entered the Zaragoza studio of José Luzán, a one-time court-painter who had trained in Naples under the great Baroque artist Francesco Solimena, and who enjoyed a considerable reputation within Aragon. Another of his pupils, 12 years senior to Goya, had been Francisco Bayeu, who was invited in 1763 to assist the recently-appointed royal painter Anton Rafael Mengs in the elaborate decorative fresco schemes that he was undertaking for the king's new palace in Madrid. Whatever we may nowadays think about Luzán's stature as an artist, he was at the time perceived as among the first rank, and Goya probably felt fortunate to be placed with him, studying in what was the second richest city in Spain. Little is known about the four years that Goya said he spent with Luzán. His later comment that Luzán taught him to copy "the best prints," and the biographical outline

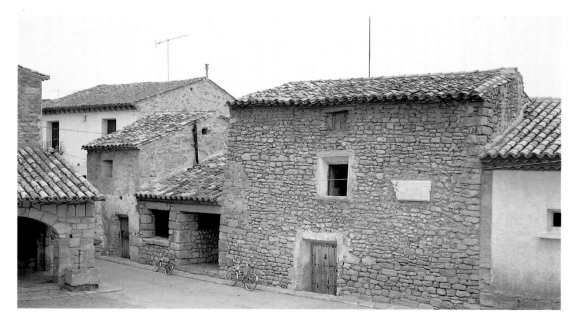

ABOVE LEFT: *Self-Portrait (Wearing a Top Hat)*, *Los Caprichos* plate 1, showing Goya in 1798.

BELOW LEFT: Goya's birthplace in his mother's village of Fuendetodos, 25 miles from Zaragoza.

BELOW: *The Painter Francisco Bayeu, c.1795.* Bayeu helped Goya to obtain commissions in Zaragoza and Madrid, and Goya married Bayeu's sister.

written by Goya's son in which he cites Luzán as having taught his father "to paint in oil," have tended to be regarded as suggesting that Luzán's influence upon the young Goya was limited and rudimentary rather than strongly formative. This may not have been so.

From 1764 until 1770 virtually nothing is known about Goya's life. He failed in 1763, and again in 1766, to obtain a scholarship to study in Madrid, at the Royal Academy of San Fernando. It is assumed, probably correctly but on slender evidence, that instead he worked in the Madrid studio of Francisco Bayeu and his younger brother Ramón. His next definite appearance is in Italy, in April 1771, where he is recorded as entering a painting competition at the Royal Academy of Fine Arts in Parma, describing himself as a pupil of Bayeu. His picture won special mention and praise, but no prize. Then in October 1771, aged 25, he obtained an important commission for the new Zaragoza basilica, to paint for 15,000 reales ($250) a frescoed ceiling in the retro-choir on the theme of *The Adoration of the Name of God.* To add to the complexity of disentangling Goya's youthful biography, this fresco is also the first major painting that can with certainty be ascribed to his hand.

The paucity of information about the young Goya led certain nineteenth-century French writers, who were keen to emphasize his romantic, solitary and wayward genius, to invent an appropriate biography for an artist who was later to paint scenes of such extreme emotion and human suffering. Thus came into being the legend of Goya the bullfighter, the swordsman quick to anger, the lover who abducted a nun from the Roman convent. Parenthetical comments were elaborated into highly-colored fact. For example, his statement in a petition to the King that he had lived in Italy "at his own expense" had biographers describing him hawking small oils of classical views through the streets of Rome (all lost, needless to say). The evidence of Goya's later life suggests that he was in nearly all things prudent and circumspect. A likely explanation of the so-called missing years is that he was working as an assistant journeyman-painter in Zaragoza and elsewhere, with Bayeu, with Luzán, and possibly with others, on commissions to which, precisely because he was an assistant, he was not entitled to add his name. By saving money he could therefore travel "at his own expense" to

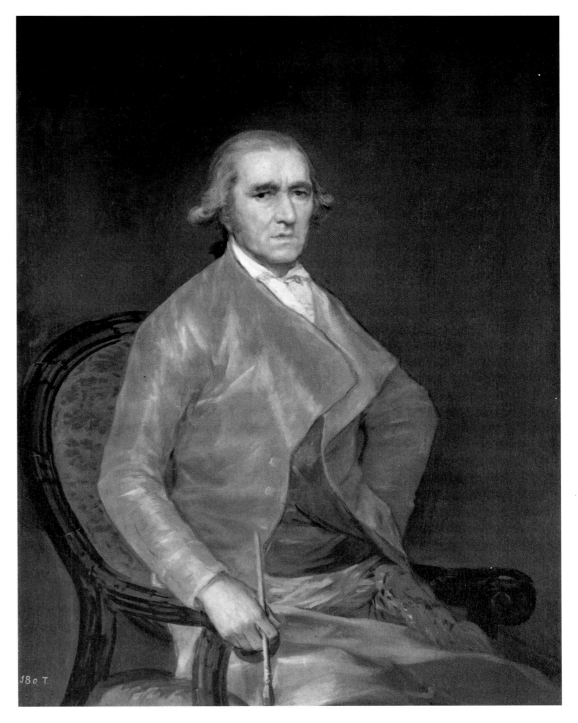

Italy and probably France, to study what was fashionable among his contemporaries, as well as to look in depth at great art of the past.

Suggestions that he mastered fresco in Italy or that what he had learned in Italy helped him obtain the cathedral commission are also unlikely to be true. Goya did acquire a considerable fund of ideas there, and his recently re-discovered "Italian notebook" indicates the range of his sketches after Roman paintings and sculpture, but they are not untypical of what almost any student studying in Rome at the time might have recorded. Goya developed into a mature artist at a period when systems regulating apprenticeship were still relatively strong in Spain. Despite the setting-up of royal and

provincial academies intended to develop artists' training, and the increasing artistic independence of individual artists, the guild framework predominated for most trades and largely shaped the conservative perceptions of those commissioning work (and their perception of the status of the artist and craftsman). Rather than any sudden recognition of his genius, Goya's strongest recommendation would have been a proven track record of collaborative work successfully completed. He may well have had a reputation for working quickly – the entire retro-choir project was completed by June 1772.

In July 1772 Goya married Josefa, Francisco Bayeu's sister. He was effectively marrying into the Bayeu business,

The fresco study *Spain Rendering Homage to Religion and the Church* (1759) by Corrado Giaquinto is typical of Spanish religious art in the period just before Goya's apprenticeship.

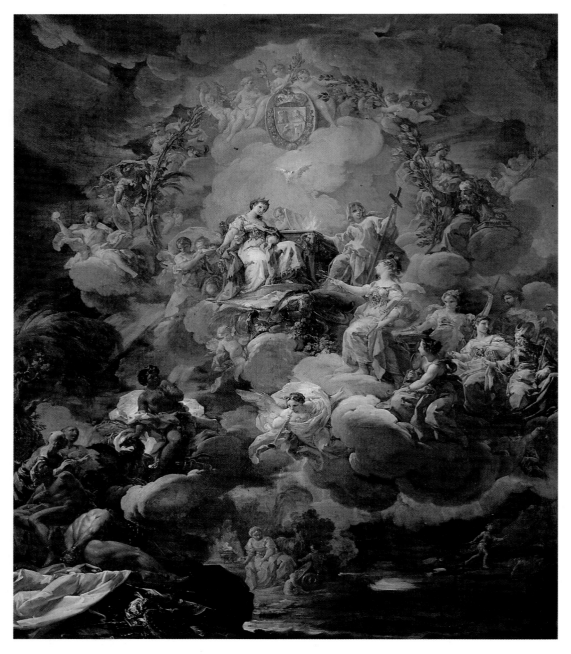

in an arrangement that in many respects paralleled the traditional one where the best apprentice married the master's daughter for the dynastic continuity of trade. Both sides benefited, from the future pooling of skills for larger commissions and from the elimination of any possible competition between them. Goya's dependability, capacity to earn money quickly, and even possibly his *hidalgo* ancestry, were the qualities that probably made Bayeu happy to offer his sister's hand to him in marriage. Since the death of his parents, Bayeu had been responsible for Josefa's upbringing and for the provision of her dowry. The need to supply the latter had been sufficient grounds for him to appeal for an increase in his royal salary.

During the remainder of 1773 and 1774 Goya continued to work in the Zaragoza region, painting principally in fresco, and virtually all his commissions

were religious ones. Traditionally these early pictures have been held in low esteem. Their relative inaccessibility, infrequent reproduction in books, and not least a general reluctance to consider Goya as a serious religious artist, have led to their being ignored or dismissed. Oscar Wilde's son Vyvyan Holland, writing in 1961, expressed what was then a prevalent prejudice about the El Pilar frescoes:

The result is far from being a credit to Goya. In the first place the position of the frescoes is unfortunate, the vault of the cathedral being too high and its lighting too dim for them to be seen clearly. Were they not by Goya no one would even notice them, for they are no better than other frescoes painted in other parts of the cathedral. In fact they are hack work; his heart was not in them. This too was the period when Goya's work was least satisfactory, before he had found his own feet.

Now that they are cleaned, better lit and more widely reproduced, a more generous estimation of their merits has become possible and the case has even recently been advanced for Goya to be celebrated as an outstanding fresco painter from his youth.

His next major break came in late 1774, when he was summoned by Mengs to Madrid to produce designs in oils (cartoons) for the royal tapestry factory of Santa Barbara. *The Quail Hunt* is one of nine hunting scenes that were subsequently woven in tapestry for one of the dining rooms of the El Escorial palace outside Madrid. In identifying the major influences upon Goya at this early stage in his career, it has been usual to see how far his paintings relate either to the work of the royal painter Mengs, who had come to Spain from Italy in 1761, or alternatively with that of the Venetian artist Giambattista Tiepolo, who worked for the Spanish crown from 1762 until his death in 1770, and whose brother Domenico continued to work in Spain thereafter. These imported giants of European art have often been presented as the dominant shaping influences upon artistic practice and taste in late-eighteenth-century Spain. The situation was, however, slightly more complex, because some of what was stylistically distinctive about Tiepolo's handling and composition was also characteristic of other Italian art of the period, whose influence had already percolated into Spain. Also qualities which might be regarded as characteristic of Mengs were in fact shared by other academic artists who, like him, eschewed Rococo fashions in favor of more classical values. Additionally Tiepolo, and more especially Mengs, had the ability to paint in more than one manner; indeed in Spain, working for the crown, they were almost obliged to do so.

It is this third characteristic that Goya appears most definitely to have picked up. He imbibed influences from a wide variety of sources, Italian, Spanish, and French, but above all at this stage he was adaptable. Both Ramón Bayeu and Domenico Tiepolo were already working on tapestry designs similar to those that Goya was to undertake. Given that Goya's invitation to Madrid probably arose out of Francisco Bayeu's influence and on the understanding that he was, so to speak, part of the Bayeu workshop, it is hardly surprising that Goya would deliver what was expected of him. In so far

as his first, not especially commanding, tapestry designs indicate any influence, they suggest French Rococo artists like Lancret and Fragonard, as well as the voice of the elder Tiepolo. Interestingly, Francisco Bayeu claimed authorship of five of the designs, although documentary proof links them without doubt to Goya. Jealousy of his more talented co-worker has been suggested, but it may simply have been a piece of workshop book-keeping that had little real significance.

Goya's next major series of tapestry designs, produced between 1776 and 1780, were scenes of everyday life. These *costumbrismo* belonged to a type of picture that was becoming increasingly fashionable throughout Europe, and showed peasants and popular life benevolently perceived, the high and low in society mixing happily, the populace at work and play — wood-cutting, selling ham or crockery, playing cards, brawling outside an inn. It is scarcely gritty realism, but it is reflective of that shift in European aristocratic taste away from pastoral scenes of bucolic revelry among classical deities, toward something more contemporary, something in many cases more precisely national. These images display an essentially benign, sentimental view of peasant life. It is not until Goya's third

series of tapestry designs, produced between 1786 and 1788, that we encounter a slightly tougher view of the life of the poor.

Goya's further advancement in Madrid depended in part upon his obtaining membership of the Royal Academy of San Fernando, and, if possible, his being appointed to one of the posts of *"Pintor del Rey"* (painter to the King). His *Crucifixion* (1780) was submitted in support of his Academy application. It has been

linked to a similar painting by Mengs and to a study by Francisco Bayeu, but in overall conception it most clearly resembles the *Crucifixion* by Velázquez that is now in the Prado. In its handling it also suggests that Goya had been looking at the several pictures by Rubens in the royal collections, to which his work for the royal tapestry works gave him access. Despite these influences, however, it is also true that this type of crucified Christ, shown starkly lit as though by lightning and with his beautiful body punctured by wounds, was almost a cliché of Spanish devotional art. Goya may in this case have decided to play safe in order to obtain the election, which duly came to him in May 1780.

The following fall the Bayeu-Goya partnership was employed to fresco three domes in the El Pilar basilica in Zaragoza. Conflict arose when Goya disputed his brother-in-law's desire to correct his designs. Much has been read into this argument — it was certainly serious. Bayeu's supervisory role gave him a contractual entitlement to oversee the entire project in detail, and he probably felt an obligation — not without reason — to point out that Goya's plans did not harmonize with the rest of the ceiling. Goya, after having his oil sketches approved, completed his dome, *The Queen of the Martyrs*, to his

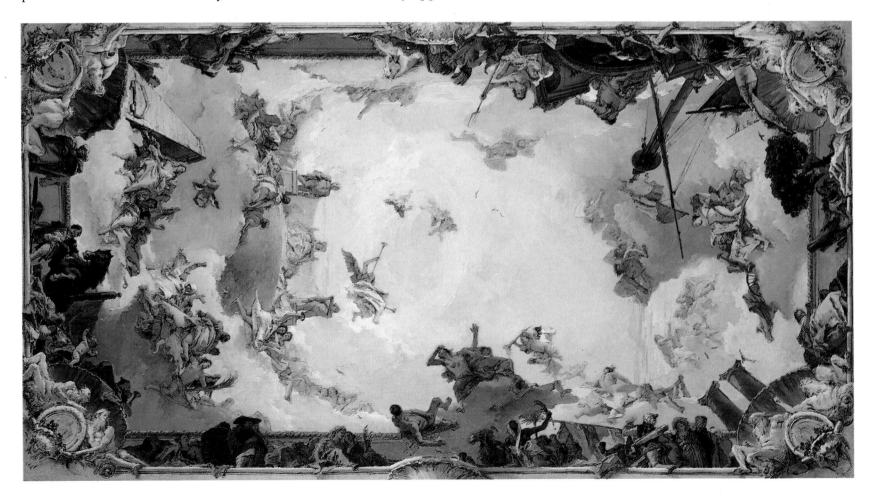

authority and mediocrity. He was certainly angry, even possibly humiliated, by this episode, but he was also undoubtedly well aware of the constraints of patronage in provincial Spain.

Goya's reputation as an artist independently of Bayeu and aside from tapestry commissions came principally as a result of the portrait practice that he developed during the early 1780s. Royal and ecclesiastical interior designs and frescoes had ever-present collaborative implications, whereas portrait-painting was a solo business. The temporary closure of the royal tapestry factory may have contributed to his opportunities. Three of his most important early portrait commissions were *The Count of Floridablanca* (1783), *The Family of the Infante Don Luis* (1783), and *Ventura Rodríguez, the Architect* (1784). The first probably arose out of the contact that Goya had with Floridablanca when the latter was supervising the commissioning and installation of an altarpiece that Goya painted in 1782 for the Madrid church of San Francisco el Grande. Floridablanca was Prime Minister of Spain and one of the leaders of a group of reforming aristocrats who, inspired by the ideas of the French Encyclopedists and the success of English financial institutions and agricultural im-

own design. He then refused Bayeu's and the commissioning committee's request to him to modify it, and to control more strictly his designs for the figures of Virtues that he intended to paint on the dome's supporting pendentives. Goya, the newly-elected academician, suggested that judgment be passed on his work by the Academy as a whole, instead of just by Bayeu and the cathedral authorities. Eventually he was persuaded by a wise friend to climb down, to modify his drawings with his brother-in-law's aid, and to act more humbly. This is one of the best documented episodes in Goya's life, and has provided the basis for the romantic characterization of him as a thwarted youthful genius hamstrung by

François-Hubert Drouais' *Portrait of the Comte de Vaudreuil* is an example of the fashionable French painting which influenced Goya's own early portraits.

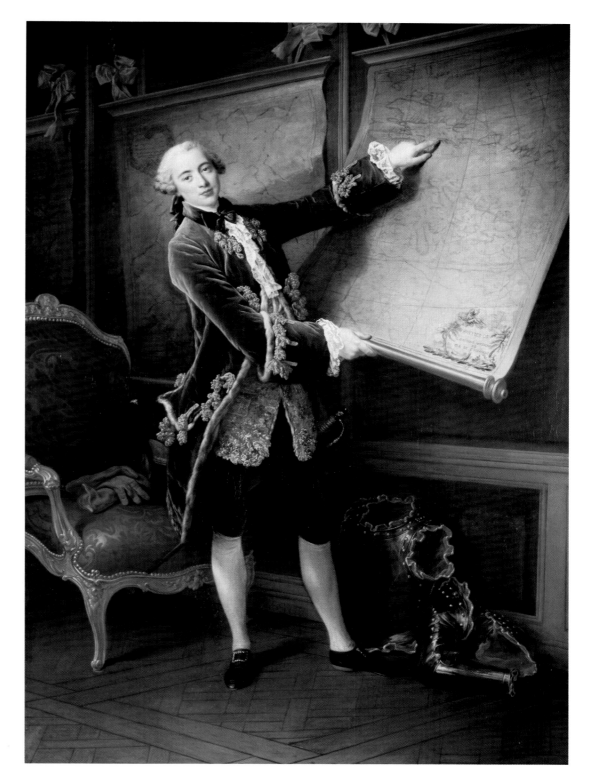

provements, wished to modernize their country. Known as the *ilustrados*, this group helped shape Goya's political and social ideas. They believed in a limited constitutional monarchy, in the eradication of outdated feudal dues and obligations, and in the reduction of some of the cumbersome proprietal and administrative privileges of the church and its institutions, especially the Inquisition.

Goya's portrait of Floridablanca still belongs to the National Bank of San Carlos, founded in 1782 by the Count and others in emulation of the Bank of England. It is a grandiloquent picture, full of iconographic detail suggesting the sitter's sense of public duty. A large clock symbolizes the unfailing regularity of his labor; unrolled plans show the Aragon canal that Floridablanca part-financed; a copy of Palomino's *Práctica de la Pintura* signifies his artistic patronage. On the wall above, a portrait of a grateful monarch, Carlos III, benevolently gazes down both at his senior minister and also at Goya, sycophantically advancing toward Floridablanca to show off an oil sketch or study, possibly one linked to his San Francisco altarpiece. Goya's inspiration for this picture lay principally in fashionable contemporary French library portraiture. It is redolent of similar pictures by, for example, François-Hubert Drouais (1727-75) and Alexandre Roslin (1718-93). What is distinctive, however, is the slightly uncomfortable dislocation of space, the overlapping clutter of figures, and, what was to become characteristic of so many of Goya's subsequent portraits, the separation of solidly portrayed figure from altogether more ethereal ground.

Goya's portrait of the family of the Infante Don Luis probably came about through family connections. Don Luis's court secretary was the brother-in-law of Goya's wife's sister. For this magnificent group portrait, Goya conflated two popular types of picture, the "candlelight" and the conversation piece. The conceit is that the entire room is illuminated by one candle, supplemented by the glow that radiates from the seated central figure of the Infante's wife, Doña Teresa, who is having her hair dressed. Don Luis (1728-85), who appears already to be ill and who died in the year following this picture's completion, is the ruddy-faced man seated in profile. The younger brother of Carlos III, he had originally been destined for the church. His dissolute life, abandonment of ecclesiastical office, and a thoroughly unsuitable marriage to a cavalry officer's daughter, all led to his being effectively barred from Madrid court life. He moved to a small town, Arenas de San Pedro, 70 miles from the capital, with his children and a small household court, several of whose members appear in this picture, including the rather maniacally cheerful Francisco del Campo, Goya's relative. For this, his very first royal portrait, Goya paid homage to Velázquez's *Las Meniñas* and placed himself in the picture's bottom left corner. Pre-dating by 16 years, and in several respects anticipating, his most famous royal group portrait of *Carlos IV and his Family*, this astonishing picture has to date been little exhibited. What shocks, as with the later picture, is the faint air of vulgarity, the lack of decorum, the curious tension between the studied grandeur and ordinariness — almost as though Goya has decided to concentrate on events before and during the taking up of the pose, when hair is still being arranged, when a bored old man plays a quick hand of solitaire and others practice facial expression and gesture before resuming their positions. It is an extraordinarily original painting and it led to several other commissions from the same family.

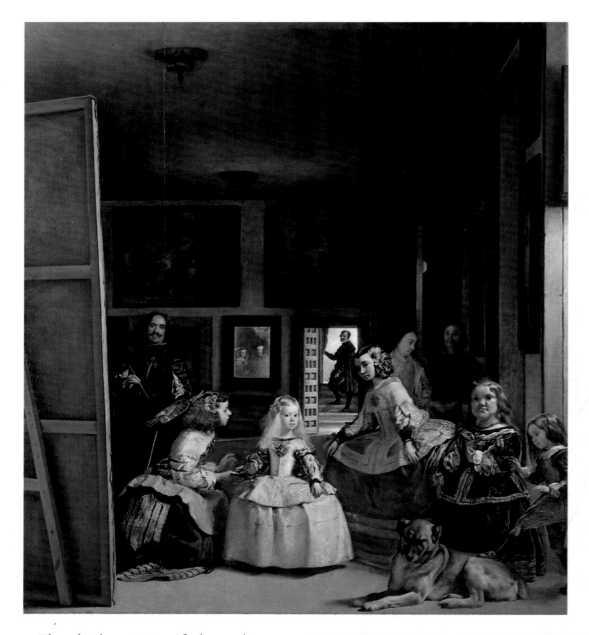

vated "*Pintor de Camera*" and obtained his first royal portrait commissions.

Among the many pictures made during this decade for his growing circle of liberal intellectual patrons, Goya painted important portraits of *Francisco de Cabarrús* in 1787, *The Family of the Duke of Osuna* in 1788, and *The Marquesa de Pontejos* in 1786-87. The Aragonese economist, financier and merchant Francisco de Cabarrús had been a co-founder and prime initiator of the Bank of San Carlos. Even by contemporary enlightened Spanish standards he was a radical, believing in universal primary education based upon teaching by play, freely available divorce, the restriction of hereditary titles, and the control of venereal disease by a system of state-supervised brothels. In 1787, the year Goya painted him, he was summoned to the French court at Versailles to advise on possible solutions to disastrous state debts, a problem he had earlier remedied for the Spanish crown. For such a dynamic man Goya chose a dynamic pose, closely based on Velázquez's 1632 portrait of Pablo de Valladolid, a picture which in its own day had heralded a bold departure in its suppression of background and the emphatic directness of the sitter. By blurring the background, Goya achieved not a lessening of reality, but rather an immeasurably heightened sense of the physical presence of the figure.

The third portrait, of the architect Rodríguez, is an altogether more formulaic Baroque picture, evocative above all of Mengs's similar depictions of artists and scholarly Grand Tourists. Rodríguez points at the plan of the chapel that he had recently designed for Zaragoza's El Pilar. The picture was commissioned by Maria Teresa, wife of the Infante Don Luis; Rodríguez was her court architect and they were both Aragonese.

Between 1782 and 1792 Goya's career blossomed. His portrait practice expanded and he at last gained substantial official honors. In 1784 his son Francisco Xavier was born, the only one of 20 children born to Goya and his wife who survived to adulthood. In the following year Goya was appointed Assistant Director of the Academy of San Fernando, and in 1786 made *Pintor del Rey*, on a salary of 15,000 reales, with specific responsibility for royal tapestries. In 1789, following the accession of a new king, Carlos IV, he rose from court painter to the more ele-

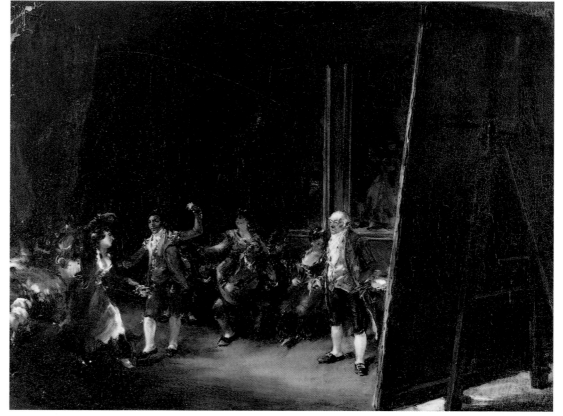

Goya's portrait of *Carlos III in Hunting Dress* (1786-88) was clearly influenced by works such as Velázquez's similar portrayal of Prince Balthasar Carlos (page 17), and demonstrates the strong element of artistic continuity in Spanish portraiture.

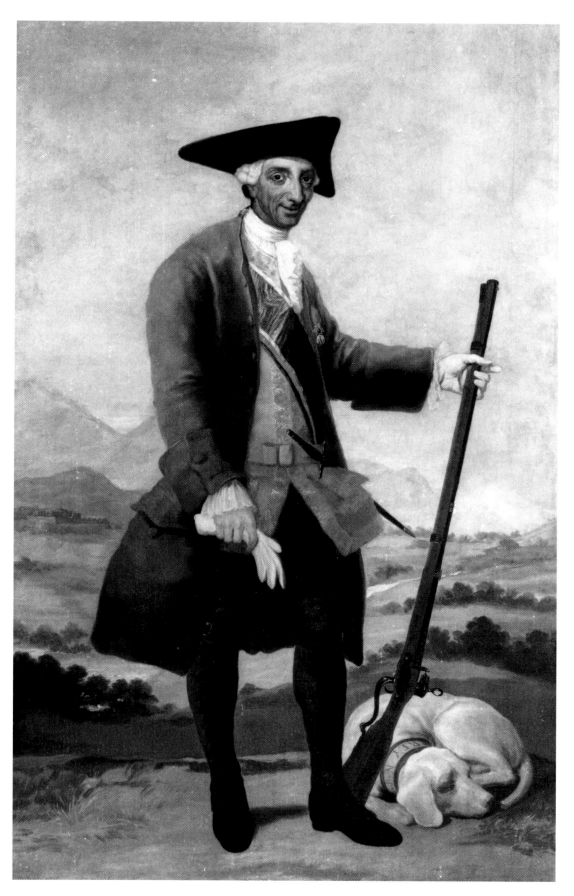

The earlier *Portrait of the Marquesa de Pontejos*, the Count of Floridablanca's sister-in-law, also pushes the sitter forward toward the picture plane. Of all Goya's female portraits, this is the one that most strongly evokes the work of Gainsborough, prints of whose pictures Goya possessed. Frothy white gauze, silk and lace, are offset by accents of pink in the heavy-headed (probably emblematic) carnation, roses, sash, cheeks and the collar of the comic diminutive pug-dog who improbably strides forward to protect his mistress. It is a bravura piece of painting. Like Gainsborough, Goya appears to have delighted in the depiction of specific fabrics and their subtle gradations of weight and texture. By contrast the landscape is simply flat backdrop. To modern eyes it is charming and rather stiff; to contemporaries it suggested pastoral informality, the sitter clad as an aristocratic shepherdess.

The Osuna family group is, at first sight, disarmingly pretty, and on second view distinctly uncomfortable. Using conventional pyramidal pictorial structuring to unify the six figures, Goya then subverts this unity by the individual separateness of each of the sitter's poses. The dark-clad Duke, who leans forward into the group with eye-catching red cuffs, collar and pocket, is particularly destabilizing. It is a picture in flux, like the earlier family picture of the Infante Don Luis, the calm adults and anxious fragile little children caught taking up their positions, accidentally glimpsed, as though by a photographer. Both the Duke and his wife were liberals and supporters of the arts. They ran a salon in Madrid that Goya attended, had their own private theater, collected original musical scores by Haydn and others, and had an enormous library. The Duchess was among Goya's best patrons, commissioning in 1786-87 seven pictures of rural life for her summer house (called El Capricho) outside Madrid. In 1788 she and her husband commissioned two pictures for Valencia Cathedral showing scenes from the life of one of their ancestors, Saint Francisco Borgia. One of these, showing the Saint at the bedside of a dying impenitent, was the first picture in which Goya included supernatural monsters.

Goya's elevation to *Pintor del Rey* roused him to greater efforts; the series of tapestry designs of the *Four Seasons* produced in 1788 for the King's dining-room of the El Prado palace are the most outstanding of all his works in this field. Those of *The Harvest* and *Winter* are particularly exceptional. The King had requested "paintings of pleasant light-hearted subjects," but the resulting designs are altogether more monumental and pared-down in their approach. Two contrasting views, of peasants at their noonday rest in the parched high plateau of central Spain, and their fellows struggling against the biting windswept chill of an Aragonese winter, sympathetically show the hard existence of the day-laboring poor, inadequately shaded or imperfectly clad; in conflict with nature's rigors. They are not as prettified as his usual peasants, nor indeed as those depicted in other designs in the same series.

BELOW FROM LEFT: *Los Caprichos* plate 6, *Nobody Knows Themselves*; plate 68, *A Fine Teacher*, one of several images satirizing both prostitution and fear of sorcery; plate 43, *The Sleep of Reason Produces Monsters*, the original title plate of the series, suggesting the dominant theme.

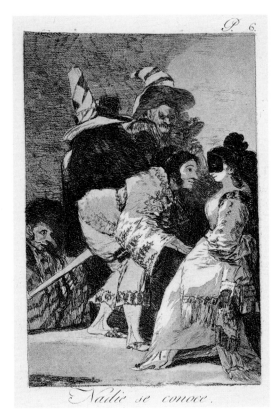

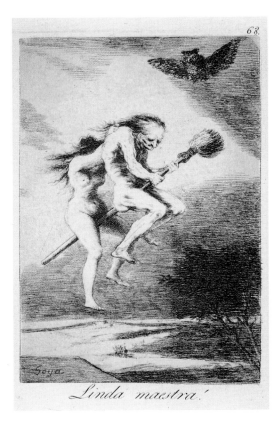

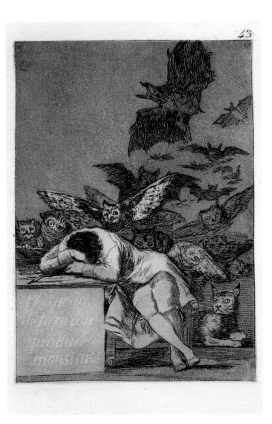

Goya's connections with reforming liberals initially brought him patronage, but soon brought him problems. By summer 1789 the revolutionary rumblings in Paris had led the new king, Carlos IV, and his previously liberal Prime Minister, Floridablanca, to fear the spread of advanced democratic ideas to Spain and her American territories. Censorship and preventing students from traveling abroad were among the means adopted to halt the influence of revolutionary thought, and the Inquisition was revived to assist in this task. Spain and France were allies, Louis XVI and Carlos IV being first cousins, and both countries had backed the American colonists in their revolt against Britain. Spanish and French foreign trade agreements were also closely linked, but when Louis XVI was forced to accept further constitutional reforms, relations worsened between the two countries. When a French republic was declared and Louis was imprisoned, the possibility of war increased. Unsuccessful attempts were made in November 1789 by Cabarrús to obtain, through bribes or other means, Louis's escape (legend has it that Goya traveled with him to France to help). The offer of Spanish neutrality in the event of a European conflict was the last card played to save Louis's life; his execution in January 1793 made further accord unlikely, and Spain was put on a war footing.

Meanwhile Goya's friends had already been forced out of office, into exile, banished to their homes or worse. Cabarrús, who fell from grace in 1788, was imprisoned in May 1792. His release to try and save Louis XVI was only temporary. Gasper Melchor de Jovellanos, the greatest intellectual of the Spanish enlightenment, was banished to Gijon. Political power in Spain under Carlos IV gradually accrued to Don Manuel Godoy, a nobleman and soldier who had exploited his position within the King's bodyguard to become the lover of Queen Maria Luisa. Godoy's talents, nonetheless, were considerable. He became Prime Minister in 1792, and earned, or rather endowed himself with, the title ''Prince of Peace'' when he negotiated a humiliating agreement with the French in 1795. Goya's position as a senior court-painter in the middle of all these shifts of power must have been extremely delicate.

The serious illness that struck Goya while he was in Seville in late 1792, and which left him stone-deaf, has not been satisfactorily explained. It was possibly a form of meningitis; he suffered fevers, temporary partial blindness, and may also have had hallucinations. Some commentators have viewed his illness as marking a major break in Goya's art, from eighteenth-century court-painter to nineteenth-century realist and depictor of personal visions. This view, however, underestimates the importance of Goya's earlier art and does not square comfortably with his subsequent career. To see Goya's illness as a terrible personal

odyssey that in some way paralleled the disintegration of liberal values and reason in his own society is to impose retrospectively a dramatically appropriate starting-point for Goya's later images of pessimism. Goya's art following his illness did change, but very slowly, not suddenly.

In summer 1793, Goya returned to Madrid and to his duties at the Academy, after several months convalescence with his friend Martín Zapater. He showed his fellow academicians a series of small works, and recorded how they came about:

In order to distract my mind mortified by reflection on my misfortunes and in order to recoup some of the expenses they have caused, I painted a group of cabinet pictures in which I have shown things that commissioned works do not allow because they do not permit invention and fantasy.

Yard with Madmen was one of this group, which also included eight bullfighting subjects, a view of brigands attacking a coach, and a scene of strolling players. Other pictures painted much later have until relatively recently been wrongly dated and identified with this group. The perceived hopelessness of the lunatics in their prison and the merciless brutality of the murdering highwaymen have tended to be read as suggesting that Goya was denouncing the unenlightened treatment of the insane, and highlighting the

Los Caprichos plate 75

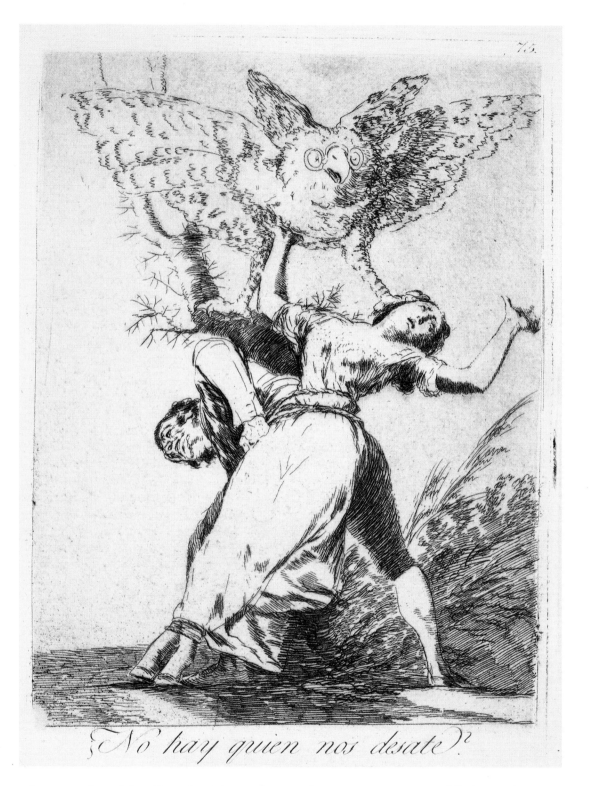

socially destructive consequences of rural ignorance and poverty.

Goya also continued to paint official pictures, including two of the military leaders who were fighting the French and equestrian portraits of Godoy. His tapestry cartoons ceased, however, possibly as a result of royal economies. In 1795 Bayeu died, and Goya obtained the position of Director of Painting at the Academy. In the same year several of his friends returned to political favor, Godoy having been persuaded to introduce a more liberal ministry.

No greater myth survives concerning the life of Goya at this time than that of his supposed love-affair with the Duchess of Alba. Goya painted two formal portraits of her, in one of which he shows her with a ring inscribed "Goya" and pointing to the words "Solo Goya" (only Goya) traced in the dust at her feet. Other visual evidence for their suggested intimacy are a few wash drawings, two small genre oils showing the Duchess and a favorite old family retainer, one mildly erotic wash drawing of what may be the Duchess, holding up her skirts to show her buttocks, and a plate intended for the *Caprichos* series entitled *The Dream of Lies and Inconsistency*, which shows a two-faced figure, probably the Duchess, embracing the head of what might be Goya. Further evidence attested for their liaison is the lengthy time that Goya spent with the Duchess following the death of her husband in 1796, and the fact that on her premature death in 1802 she left Goya's son a pension of 10 reales a day. In 1796, however, Goya was 50; the Duchess was 33 and one of the most socially successful and beautiful women in Spain. Goya's infatuation is easy to believe but no solid evidence exists to prove a closer connection. The suggestion that the Duchess may have modeled nude for *The Maja Naked* has never been seriously sustainable.

In February 1799 Goya advertised in the *Diario de Madrid* the publication of a series of 80 engraved prints, each approximately 12½ × 8¾ inches. Entitled "*Los Caprichos*," they were put on sale at 320 reales the set at a perfumier's shop opposite Goya's house. He had been working on them for at least two and probably three years. Although he had earlier engraved reproductions of various Velázquez pictures in the royal collections and made other prints, this was Goya's first major print venture, emulating, and to an extent imitating, the various *capricci* and

scherzi produced by Tiepolo, Morieschi and Canaletto in the 1740s. The inspiration for the *Caprichos* has been variously accounted for, and over the years complex and very diverse readings have been made of them. It has been suggested that they lampoon specific individuals in Spanish society, whose identity we no longer recognize. Alternatively they have been viewed as containing very elaborate layers of punning that link them with folklore, traditional literature and popular myth.

There is much in the *Caprichos*, with their underlying strand of moral castigation of sexual folly driven by lust, mendacity, superstition and fashion, that suggests the satirical attitude of Hogarth in his prints of rakes, harlots and the superficially modish. On the other hand, those *Caprichos* dealing with education, which advocate that children be treated gently and firmly guided, rather than beaten, scared, or spoiled, suggest contemporary Rousseauesque and enlightened French beliefs about childhood. Prints showing various mules and asses preoccupied with books of lineage and genealogy have precedents in church miserichords, and popular theatrical types or characters who mock Spanish society's obsession with the minor nuances of status. The

BELOW AND BOTTOM: San Antonio de la Florida,
Madrid, frescoed by Goya in 1798. In 1929 his
body was reinterred here.

devil, goblin and witch images also have roots in medieval church art, although it is very difficult to see some of them as having anything to do with a moral critique – they seem to be simply gruesome illustrations of witches playing games with dead babies. There are a few anti-clerical images, fawning monks before the golden beak of a prelate or preacher, and two Inquisition scenes in which the innocence of the victim is made obvious.

For the title plate of the series Goya had originally planned to use an image of a sleeping man inscribed ''The Sleep of Reason produces Monsters.'' Instead, less controversially, he engraved his own portrait on the front page. He described his overall intention for the series as being ''to banish ideas commonly believed and to perpetuate with this work . . . the solid testimony of truth.'' Sometimes cruel, occasionally sadistic, the *Caprichos* are nonetheless broadly humorous and satirical, and are not distinctly pessimistic. They are not to be viewed (as they sometimes have been) as suggesting the disintegration of rational life in Spain, or as veiled criticism of government repression; their targets are the more general and persistent follies of society. Goya sold 27 of the 300 sets that he printed, principally to liberal friends or patrons who were in agreement with the reforming tone of the series, and who were able to understand the sophisticated allusions. The Duke and Duchess of Osuna, for example, who had already in 1797 commissioned six small pictures that mocked witchcraft and superstition, bought four

sets. Guillemardet, French Ambassador to Madrid also had a set. In 1803 Goya sold the entire series of plates, plus the unsold sets of prints, to the Calcografia (royal printworks) in exchange for a pension for his son of 12,000 reales a year – an extremely shrewd move. He later suggested that the *Caprichos* had attracted opposition from the Inquisition and this led to his withdrawing them from sale, but he may have been exaggerating. The likeliest explanation of their failing to obtain a wider initial audience was that they were priced too high. When the Calcografia advertised them for sale in 1816 they lowered the price to 200 reales a set, rather than the original 320 reales.

Aside from working on the *Caprichos*,

Goya's most outstanding work during 1798 were two religious projects. The first, for the sacristy of the cathedral in Toledo, was *The Arrest of Christ*, which was intended as one of two altarpieces to be placed either side of a newly-designed altar for El Greco's painting of *The Disrobing of Christ*. Taking account of the composition and tonal structure of El Greco's work and the very low light levels in the sacristy, Goya exploited the play between strong lights and darks. Christ is shown by lamplight, his meek face and the contrasting rough features of Judas and the assailants shining in an effulgent bright yellow glow. Goya's admiration for the religious narratives of the paintings of Rembrandt is clearly evident.

The second religious commission was for the royal chapel of San Antonio de la Florida in Madrid (since 1929 Goya's burial place) where, between August and November, he frescoed the dome, pendentives and vaults with a depiction of the miracle of St Anthony of Padua, raising a murdered man from the dead in order to find out who had killed him. In the dome Goya painted a fictive balustrade, against which lean 50 or more summarily-painted animated figures, palpably Spanish, mostly poor, some rich, both old and young. The various reactions of these spectators to the miracle, rather than the miracle itself, forms the principal focus of the picture. Released from the constraints of the narrow altarpiece format or the need to integrate his work with that of others, Goya produced a masterpiece of religious art. The free, loose paint-handling and the unforced

Diego Velázquez: *Prince Balthasar Carlos Dressed as a Hunter, c.1635.*

naturalism of the figure-painting is outstanding.

Goya may have petitioned for the opportunity to paint in San Antonio, but between 1799 and 1801 he was commanded to paint a series of royal state portraits. Queen María Luisa and Carlos IV posed for monumental equestrian portraits which deliberately imitated similar portraits in the royal collection of Isabella of Bourbon and Margarita of Austria by Velázquez. Dynastic continuity was thus emphasized by an artist's stylistic conformity, just as Velázquez in his time had taken account of Titian's great portrait of the Emperor Charles V, also in the Spanish royal collection. The Queen is shown on her favorite mount, Martial, a gift from her lover Godoy. Goya also painted the King with rifle and dog, just as he had earlier painted Carlos III, again based upon a Velázquez prototype.

The greatest of this group of royal portraits is *Carlos IV with his Family*. Like the earlier group portrait of the Infante Luis, Goya centers attention on the principal female, the Queen, ugly, by all accounts ridiculously vain, especially proud of her beautiful, rather plump, arms (so much so that she forbade the wearing of gloves by women at court). Rich fabric, regalia, jewelry, all the obvious indicators of rank are superbly painted in feathery impasto and coruscate in the one bright light that shines from the left. The low viewpoint, the cluttered and haphazard arrangement of the frieze (almost a queue) of royal sitters, and the unflattering honesty of the individual faces, have made this painting a byword for naturalistic portraiture. Théophile Gautier's later remark that the King "looks like a grocer who has just won the lottery, with his family about him" still rings true. Goya's inclusion of himself in the portrait, actually painting the picture, is yet another act of homage to Velázquez, once again to the great royal portrait *Las Meniñas*.

Goya was not asked by Carlos IV to do any further royal group portraits after this, although that does not necessarily indicate that he was out of favor. It seems that during the last years of the eighteenth century, what we would now regard as rather ruthless verisimilitude was actually fashionable among certain sections of aristocratic Spanish society, and that, despite their extremely rigid etiquette and maintenance of elaborate social distinctions, being painted with

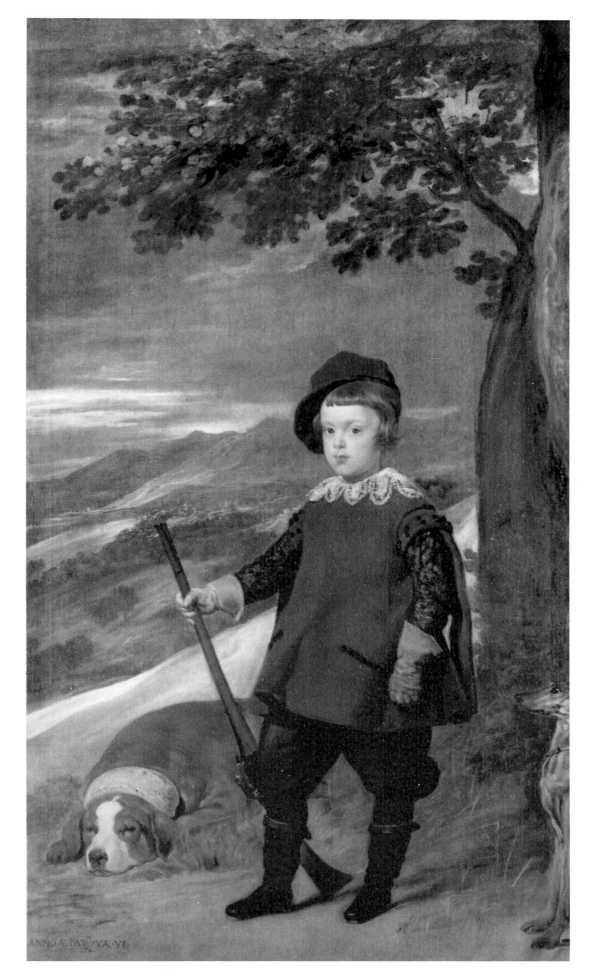

unvarnished truth and depicted in mundane rather than heroic attitudes was what they sometimes required. One sees it again in Goya's 1801 *Don Manuel Godoy*; despite the flags, military gear and symbolic accouterments of office, the rubicund Godoy lies sideways in a relaxed pose more reminiscent of a pensive poet on a grassy knoll, considering the alteration of a line of verse, rather than of the masterful commander-in-chief who

had just achieved complete victory over the Portuguese. Contrast it, for example, with a more or less contemporaneous portrait of the French Ambassador *Ferdinand Guillemardet*, similarly decked out in the braid, buttons, ribbons and cockades of military rank, but altogether more stiffly presented, with fist clenched, arm bent, and elbow forward in the traditional pose of male authority and gentility adopted from Titian onward.

Goya's house on the outskirts of Madrid, which he bought in 1818 and which was nicknamed "the house of the deaf man." He made his famous series of "black paintings" here.

Godoy, at the height of his power in 1801, was an important patron to Goya. He commissioned pictures by contemporary artists to augment his already large accumulation of over a thousand Old Master paintings. His appetite for the latter was voracious; at the death of the Countess of Alba, for example, he ensured that he obtained from her heirs pictures intended as a gift to the King. These included a Correggio and a Raphael that had been in the family for generations and Velázquez's *Toilet of Venus*, now in the National Gallery, London. Godoy hung this latter work in a private drawing-room in his palace, next to the horizontal full-length portrait that Goya had painted of his naked mistress Pepita Tudo, the so-called *Maja Naked*. It was once mistakenly believed that this picture and a companion picture *The Maja Clothed* had also belonged to the Duke of Alba, a misunderstanding that helped fuel the suggestion that the naked Maja was in fact the Duchess of Alba. The date when Goya painted these two pictures is unclear, but around 1800 seems most likely, when Godoy was in a position to demand and obtain such work from Goya. In 1808 Godoy fell from grace and the Spanish government ordered his property to be sequestered and sold. The Old Masters found their way onto the art market, but the two Majas were secreted in private rooms within the Academy, probably to avoid scandal, although they later, in 1814, attracted the disapproval of the Inquisition.

It has been suggested that Goya's inspiration for his naked Maja was Velázquez's *Venus*, but it has quite recently emerged that it was another Venus, also owned by Godoy and painted by a Venetian contemporary of Titian, which provided the model for Goya's forthright full-frontal depiction. Believed to be by Titian or his contemporary Pordenone, this second Venus (now known only from old photographs) had also been in the Alba collection. It was a picture that Velázquez had known and admired, probably also believing it to be by Titian, and his own Venus, with its chaste and idealized rear view, was commissioned as a pendant to it. All three nudes, with a fourth – a copy after Titian by Luis Eusebi – hung together with *The Maja Clothed*, probably in one room in Godoy's sumptuous Madrid palace, an extraordinary testimony to the continuity of Spanish painting and its iconographic and technical debt to Venetian art, as well as a most potent pictorial affirmation of the power of the arriviste Godoy, lover of the Queen, confidant (and possibly also the lover) of his foolish monarch, controller, briefly, of all spheres of Spanish public life.

The female nude is extremely rare in Spanish art and was not conspicuously displayed in royal or aristocratic collections; indeed curtains were often hung over nude paintings. In 1762 the puritanical Carlos III had even contemplated burning all the nudes in the royal collections. Goya's Maja, probably the first in European art to show pubic hair, is all the more startling in this context. No myth-

ological allusions or props were used to disguise the frank eroticism of the figure. It is possible that the two Mayas overlapped in some way, *The Maja Clothed*, if decency required, being hung on top of *The Maja Naked*.

Godoy asked Goya to paint his naked mistress at approximately the same time that he commissioned him to paint his pregnant wife. The Countess of Chinchón had married Godoy in 1797 at the bidding of Queen María Luisa. She was the daughter of the disgraced Infante Don Luis, the little girl in Goya's earlier 1784 family portrait, who, following the death of her father in 1785, had been ordered by Carlos III to live apart from her mother in a Toledo convent. María Luisa apparently hoped to separate Godoy from his mistress, Pepita Tudo. The 18-year-old Countess • obtained escape by this loveless marriage from her convent, and reintegration into the highest ranks of Spanish society, while Godoy, albeit by marriage, became part of the royal family. Jovellanos described how Godoy dined with Pepita Tudo seated on one side and his wife on the other. In this coldly calculating world Goya maneuvered carefully. His *Portrait of the Countess of Chinchón* is sensitive and sympathetic. Within the huge void of a darkened room the diminutive five-month pregnant figure sits staring abstractedly, one hand clasped over another, her finger displaying the huge cameo portrait of her faithless husband. The cornflowers and unripe wheat in her hair are symbolic of her obvious fertility and impending confinement, the pale blue picked up in the beribboned edging of her cuffs, train and bonnet. María Luisa wrote approvingly to Godoy over his choice of Goya to paint his wife's portrait. It is always tempting with a picture such as this, which has such a highly-colored context surrounding its genesis, to read more into it than the portrait itself suggests, but in this case the pathos is almost tangible.

Spain's position as a satellite of France became increasingly complex as the internal and external fortunes of her more powerful neighbor waxed and waned. Napoleon's *coup d'état* in November 1799 had ushered in a centralized state authority in France which removed political power from the electorate, drew the teeth of remaining ultra-democratic forces, and, by a mixture of clemency and force, integrated royalist and revolutionary tendencies within French govern-

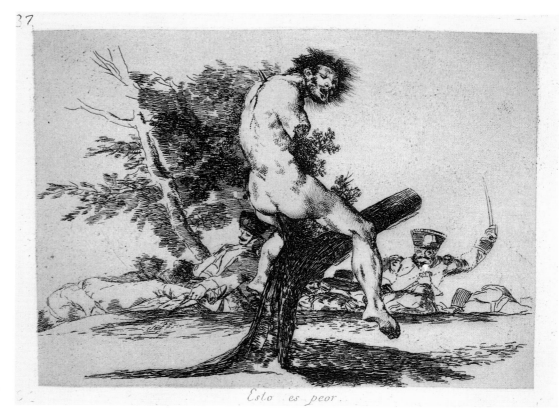

Los Disastros plate 37, *This is Worse*. Goya's series of prints *The Disasters of War* reflect his horrified reaction to the Peninsular War.

ment. A secret treaty of alliance united Spain and France in October 1800, and when the Treaty of Amiens in 1802 brought a year's temporary peace to Europe, the Spanish royal family indirectly benefited from the grant made by Napoleon of the Duchy of Tuscany to the Bourbon Duke of Parma. As part of the same negotiations, however, Napoleon ceded the Spanish colony of Trinidad to the British without consultation.

Despite his dictatorial high-handedness, Napoleon was attractive to some Spanish liberals, just as he was, at this same period, to certain sections of enlightened British society. His reforms, imposed upon various invaded European countries, had swept away feudal privilege, helped erode priestly and autocratic authority, and laid the basis for a uniform code of European law. To some Spaniards living under the arbitrary and corrupt governance of Godoy, French models of modernization must have seemed appealing. In 1805 the Spanish navy was crippled by the British fleet when it fought alongside the French at Trafalgar. In 1807 France and Spain joined forces to invade Portugal. By the beginning of 1808 there were over 100,000 French troops within the Iberian peninsula. It is not too surprising that, given the troubled state of Spanish government, Napoleon's economic and dynastic ambitions should eventually have turned toward Spain. In May 1808 he pressed his opportunity.

The bulk of Goya's work between 1802 and 1808 was taken up with aristocratic and society portraiture. Among these are an outstanding group of female portraits made around 1805. They include that of *The Marquesa de Vilafranca*, sister-in-law of the Duchess of Alba, shown seated and holding a mahl stick and brush, in the act of painting her husband's portrait. Painting and drawing had become fashionable accomplishments by the late eighteenth century, and several of the nobility displayed amateur works at exhibitions at the Academy of San Fernando. The Marquesa was elected in her own right to the Academy as a painter. Another of this group, *Isobel Cobos de Porcel*, wife of a protégé of Godoy's, is portrayed half-length, her peach, rose and white complexion framed by a nimbus of exquisite freely painted black lace. She wears the mantilla and tight jacket of the Maja, the dress of the Spanish lower classes that had been adopted with modifications by upper-class Spanish women

from the 1780s as a rather chic mark of national pride. (Its male equivalent, which survives today in the costume of bullfighters, never gained the same footing.) The most unusual of this distinctive group is *The Marquesa de Santa Cruz*, daughter of the Duke and Duchess of Osuna, who lies full-length on a sofa, rather like the earlier *Maja Naked*, but dressed and decorated in neoclassical Empire style, clutching a lyre, like a female Apollo, and crowned with oak and vine leaves. It is Goya's most sustained exercise in the manner of David and indicates how French fashion predominated at this time in Spain. (A rather sinister footnote to this picture's history is that Franco considered making a gift of it to Hitler, thinking that the swastika-like marquetry motif on the lyre would appeal to him.)

In early 1808 it was becoming clear that France's ambitions for territorial aggrandizement included Spain and not just Portugal. Godoy was blamed, and public dissatisfaction led to rioting in Madrid. Fernando, son of Carlos IV, had been secretly plotting with the French for help to displace Godoy and take over the throne. In March, Carlos IV abdicated in favor of his son, partly in order to save Godoy's life. From March 18 until April 10 Fernando VII enjoyed a brief reign, until he too was forced into exile in Bayonne, where his parents were already being held. Napoleon intended that Spain's new king should be his brother

Joseph Bonaparte, José the First. Characteristically, even in the middle of this political to-ing and fro-ing, Goya was employed to paint a portrait of Fernando VII for the Academy of San Fernando. On May 1, when the French attempted to remove further members of the royal family from Madrid to Bayonne, the citizenry of Madrid rose up. On May 2 there were massacres, as crack French troops fought with the poorly armed citizenry. The city soon fell under complete French control, and on May 3 over 100 executions took place of those Madrilenos who had been captured in possession of weapons.

These courageous and cruel events were immortalized by Goya in two canvases painted six years later, *The Second of May, 1808* and *The Third of May, 1808* (pages 93 and 94), which together form one of the greatest, if not the greatest, memorials of war that have been produced in the last two centuries. What is astonishing is that they constitute a public and official war memorial, although never prominently displayed, and not simply a private commentary upon the conflict. Goya had informed the ruling regency in 1814 of his "burning wish to perpetuate with the brush the most notable and heroic acts and episodes of our glorious uprising against the tyrants of Europe," and he was paid to make these pictures. When one considers the triumphalist pomp, melodramatic heroics, or calm dignified grief which is

Los Disastros plate 9, *They Do Not Want To*; an old woman stabs a French soldier who is trying to rape her daughter.

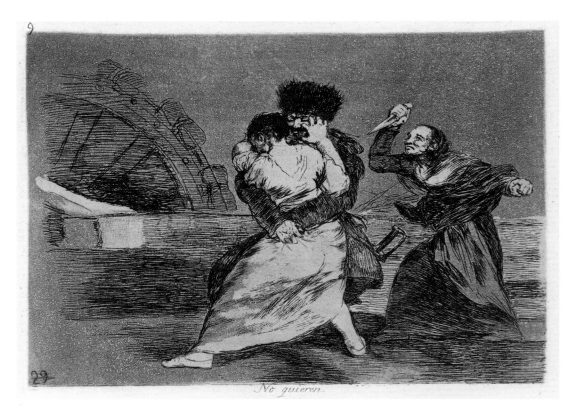

the normal language of the state or civic war memorial, Goya's amalgam of frenetic cruelty, violence, courage, fear and despair is extraordinary. To show one's own side out of control, terrified and being executed is unique in official war art. Goya did not retreat into generalizations, but instead focused on specific detail that leaves the spectator little chance to derive contemplative solace. He may have said with disarming lack of candor that he wished to celebrate "heroic acts," but what he in fact produced was a damning indictment of war itself. And yet these are also such exquisite pictures. A knife-slashed beautifully-blue-jacketed Mameluke warrior is central in *The Second of May*, his gorgeous red pantaloons providing the striking focal point. Pastel greens, subtle pale peach and oranges, delightful passages of paint, chronicle the most horrible of wounds. Pools of gore are so exquisitely painted that their facture produces a sensuous frisson uncomfortably in conflict with the horror of the episode depicted.

In addition to documenting these famous events in Madrid, Goya also as part of his memorial series painted two less well-known pictures, showing the manufacture with crude equipment of bullets and gunpowder in woodland clearings in the Sierra Tardienta near Zaragoza. These recall both his earlier tapestry designs and a small 1792 picture of bandits robbing a coach in a desolate spot. Indeed the organization and operational methods of the Spanish people's

resistance during the Peninsular War was not dissimilar to that of brigands. It was this war that gave us the word "*guerrilla*," literally "little war," whose fighters evolved the extremely successful tactic of ferocious surprise attack upon marching French columns, followed by immediate retreat, that has been the model for popular military resistance to alien invasion to this day. Goya may actually have witnessed these or similar events, although with his wartime images it is never clear how much he saw and how much he translated into art the description of others.

Throughout the Peninsular War, from 1808 until 1812, Goya's painting output dropped – less than 20 pictures and perhaps as few as 13, and dating them is difficult. A few images dealt directly with the war. Of these *The Colossus* is perhaps the best known; columns of panic-stricken Spanish refugees loaded down with wagons, cattle and their worldly goods, flee some battlefield or sacked city, while in the stormy background a sturdy giant figure strides away from them. His significance is unclear. An avenging Spanish giant bent on defeating the French; a rapacious monster symbolic of the savagery on both sides; an impotent colossus trapped above the knees in the land and unable to prevent the horrors around him; possibly even a symbol of Napoleon himself: all these and more have been offered in explanation. Like the later pictures of *The Second* and *The Third of May*, the exquisite delicacy of

certain paint passages – for example the pink-tinged clouds and the clothing of the figures – is incongruous given the fearfulness of the events depicted. It is as though sudden terror had descended upon the same meadow of San Isidro that Goya had so affectionately painted in 1788.

Soldiers Shooting at a Group of Fugitives, probably painted around 1810, also anticipates certain features of Goya's *Third of May* picture. The massed rifles of the right-hand group later reappeared as French troops executing Madrilenos. In this case, however, they may belong to Spanish patriots shooting collaborators, including a terrified mother and baby. Her husband may be the deposition-like figure in front of her, surrounded by uniformed soldiers whose hideous, crazed faces, with black holes for eyes and mouth, later became characteristic of Goya's so-called Black Paintings of the 1820s. In the 1994 Chicago exhibition devoted solely to Goya's small pictures, this work and the seven others in the same series were redated to 1798-1800. This was proposed unconvincingly as a bandit scene rather than a Peninsular War subject, the most recent example of one element of Goya scholarship that tries to date the beginning of the dark and pessimistic side of Goya's work to the 1790s rather than from around 1808 onward.

Although rarely painting the war, Goya was privately engrossed in drawing and preparing prints of it. In 1808, following the unsuccessful French siege of Zaragoza, he was summoned by the Spanish general Palafox to "see and examine the ruins of the city so as to paint the heroic deeds of the inhabitants." Over 80 prints, *Los Disastros de la Guerra*, made from about 1808 onward, possibly began as a result of this visit, and reflect a substantial shift in Goya's art and outlook. If the *Caprichos* are a satire of social ills and superstition from a position of liberal sanity, the *Disastros* reflect the undermining of morality itself, along with truth, compassion and the most basic human decency. Collectively they may just about be read as an unfolding narrative, the progressive record of the Peninsular War. Although often specific in reference and occasionally celebrating some heroic act of fortitude, they are more generally Goya's excoriating indictment of the inhumanity of man to man. To try and read them, as some recent commentators have, as indicative of

For Being a Liberal, one of several allegorical wash-drawings produced during the repressive rule of Fernando VII after 1814.

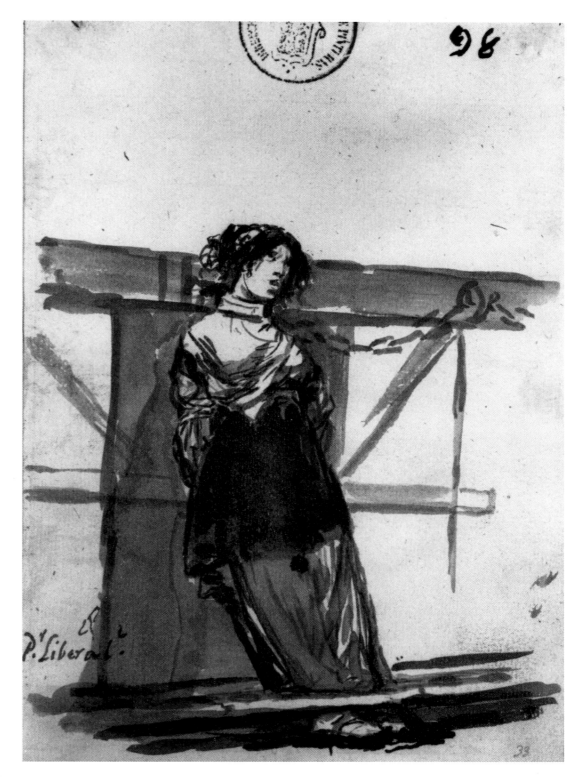

Goya's recognition that brutality had to flourish before Spanish freedom could be won, is difficult to reconcile with the tone of fatalistic inevitability that pervades this gruesome narrative. The *Disastros* are like a Hogarthian progress, not of individuals gone to the bad, since individuals scarcely seem to matter any more, but of small groups and the masses destroying each other. Ferocious brutality, mass rape, arbitrary execution, looting, desecration of sacred places, mindless mutilation of corpses, starvation, famine, despair, madness, death: it is no wonder that these images have not dated. To turn the pages of a set of the *Disastros* is to see the reportage of any twentieth-century civil war.

Goya did not publish these prints in his lifetime; it was not until 1863 that the Academy of San Fernando issued them as a set. Along with the many wash drawings made in preparation for the plates, these images, almost from their first publication, have become the most influential visual critique of war. Goya's inspiration was probably the seventeenth-century French artist Callot, who had also recorded in prints the brutality of the religious wars of his own time. Callot, however, depicted the events around him from panoramic perspectives; a group of hanged men, for example, look like mannekins on a string or dead crows on a fence. Goya pushes the gore to the forefront with revolting clarity.

In 1811 Goya was awarded the Royal Order of Spain by King Joseph Bonaparte, although he later claimed that he never wore it. Goya's skills were in demand by the French invaders, and he made a few portraits of the occupying leaders, including the sternly magnificent *General Nicolas Guye*, painted in 1810. In the same year, for the Town Hall in Madrid, he painted *An Allegory of the City of Madrid*. No picture expresses better the vicissitudes of life during this period. Initially the oval frame on the right held a portrait of Joseph Bonaparte. Around mid-1812, when the British occupied Madrid, the word "*Constitucion*" was painted over Joseph's face (by another hand). Re-occupation by the French led to a return of Joseph's features, then around 1813 "*Constitucion*" was again substituted, followed around 1815 by the features of the new king, Fernando VII. Finally, in 1843, this was replaced with the inscription "*Dos de Mayo*" referring to the popular uprising of 1808.

Those Spaniards who sympathized with French rule were nicknamed the "*Afrancesados*," and several of Goya's friends and acquaintances accepted government office under the French. Goya's own sentiments were unclear. He was obliged, as a matter of course, to swear an oath of loyalty to the new government, and he may at first have felt sympathetic toward French rule, but by 1810 he was clearly, albeit secretly, in favor of the ejection of the invading forces and the liberation of Spain.

Several liberals were anxious, with good reason, about the possible effects of a return of the Spanish royal family; Fernando VII was one of the most stupid, reactionary and autocratic of individuals, and had no time for democracy. Those Spaniards who were organizing resistance to the French formed themselves into a parliament in 1810, and in 1812 at Cadiz promulgated a constitution that enshrined liberal values, and codified

what they hoped would be the basis for future free government under a constitutional monarchy. Fernando had other ideas, however, and when he was securely back on the throne, in 1814, he scrapped this constitution, introduced press censorship, closed the theaters and universities, and revived the powers of the Inquisition. The Cadiz Constituent Assembly and its decrees were declared to be "null and void, now and forever, as if such acts had never taken place, and they were removed from time." Repression followed against all liberals, both those who had been sympathetic to the French and those who had fought in the war of liberation. Ministers were jailed, others were sent to African penitentiaries. Many left Spain to escape persecution, going to England or settling across the border in France. Guilds were re-established, and noble birth was re-introduced as a prerequisite for entry into

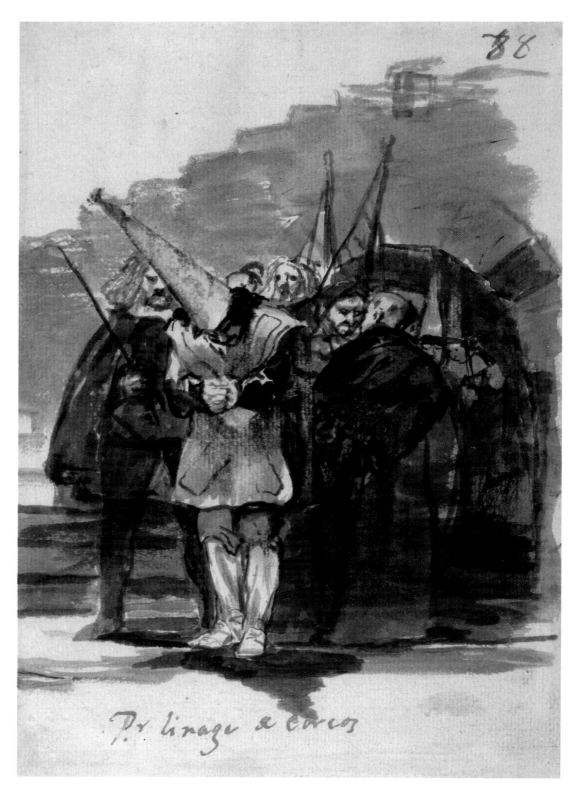

Pr linage de ebreos

For Being a Jew, Goya's response to the Inquisition's resumption of activity in the early eighteenth century.

army and navy schools. And Goya continued as court painter to this absolutist monster on an annual salary of 50,000 reales.

Of the half dozen portraits of Fernando that Goya painted for public buildings and ministries, none appear to have been directly commissioned by the King. The sittings that Fernando gave in spring 1808 seem to have been the basis for all subsequent depictures. That of *Fernando VII in an Encampment* dates from 1814. Despite the decorations, medals and military setting, the King had in fact taken no part in the war or seen any action anywhere else. Fernando's head sits rather oddly on his stiff trunk, suggesting that another may have posed for the body in this picture. He also looks curiously separate from the other figures in *The Meeting of the Royal Company of the Philippines*, commissioned to com-

memorate his meeting with the shareholding dignitaries of the company that had a monopoly of trade with the Philippines and who had agreed to make him a substantial loan. As with Goya's earlier royal group pictures, an uncomfortable spatial dissonance characterizes the picture's construction; in this case the empty floor forms the central part of the canvas, and all figures including that of the King are tiny.

Although Goya ceased to paint popular subjects as cartoons for tapestries after about 1790, he continued from time to time to paint distinct groups of pictures of the everyday. Occasionally these suggest that some grander decorative scheme may have been projected. *The Water Carrier*, usually dated to between 1808 and 1812, and its small companion *The Knife Grinder* are connected both stylistically and in conception with the

very large canvas *The Forge*. Much darker than his earlier tapestry designs, these present heroically-posed close-ups of workers. Their paint facture is redolent of the forceful, broad handling of his earlier San Antonio frescoes, Goya using a palette knife to apply rich blacks and ochers. Possibly related to this series are *Old Woman Looking in a Mirror* and *Young Woman Reading a Letter*, which are also both substantial canvases, but are satires on vanity rather than celebrations of worker-heroes, and seem in essence to be larger versions of subjects dealt with in the earlier *Caprichos*. Another from this group, *Two Mayas on a Balcony*, also a large picture, satirizes prostitution; the two Mayas are on offer, with the cloaked woman behind them probably their procuress. This picture and others from this series were subsequently owned by the French king Louis Philippe, on public view in his *Galerie Espagnole* in Paris. Until sold off in 1853, this was one of the most important collections of Spanish paintings ever assembled outside Spain. It had a profound influence on French Realist painters of the mid-nineteenth century, such as Daumier, and urban Naturalists such as Manet, who saw in Goya's pictures an innovative approach that he might adapt for his own depictions of the Parisian demimonde.

Another series which is more difficult to date includes *The Burial of the Sardine, The Procession of the Flagellants*, an *Inquisition Scene* and *The Madhouse*. These have been dated as early as 1794, but are now ascribed to between 1815 and 1820, and are linked to a series of wash drawings that Goya did at about the same time showing trials, torture and scenes of suffering perpetrated by the Inquisition and connected with the anti-liberal persecutions of Ferdinand VII's reign.

Goya's depictions of the Inquisition and flagellants need to be interpreted with caution. These subjects are not of contemporary events but seem rather, from the appearance of the wigs and coats worn by the participants, to be set in the early eighteenth century. In the many related wash drawings that Goya made on similar themes at this time, it seems clear that he did see parallels between the oppressiveness of the Inquisition and the rule of Fernando VII. However by 1816 the Inquisition had very limited powers and these did not include torture. Public flagellation was prohibited in Spain from 1777, although it still continued sporadically.

The etching *Old Man on a Swing among Demons*
(*c.*1824) has been viewed as a wry comment on
the vicissitudes of Goya's own life.

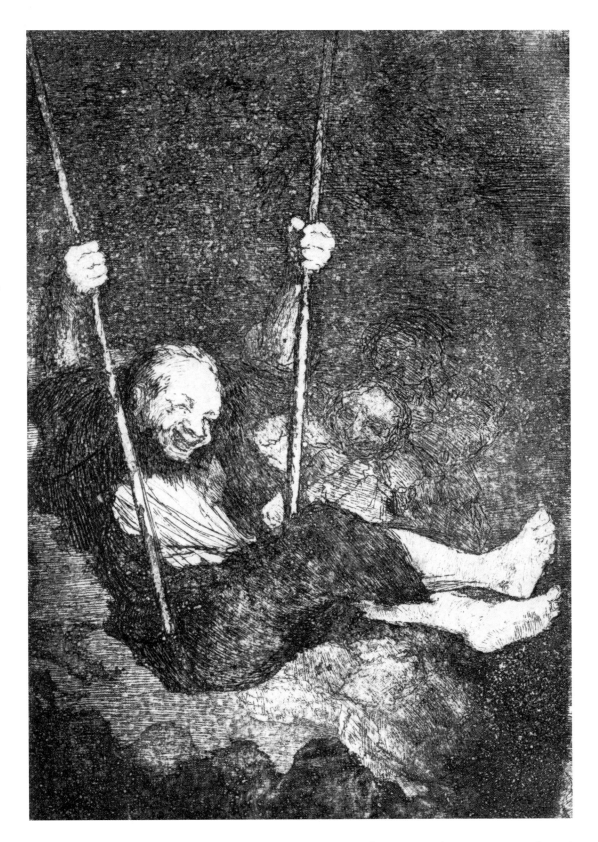

Just as Goya found himself caught in
serious political conflict between reform
and legitimacy, so too in his religious
beliefs he had tensions to reconcile. That
is why any apparent superstition high-
lighted in *The Flagellants* or in the Corpus
Christi procession shown in *The Burial of
the Sardine* needs to be considered along-
side the communal celebrations that he
seems concerned to record. Public reli-
gious life was not viewed by Goya as a
species of collective madness, or simply
as fanaticism, whatever drunkenness,
bawdiness or lack of solemnity might be
present. He continued to paint religious
subjects with sincere expressive devotion
almost to the end of his life. For example,
his *Last Communion of San José de Cala-
sanz*, painted *c.*1819, shows the seven-
teenth-century Roman saint, who has
struggled from his sickbed to receive his
final communion surrounded by his dis-
traught students and followers. Goya's
pessimism did not necessarily mean dis-
belief in Catholicism, nor did it mean
that he subscribed to fashionable early
nineteenth-century movements within
the church for individual salvation or
alternative forms of theism.

Goya's ideas about insanity are also not
straightforward. He never clearly estab-
lished a dichotomy between madness and
folly. Like Hogarth, who often treated
madness as the result of an obsessive pur-
suit of a ridiculous end, Goya too charac-
terized lunatics as a mixture of types —
punch-drunk pugilists, would-be kings,
and so on. While it is possible to con-
clude, on the basis of his drawings and
small oils of madhouses, that he was
broadly sympathetic to a more humane
treatment of the insane, he cannot be
seen, as has recently been suggested, to
have anticipated in some extraordinarily
perceptive intuitive fashion the need for
modern psychiatric care. Like other
Romantic artists of his generation, he had
a curiosity about the taxonomy of in-
sanity and extreme behavior, and his
desire to chronicle probably outweighed
any wish to reform. Reading into Goya's
art late-twentieth-century secular social
reforming beliefs, and an over-simplistic
view of his society as one in which en-
lightened reason typified by Goya did
battle against religion, government and
popular ignorance, has distorted the
understanding of his intentions. Goya
was no Shelley, although several modern
critics have tried to make him so.

The most celebrated pictures of
Goya's last years are the series of 14 so-
called "Black Paintings" done for a suite
of rooms in the country house just out-
side Madrid that he purchased in 1819.
Aged 74 when he began this group, he
had already been dangerously ill in 1819,
as the *Self-Portrait with Doctor Arrieta*, a
gift of gratitude to his doctor, records.
Old age and infirmity have been sug-
gested as a linking theme for this series,
but the overall meaning has never been
satisfactorily explained. All the pictures
were painted directly onto the wall and
they are all, to a greater or lesser degree,

damaged. In 1873 they were transferred
to canvas supports. Goya painted these
works very rapidly, using broad strokes
applied with large brush, palette knife
and possibly sponges. He may have re-
garded them primarily as a technical ex-
periment. Attempts to tease out connec-
tions with the earlier *Caprichos* or
Disastros have proved difficult. They are
perhaps best considered as hermetic self-
contained fantasies, despite several ele-
ments being based upon, or strongly evo-
cative of, earlier images. Suggestions that

23

BELOW: Peter Paul Rubens' depiction of *Saturn* (1608), in the Spanish royal collection, directly inspired Goya's treatment of the subject (page 101).

BOTTOM: Bordeaux, where Goya came in 1824 to live in the small colony of liberal Spanish exiles, and where he died in 1828.

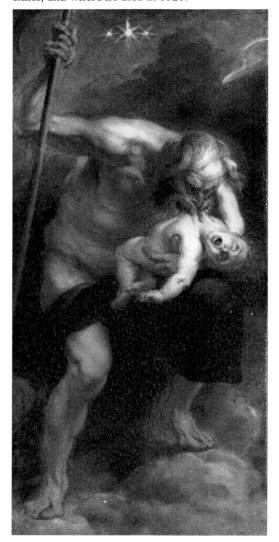

they contain an essentially nihilistic message are not convincing. If any connection can be made with earlier work it is with the "*Proverbios*" or "*Disparates*," a short series of 22 prints made by Goya between 1816 and 1823 but unpublished until 1864. These are the most fabulous of Goya's prints and include images of airborne bulls, men in bat-winged flying machines, an ecstatic woman bitten by a stallion, and cataleptic circles of figures in weird and anguished dance. The title, *Disparates*, meaning follies, derives from the inscriptions "Cruel folly," "Carnival folly," "Clear folly," "Brute folly" and so on added by Goya on a series of working proofs. Their alternative title of "*Proverbios*" arose at the time of their first publication, suggesting either that particular scenes could be linked with well-known proverbs, or, more likely, that the word was also used to refer to an allegory or homily requiring interpretation.

The political repression of liberals by Fernando VII eased in 1820, when he was forced to swear allegiance to the 1812 Cadiz constitution. Matters worsened again in 1823, however, when Fernando, with the aid of a French army of ultra-royalists sent by the reactionary Louis XVIII and led by the Duc d'Angoulême, once again swept away democratic in-

stitutions. Goya felt frightened enough to go into hiding for three months at the home of a friend, the Jesuit priest José Duaso y Latre, whose portrait he painted in thanks. When a general amnesty was announced on May 1, 1824, Goya, having already in the previous September assigned his home to his grandson, now sought to obtain six months leave from his post as court painter on the pretext of taking a cure in France at Plombières. He could, of course, have simply left the country but he had his royal income and pension to protect. The King granted him his wish and he left Spain in June. First he headed for Paris, where he visited many of his exiled friends and probably also attended the Salon of 1824. He then settled in Bordeaux along with other Spanish exiles. Apart from a brief trip that he made to Madrid in May 1826 to present in person to the King a request for his retirement, and another in 1827, Goya never returned to Spain. During the four years that he was in Bordeaux Goya lived with the woman who had been his companion since his wife's death in 1812, Leocadia Zorilla de Weiss, and her two children, the younger of whom was possibly also Goya's child.

He continued to paint portraits, mostly of his friends, and to produce prints. There was no diminution in his powers. He experimented with a series of very small pictures painted on ivory, most of which have now been lost. These were related to the Black Paintings and to earlier prints, but it is difficult to deduce what his intentions were for them: jewelry, perhaps, or decorative inlays for furniture? The availability of a lithographic press in Bordeaux led to further experiment. He made a small series of bullfight lithographs evocative of an earlier series of 33 etchings, *La Tauromachuia*, first published in Madrid in 1816. Both series suggest Goya was trying for a new market, to compensate for the falling demand for his portraits and his temporary financial difficulties. Several illustrate the achievements of well-known contemporary bullfighters, with their nicknames used as part of the titles. Despite this attempt at a popular appeal they did not sell well.

Related to these bullfighting prints are a number of small oils. Goya's bullfighting canvases span nearly 50 years of his life; curiously, that from 1793 painted for the Duke and Duchess of Osuna does not differ significantly in style from that painted *c.* 1810-20, or from the group of

The Agility and Daring of Juanito Apinani in the Bullring in Madrid, etching and aquatint from the print series *La Tauromachia*, published 1816, which included the popular matadors of the day.

four that he painted in Paris in 1824. In all cases the essentials of the action are painted in a rapid calligraphic manner, with thin color roughly glazed over line. Spectators are indicated by the most summary strokes, and the flickering pulse of action is paramount. These superb celebrations of Spain's national sport also testify to Goya's lifelong interest in the complexity and subtlety of the bullring. In the same way that Degas's ballet and laundress pictures are a record of the precise vocabulary of particular trades, so too Goya in these bullfighting oils and prints delineates the very distinct qualities of specific matadors.

Goya's last years were ones of periodic irritating illness, but were characterized by stable, domestic happiness and security. He died in April, 1828, aged 82, of a paralytic stroke brought on by the excitement of an anticipated visit from Spain of his son, grandson and daughter-in-law.

Goya had no pupils, although he did have a few imitators. His influence upon nineteenth-century Spanish art was virtually nil. During his own lifetime his pic-tures were almost unknown outside Spain, despite the oft-quoted case of Delacroix, who in 1823 expressed enthusiasm for his prints. The circulation of the *Caprichos*, and the small number of his pictures on view in Paris from the 1840s, promoted Goya's reputation with Romantic writers and painters. Very few made the trip to Madrid, however, where his work could be viewed in reasonable quantity at the Prado. His religious works in provincial monasteries, convents and churches might almost never have existed. The publication of the *Disastros* in 1863 helped increase interest in Goya's art and his name is closely linked with the revival of etching among Realist artists of the early 1860s, including Manet and Degas. Manet's own Spanish-subject pictures of this period were favorably compared with Goya by certain critics, without however any very clear parallels being made, and in the same breath as they were also being compared with Velázquez. Indeed it was Velázquez and Murillo who, until the end of the nine-teenth-century, remained the pre-eminent Spanish influences upon Euro-pean art, inspiring Millais, Whistler, Sargent, Lautrec and many others.

In 1901 Goya's body was returned to Spain, and in 1929 San Antonio de la Florida was transformed into his pantheon. It is only in the twentieth century that Goya's work and genius has been fully recognized. Even so, it was his female portraits that first attracted most interest, part of that mania for late eighteenth-century and early nineteenth-century European portraiture that especially infected American collectors. In 1853 *The Forge* sold for $20; in 1916 *A Lady in Black* sold for nearly $10,000 (Gainsborough's pictures at the same time went for up to $200,000). Since then world wars, skepticism about the perfectibility of man, doubt about the coherence of the human mind, have helped to make Goya and his work a seminal and much studied phenomenon. His cabinet pictures, Black Paintings and prints have generated enormous interest, perhaps at times at the expense of the recognition that his genius lies above all as one of the greatest portrait painters of all time.

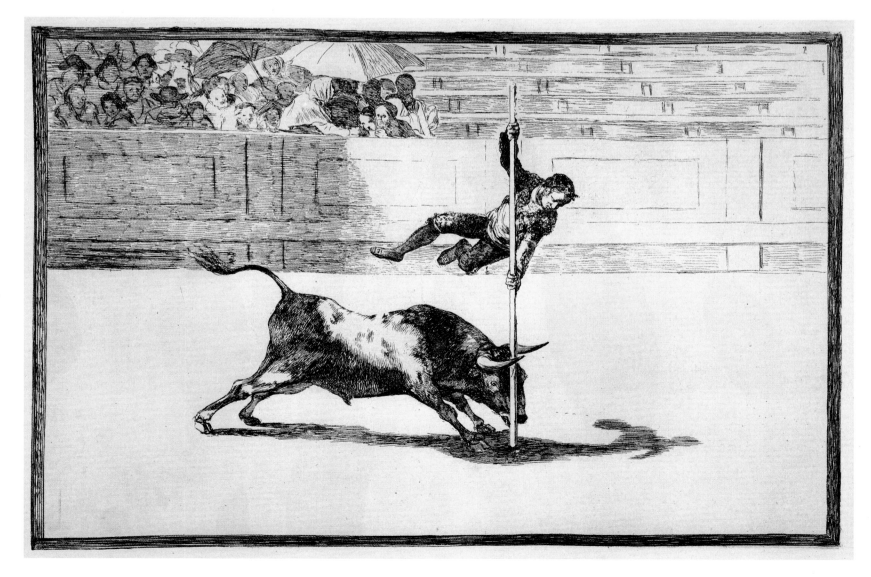

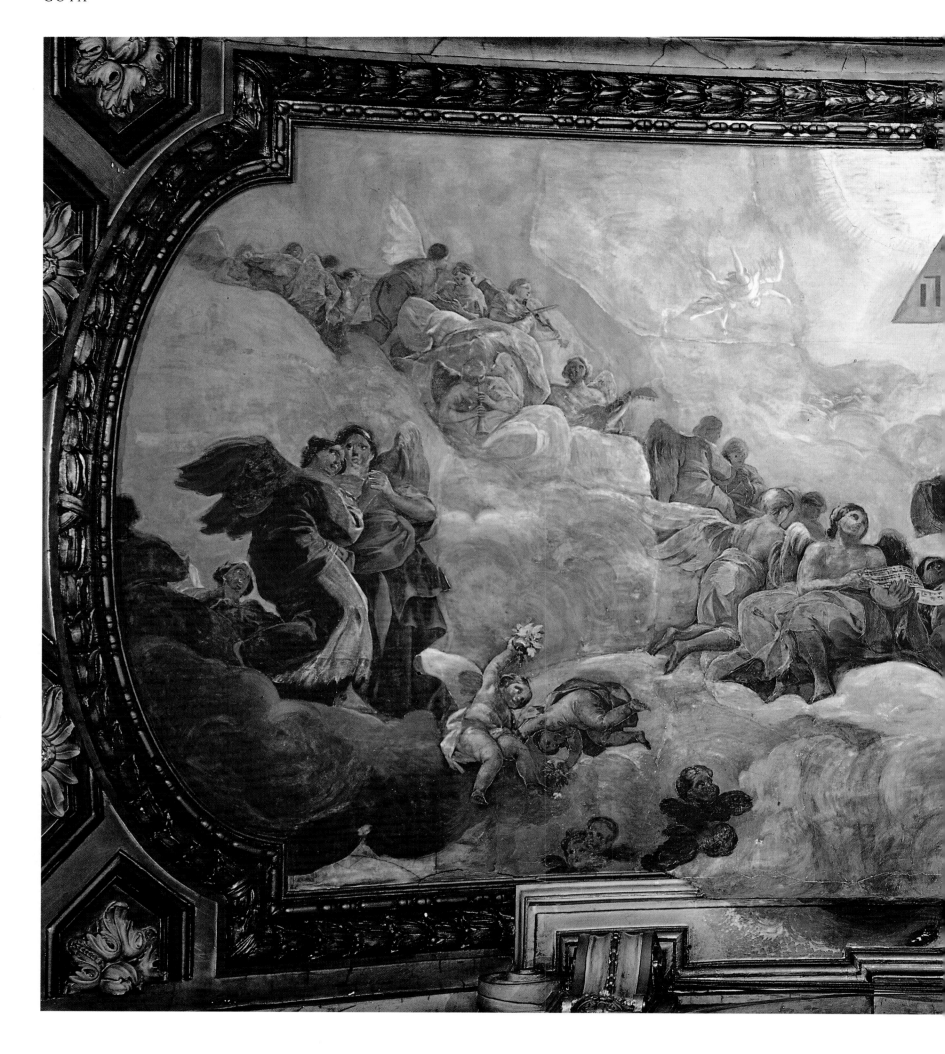

The Adoration of the Name of God by Angels, 1771
Fresco, 22 ft 9 inches × 49 ft 3 inches (700 × 1500 cm)
Cathedral of Santa Maria del Pilar, Zaragoza

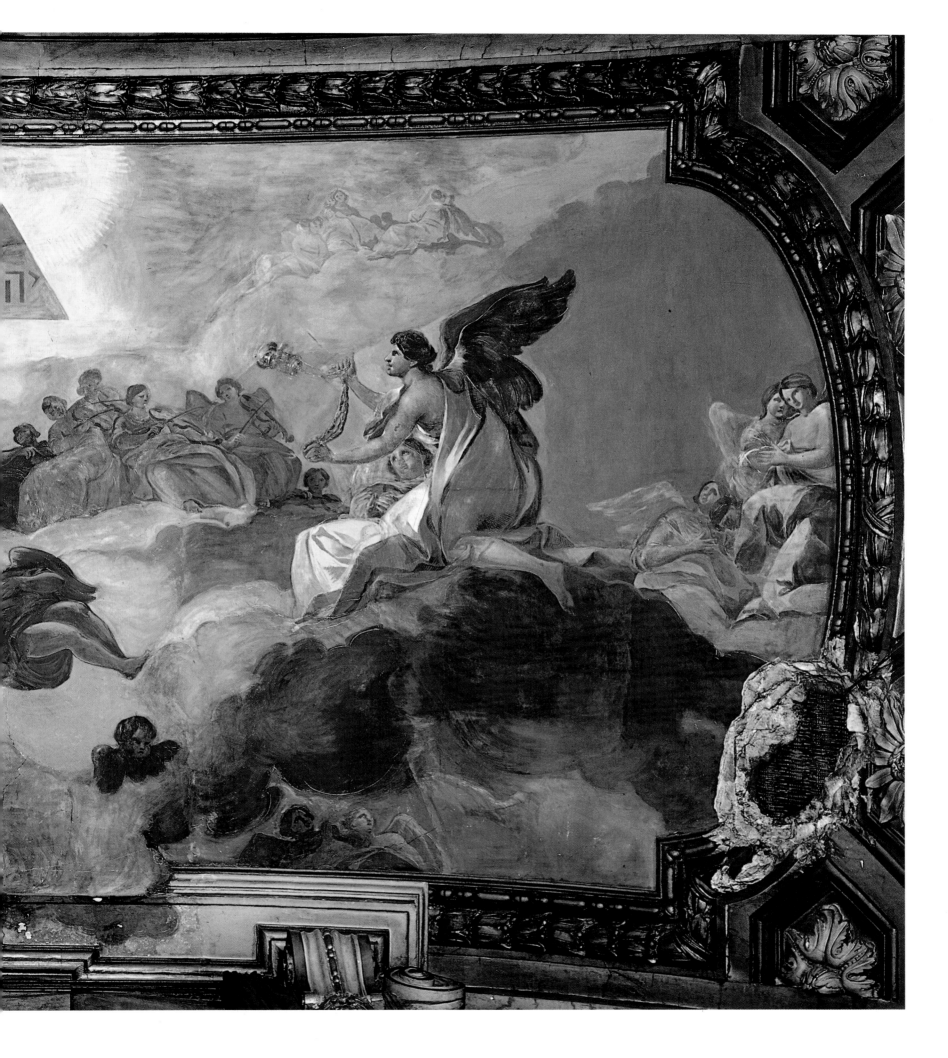

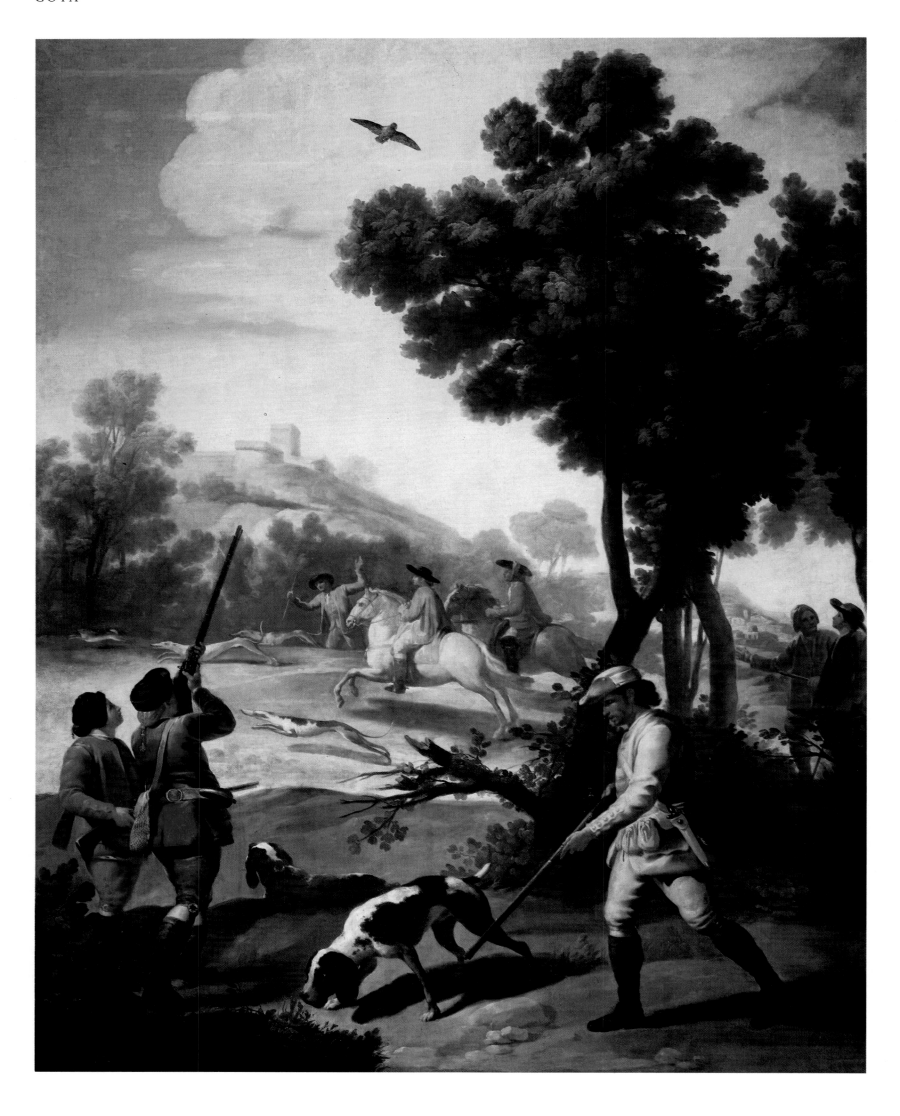

The Quail Hunt, 1775
Oil on canvas, 114 × 89 inches (290 × 226 cm)
Museo del Prado, Madrid

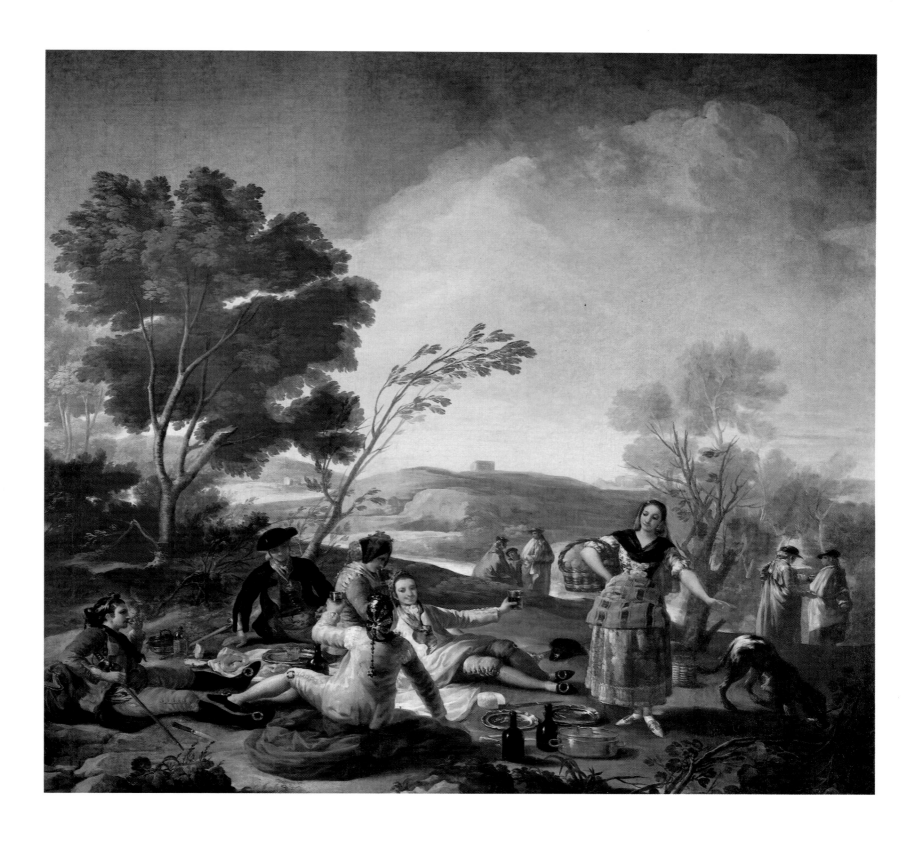

The Picnic, 1779
Oil on canvas, 107 × 123 inches (272 × 295 cm)
Museo del Prado, Madrid

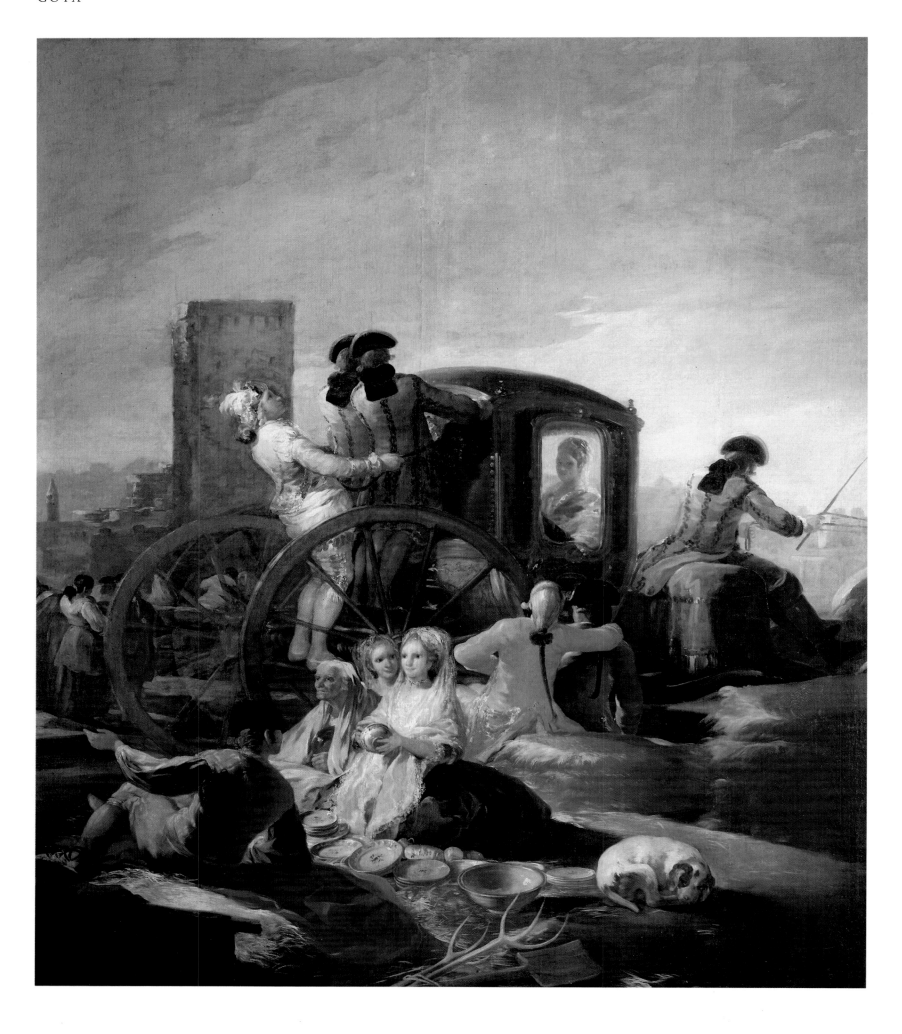

The Crockery Vendor, 1779
Oil on canvas, 102 × 86½ inches (259 × 220 cm)
Museo del Prado, Madrid

Crucifixion, 1780
Oil on canvas, 100 × 60 inches (255 × 153 cm)
Museo del Prado, Madrid

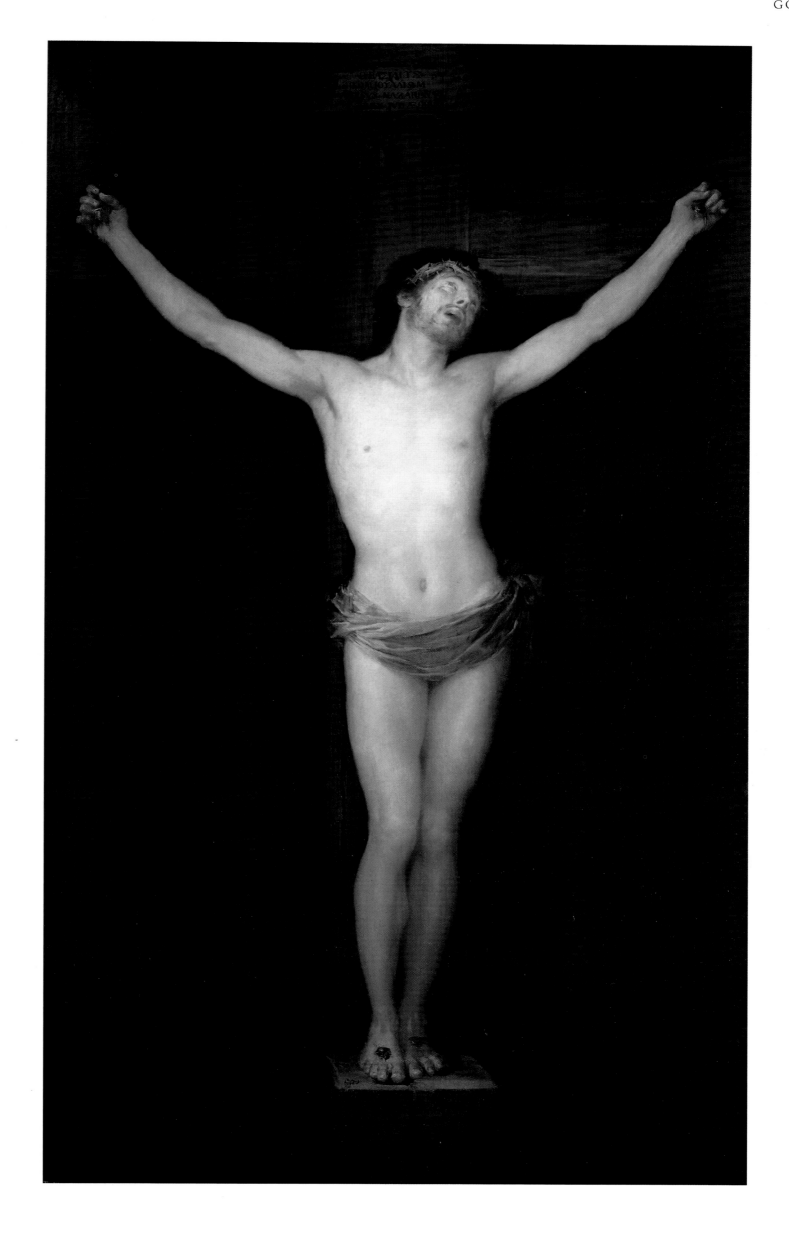

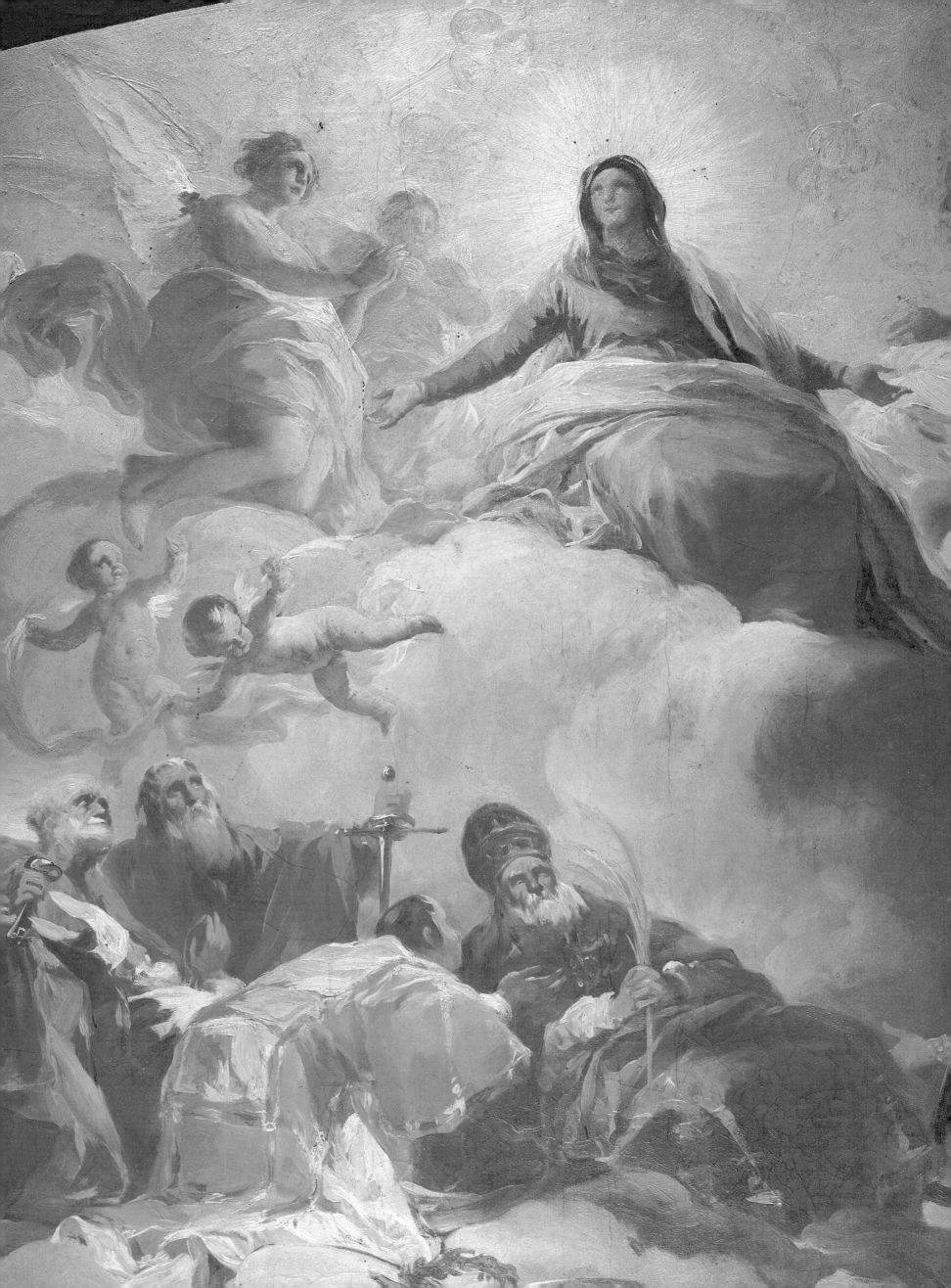

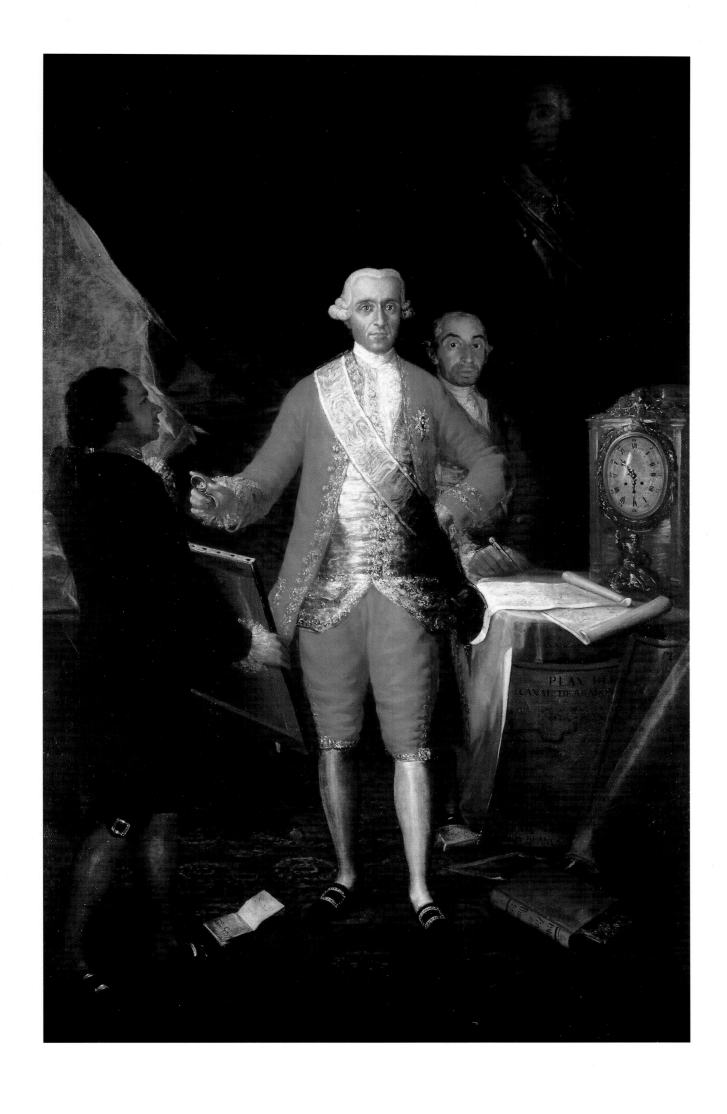

The Queen of the Martyrs *(detail)*, 1780
Fresco in dome
Cathedral of Santa Maria del Pilar, Zaragoza

The Count of Floridablanca, 1783
Oil on canvas, 102 × 65 inches (260 × 166 cm)
Collection of the Banco de España, Madrid

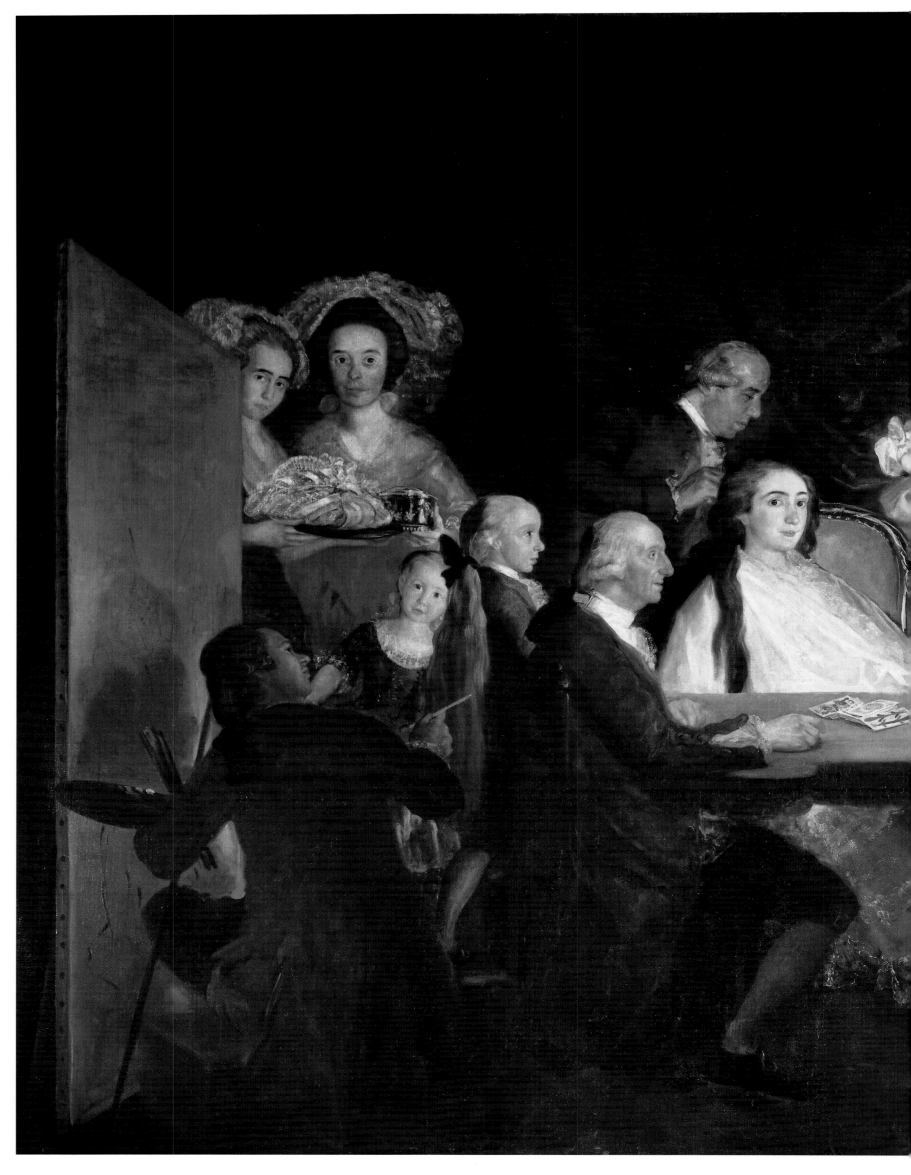

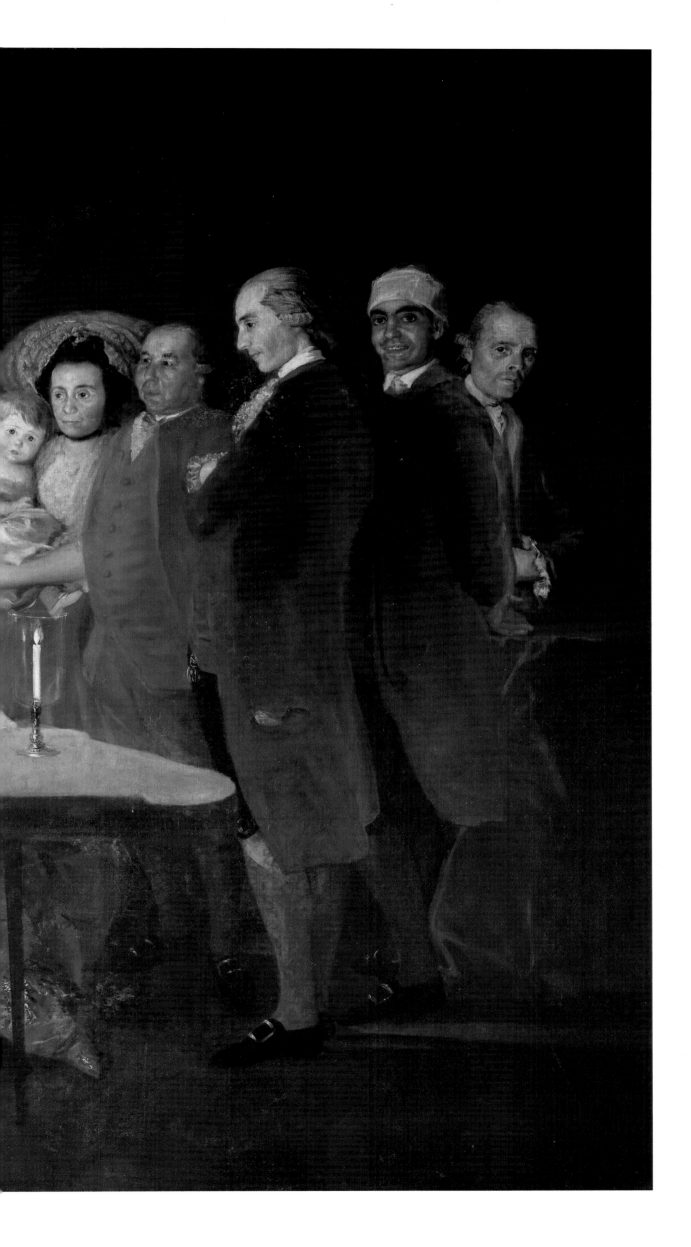

The Family of Infante Don Luis de Bourbon, 1874
Oil on canvas, 97½ × 130 inches
(248 × 330 cm)
Fondazione Magnani Rocca, Corte de Maminao, Parma

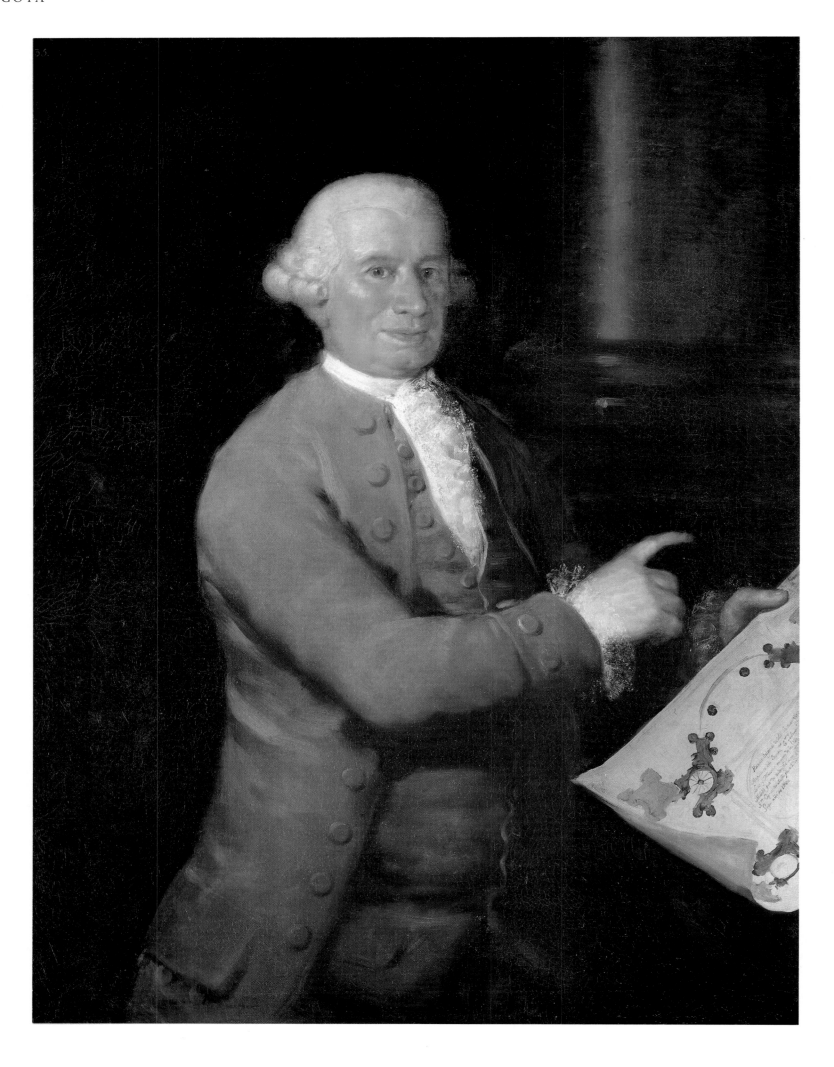

ABOVE
The Architect Ventura Rodríguez, 1784
Oil on canvas, 41¾ × 31 inches (106 × 79 cm)
National Museum, Stockholm
Photo Hans Thorwid-94

RIGHT
The Sermon of Saint Bernardino of Siena, 1784
Oil on canvas, 189 × 118 inches (480 × 300 cm)
San Francisco el Grande, Madrid

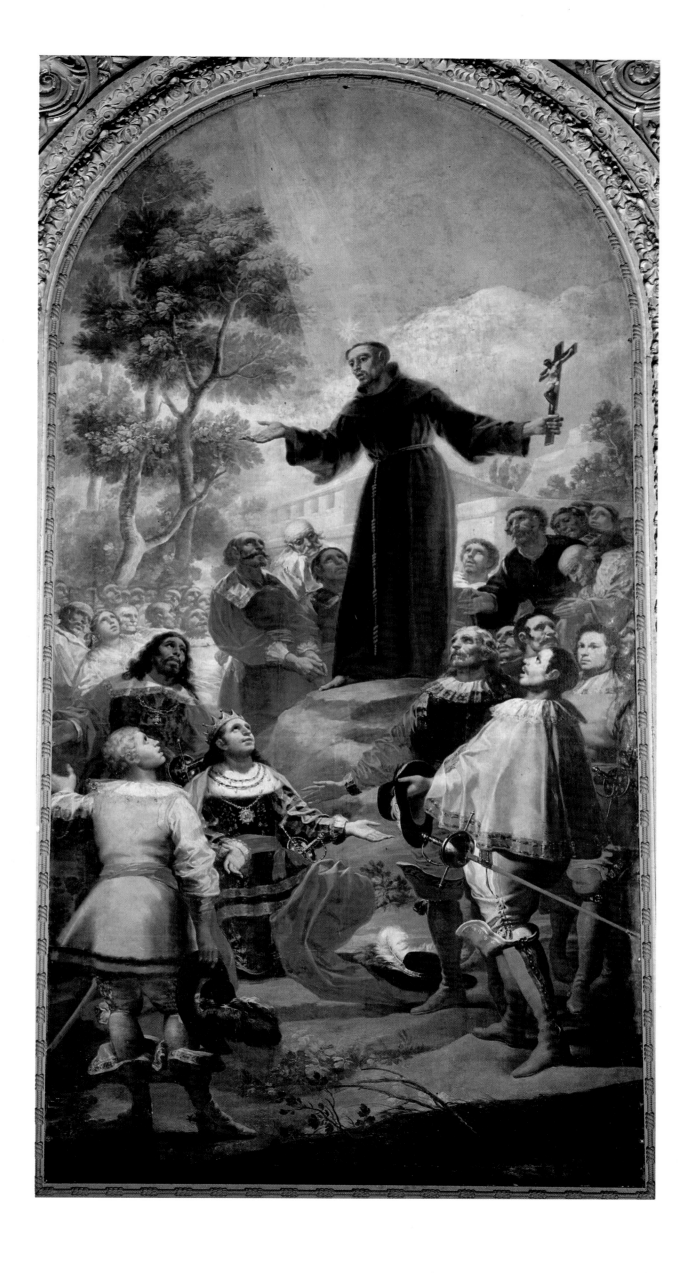

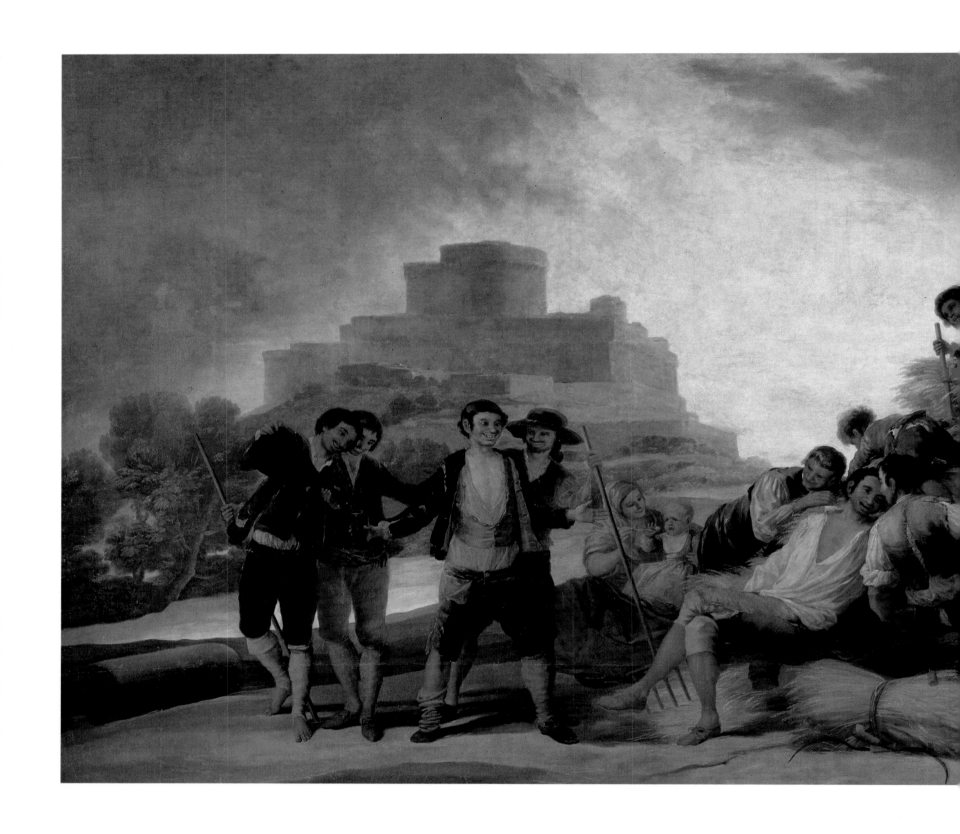

Summer or The Harvest (la Era), 1786
Oil on canvas, 108 × 252 inches (276 × 641 cm)
Museo del Prado, Madrid

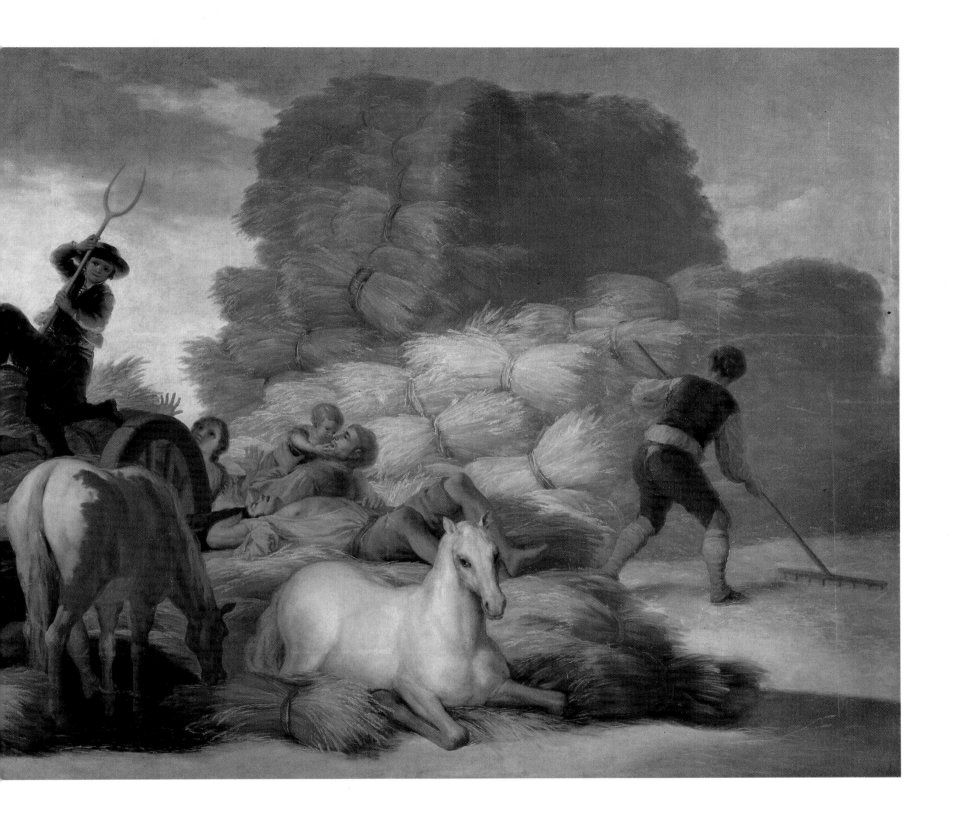

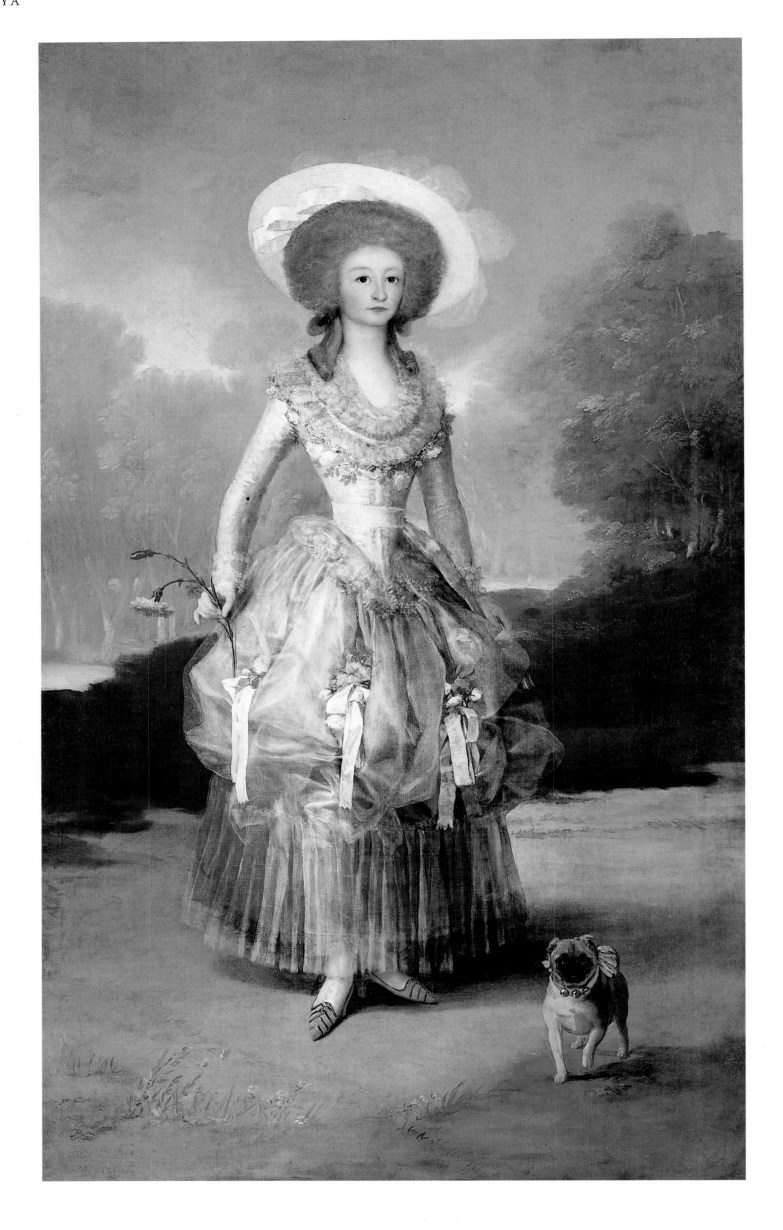

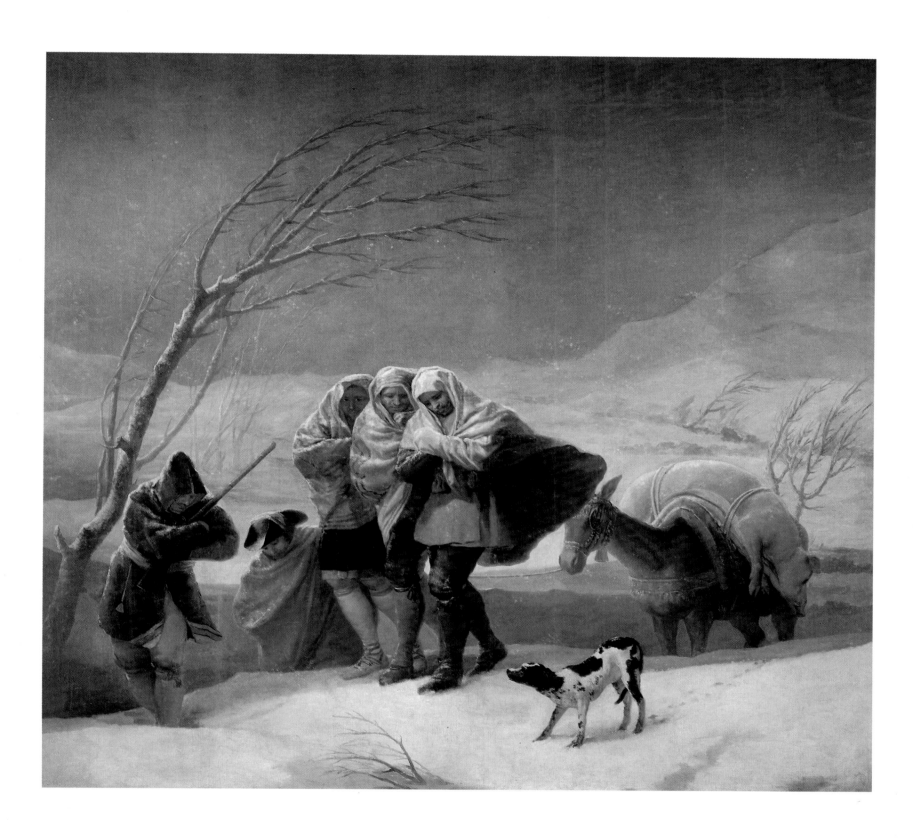

LEFT
The Marquesa de Pontejos, *c.*1786
Oil on canvas, 82¾ × 50 inches (210.3 × 127 cm)
© 1995 Board of Trustees, National Gallery of Art, Washington, D.C.
Andrew W. Mellon Collection
(19.37.1.85)

ABOVE
Winter, 1786
Oil on canvas, 108 × 122 inches (275 × 293 cm)
Museo del Prado, Madrid

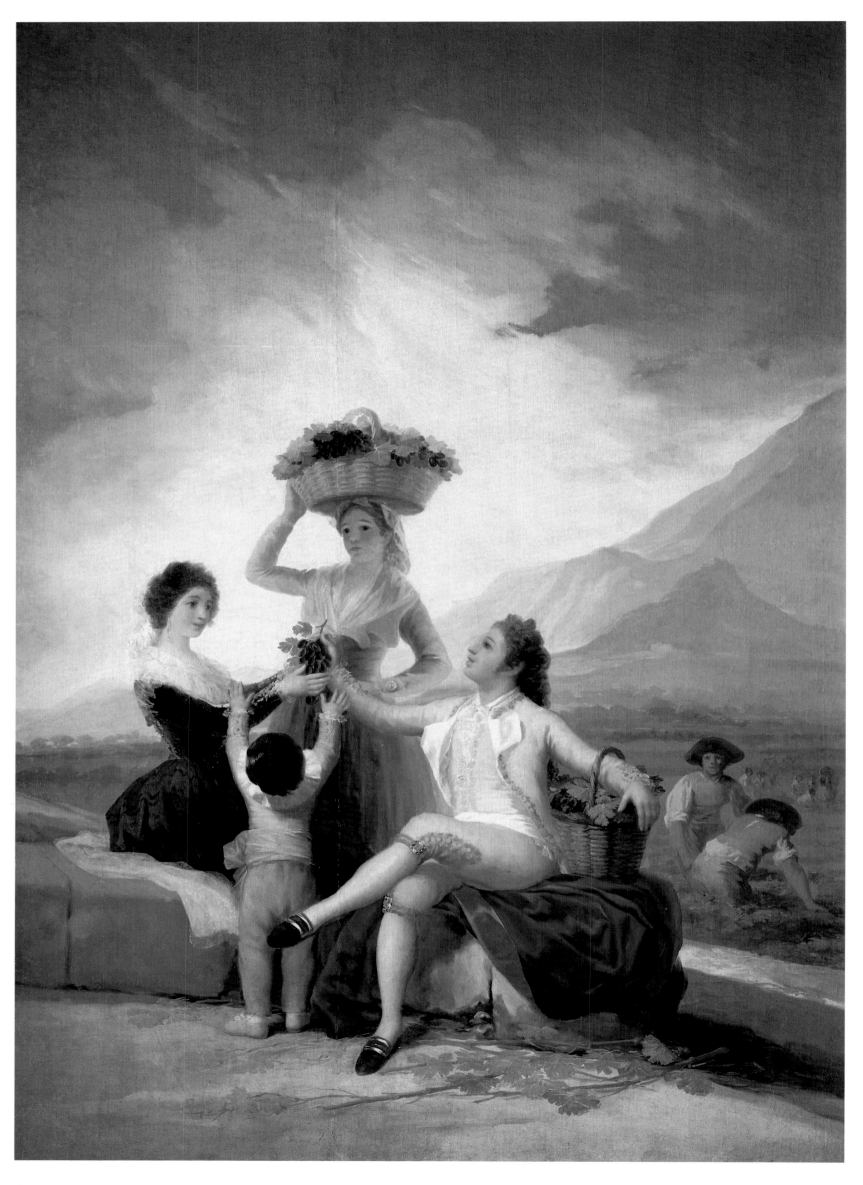

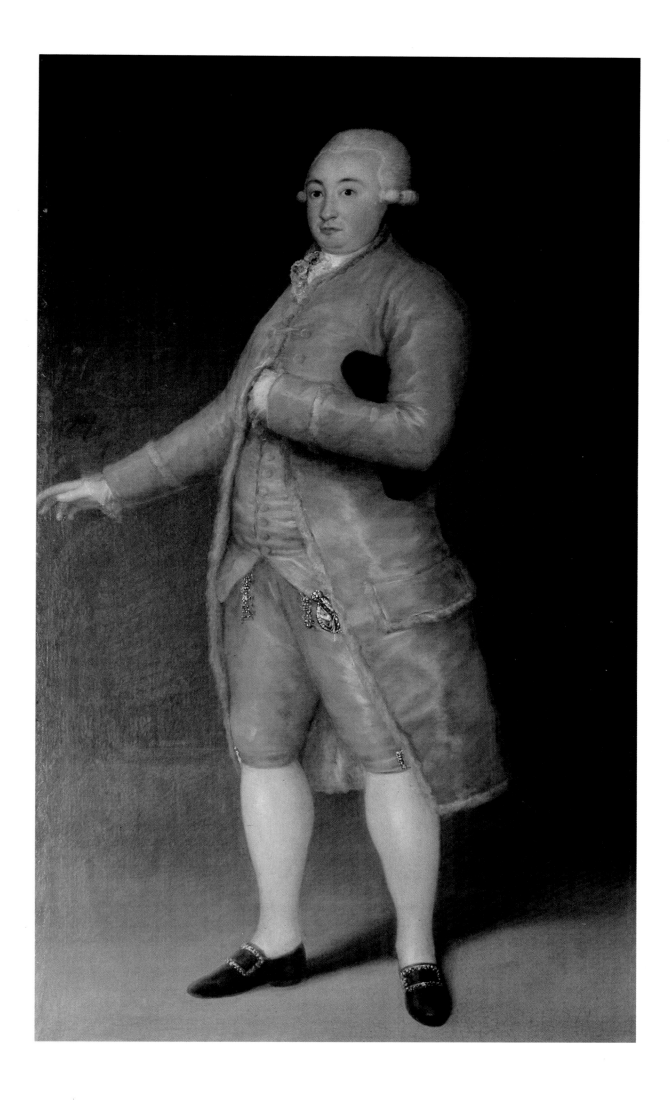

LEFT
Autumn or The Vintage, 1786
Oil on canvas, 108 × 75 inches (275 × 190 cm)
Museo del Prado, Madrid

ABOVE
Francisco de Cabarrús, 1788
Oil on canvas, 82½ × 85½ inches (210 × 217 cm)
Collection of the Banco de España, Madrid

***San Francisco de Borja Taking Leave
of his Family,*** 1788
Oil on canvas, 138 × 118 inches (350 × 300 cm)
Valencia Cathedral

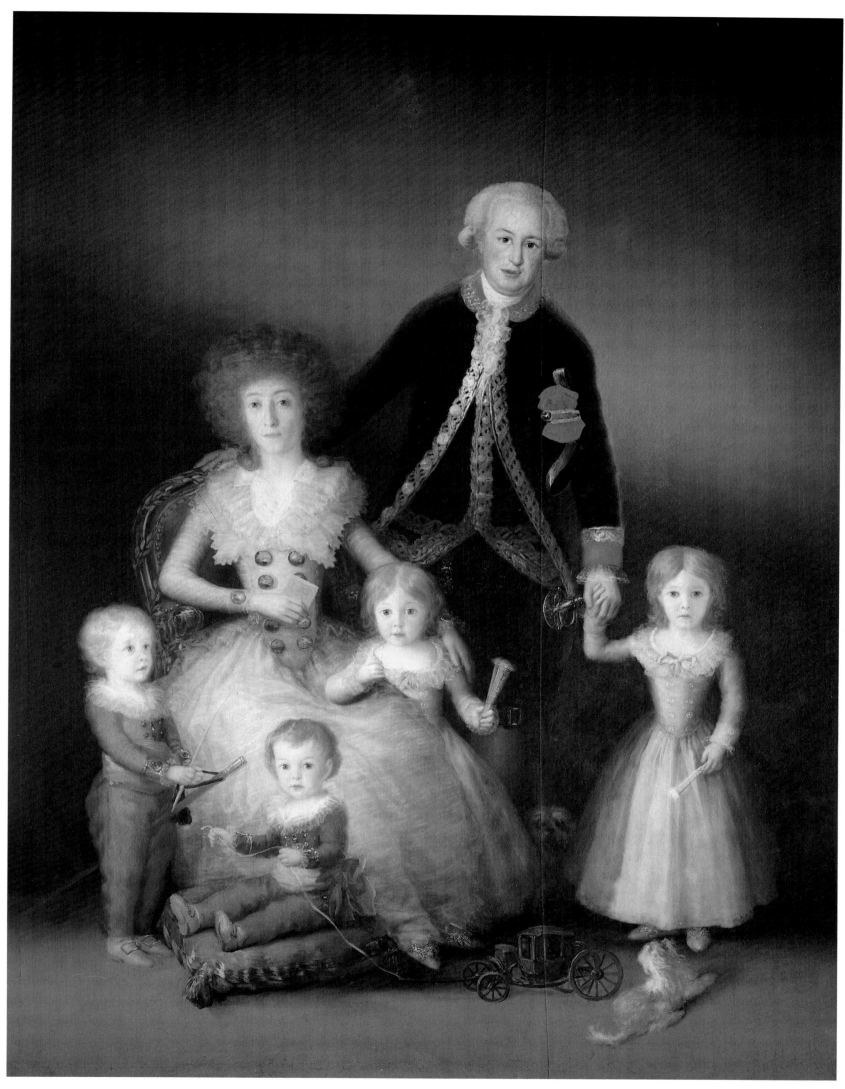

**The Duke and Duchess of Osuna
with their Children,** 1788
Oil on canvas, 89 × 68½ inches (225 × 174 cm)
Museo del Prado, Madrid

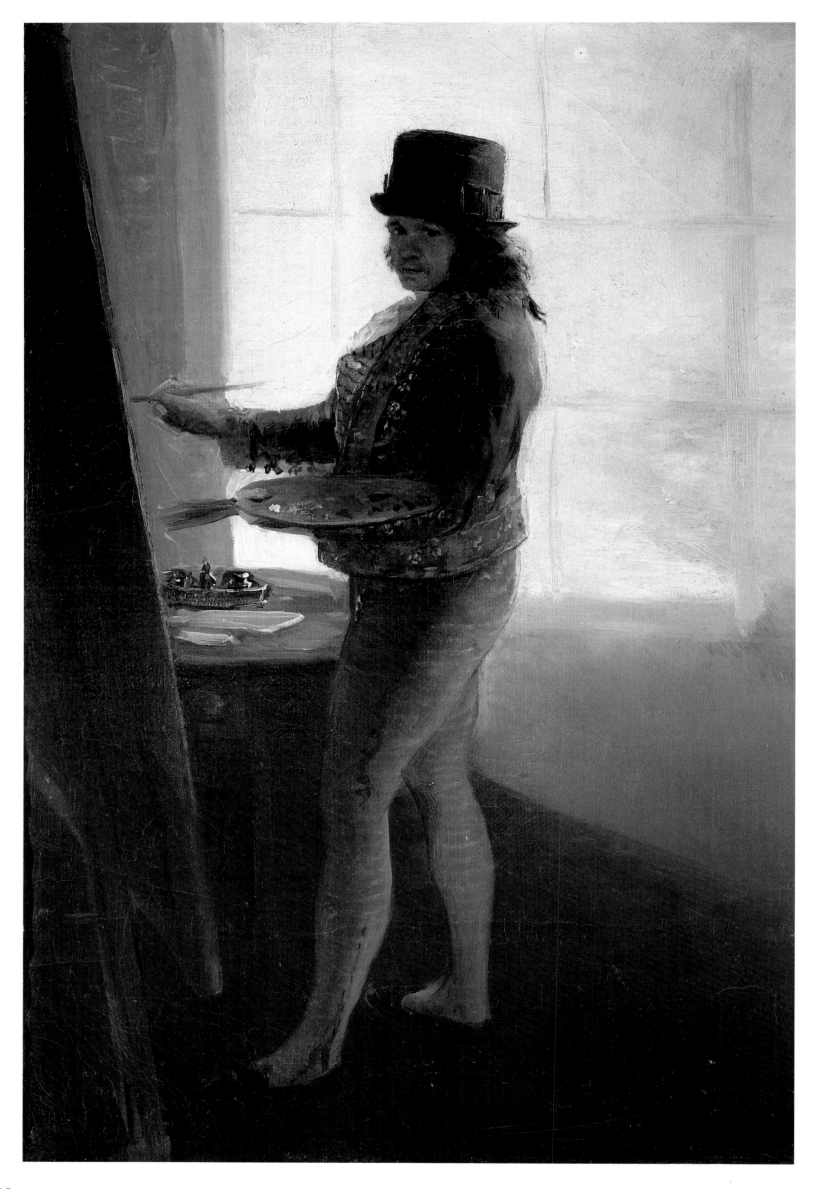

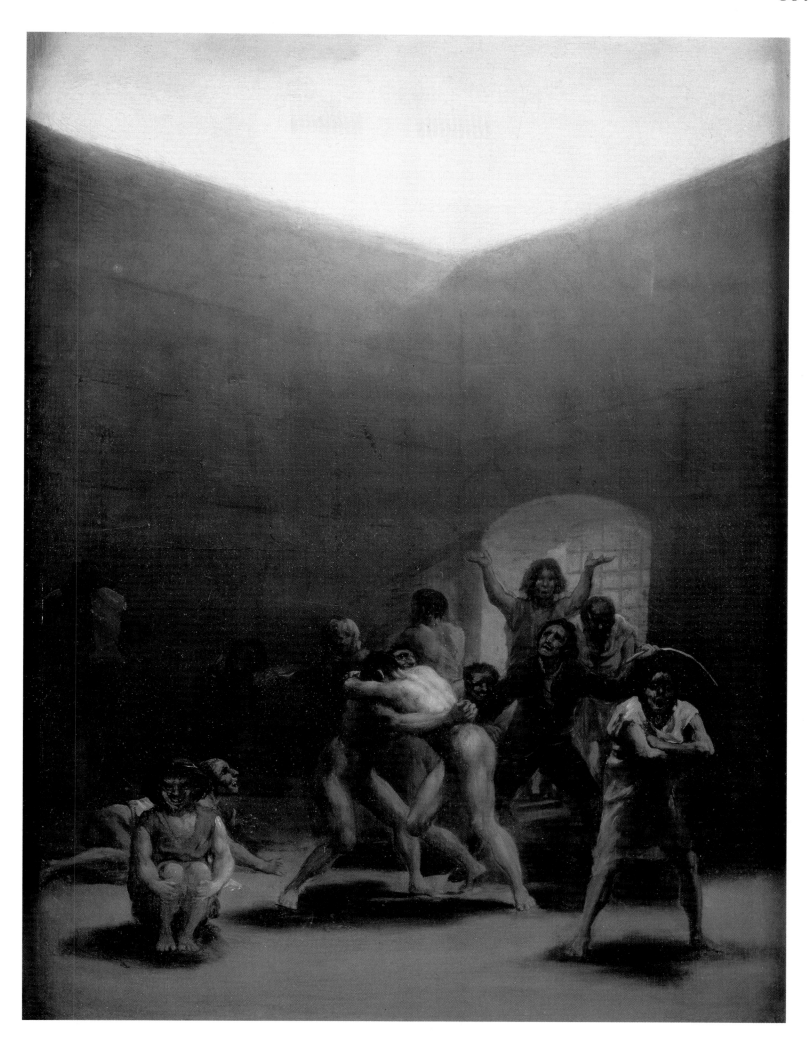

Yard with Madmen, 1794
Oil on tin, 16⅞ × 12⅜ inches (42.9 × 31.4 cm)
Algar H. Meadows Collection, Meadows Museum,
Methodist University, Dallas, TX
(67.01)

LEFT

Goya in his Studio, 1792
Oil on canvas, 16½ × 11 inches (42 × 28 cm)
Real Academia de Bellas Artes
de San Fernando, Madrid

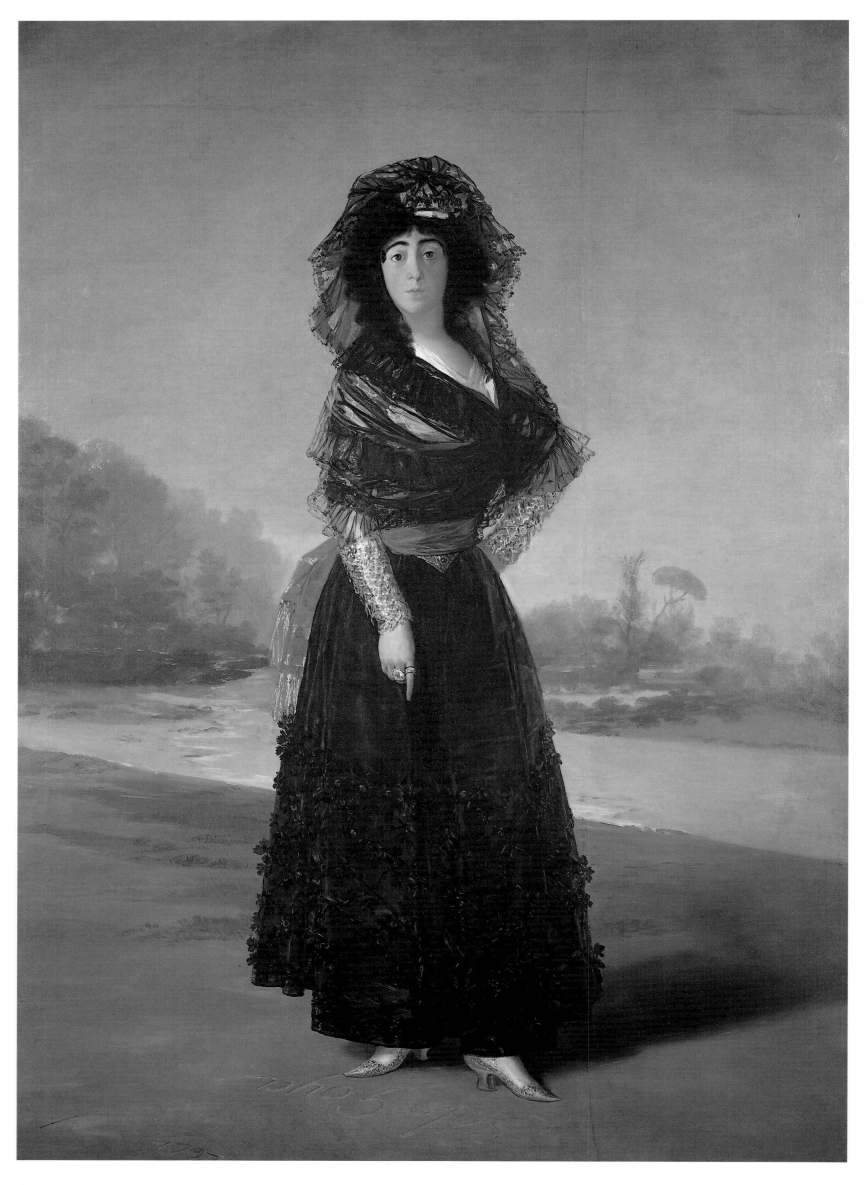

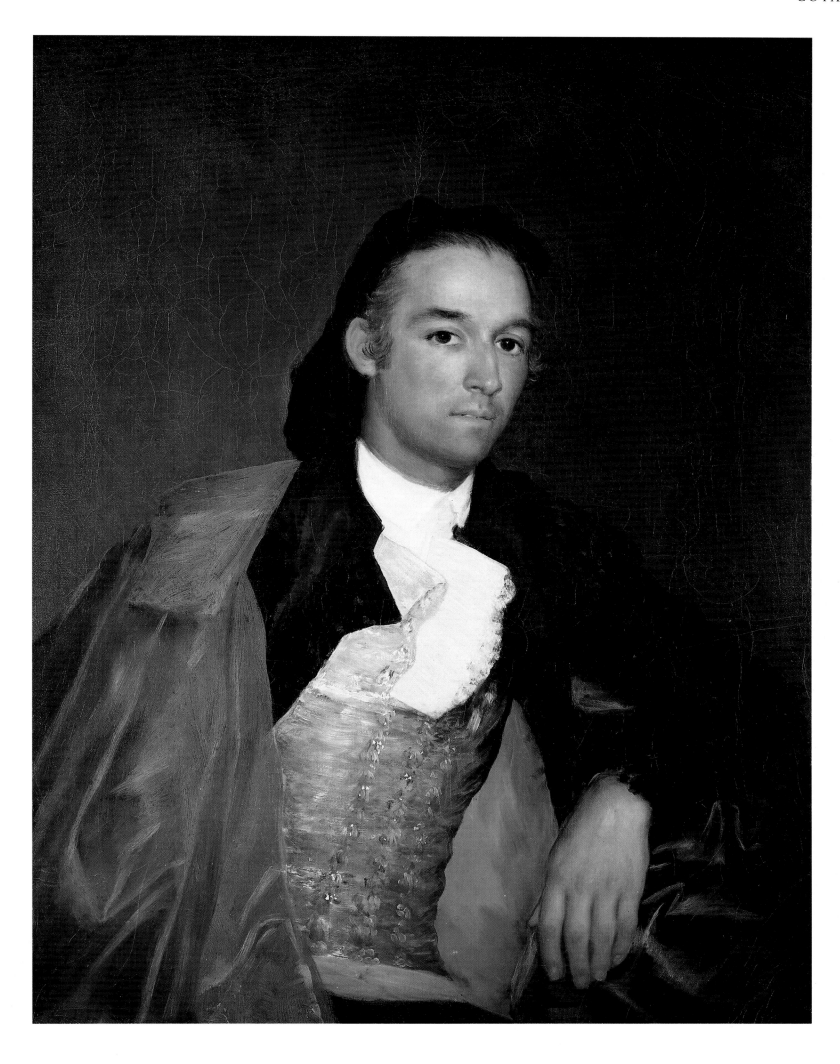

The Duchess of Alba, 1795
Oil on canvas, 83 × 58 inches (210 × 148 cm)
The Hispanic Society of America, New York, NY

The Matador Pedro Romero, *c.*1795-98
Oil on canvas, 33⅛ × 25⅝ inches (84.1 × 65 cm)
Kimbell Art Museum, Fort Worth, TX

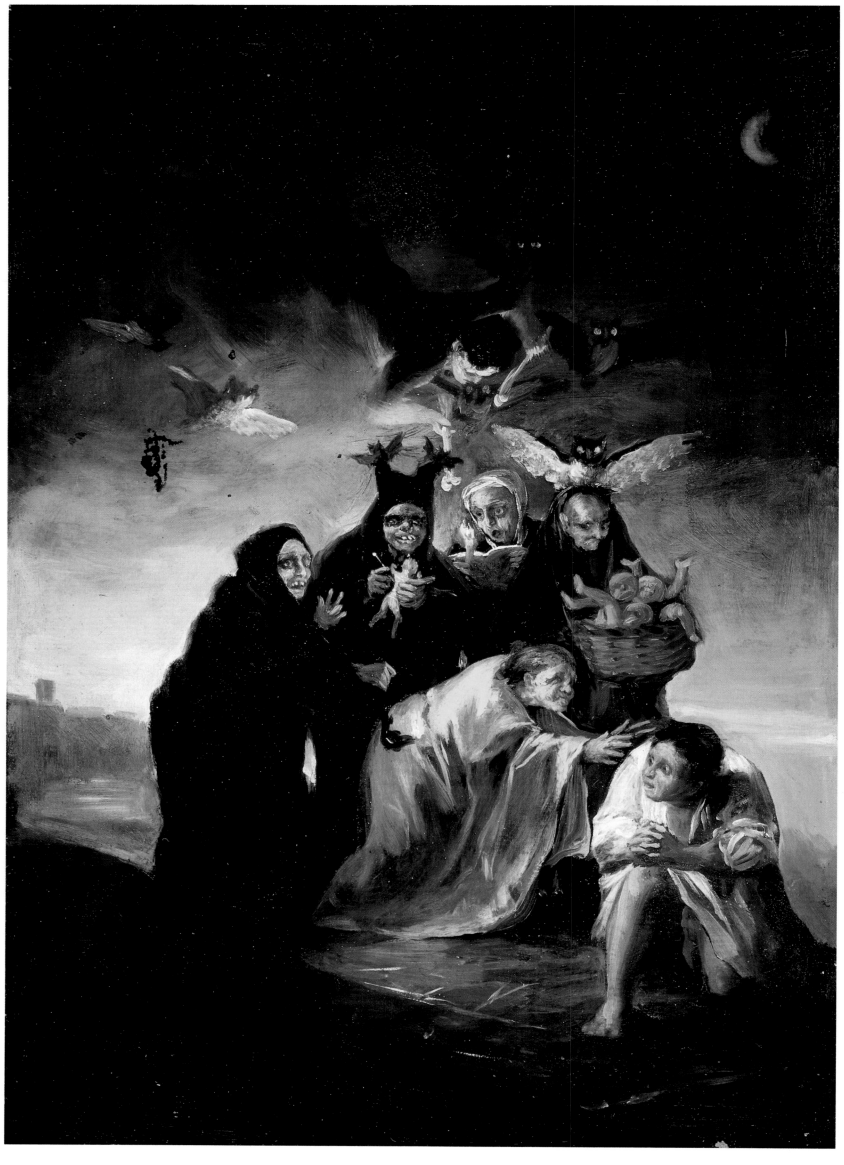

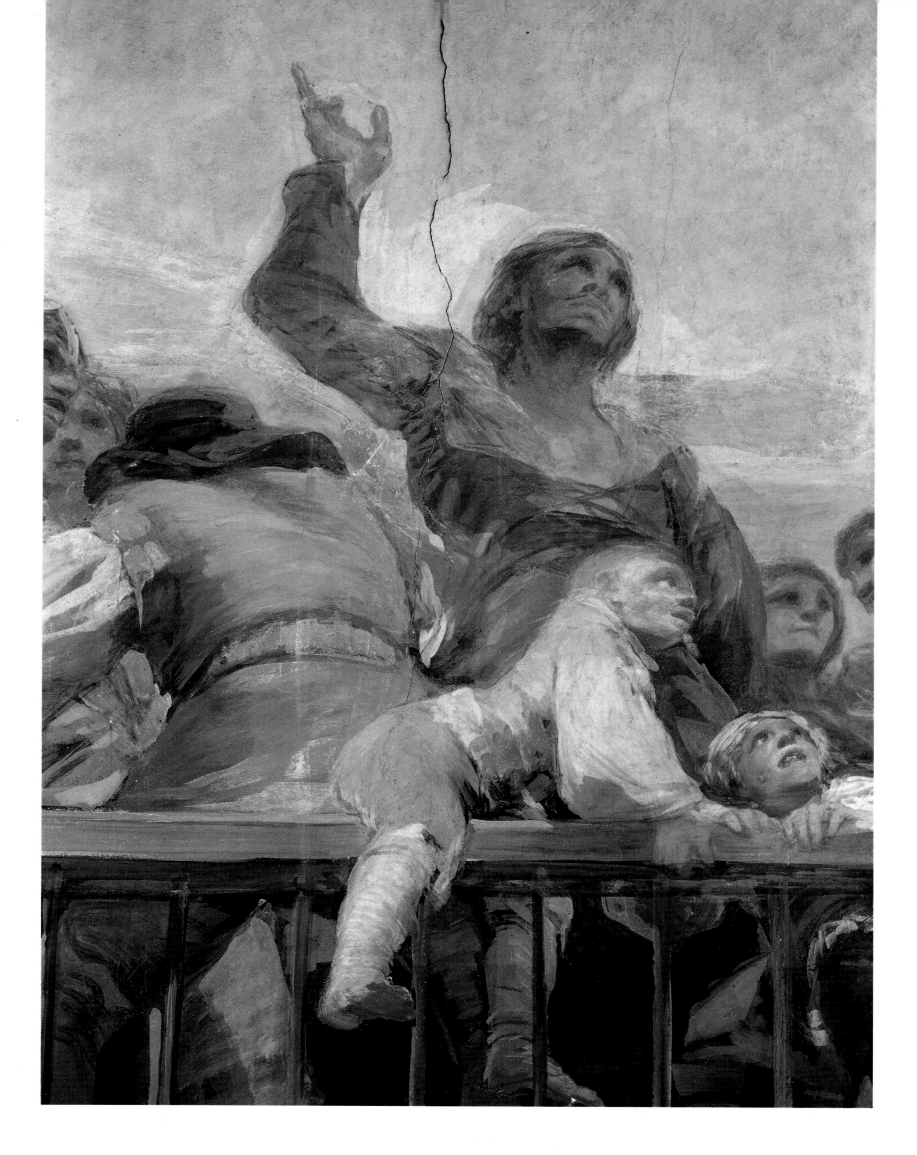

LEFT

The Witches' Sabbath, 1797-98
Oil on canvas, 17½ × 12 inches (44 × 31 cm)
Museo Lazaro Galdiano, Madrid

ABOVE

The Miracle of Saint Antony (*detail*), 1798
Frescoed dome, 236 inches (600 cm) diameter
San Antonio de la Florida, Madrid

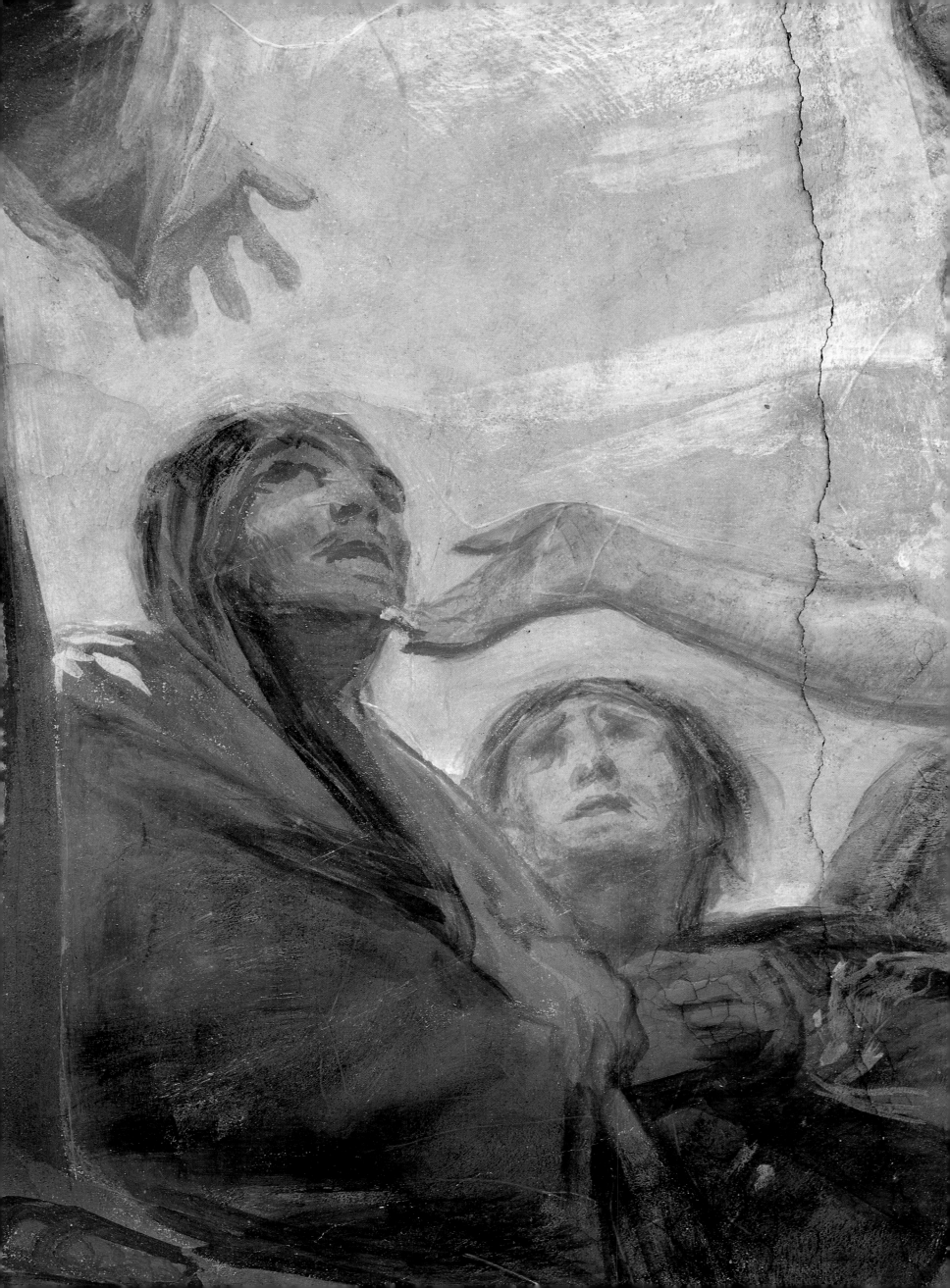

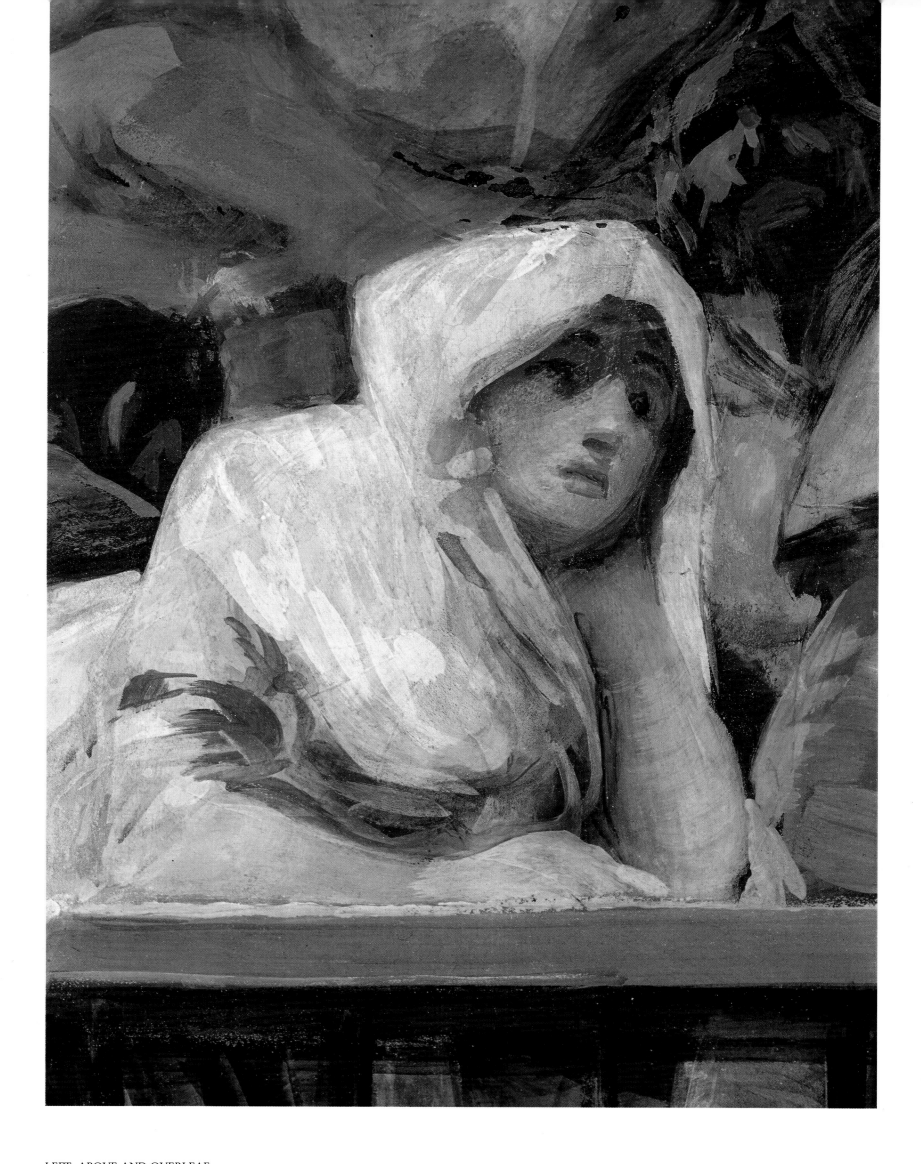

LEFT, ABOVE AND OVERLEAF
The Miracle of Saint Antony (details), 1798
Frescoed dome, 236 inches (600 cm) diameter
San Antonio de la Florida, Madrid

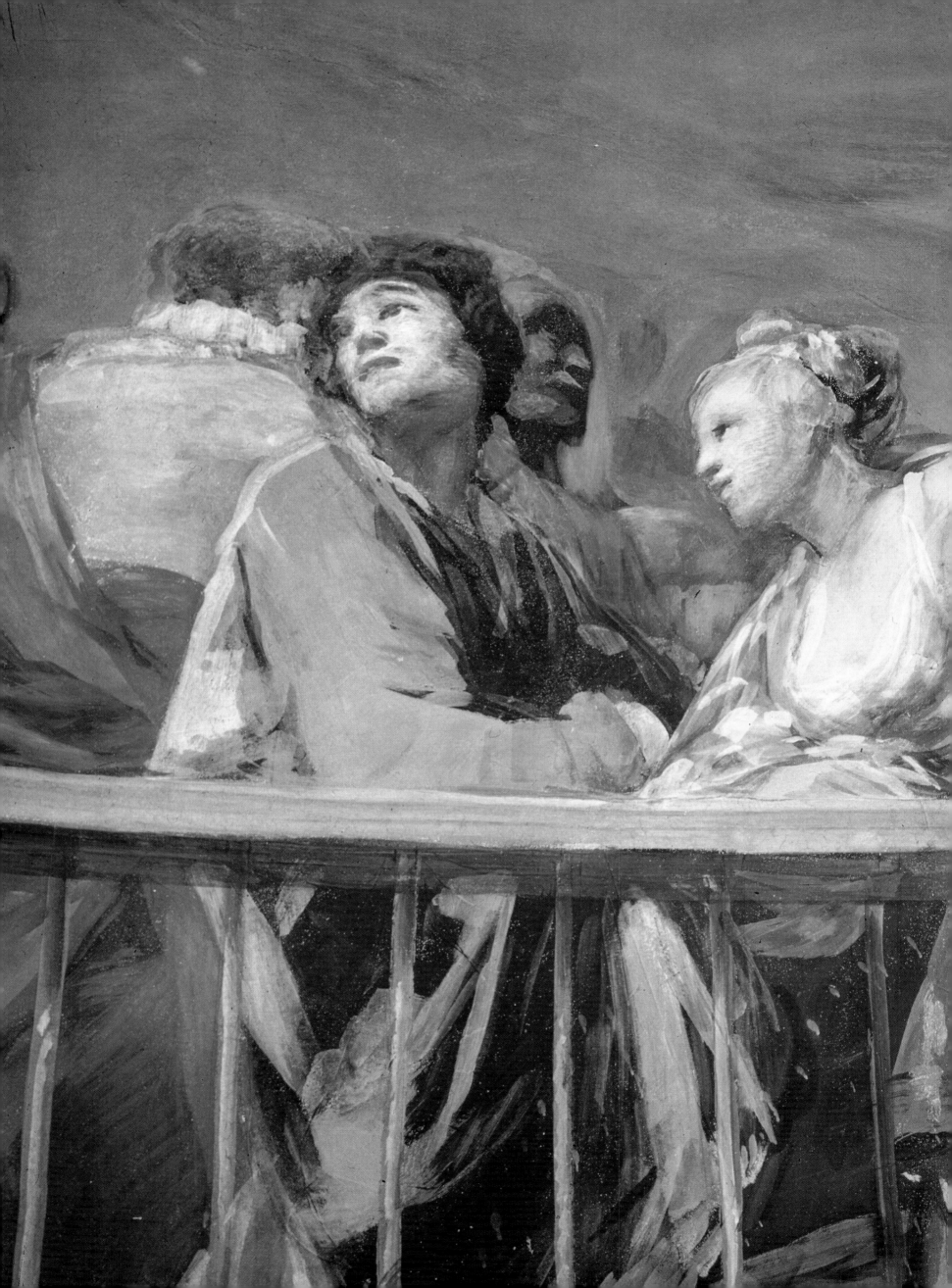

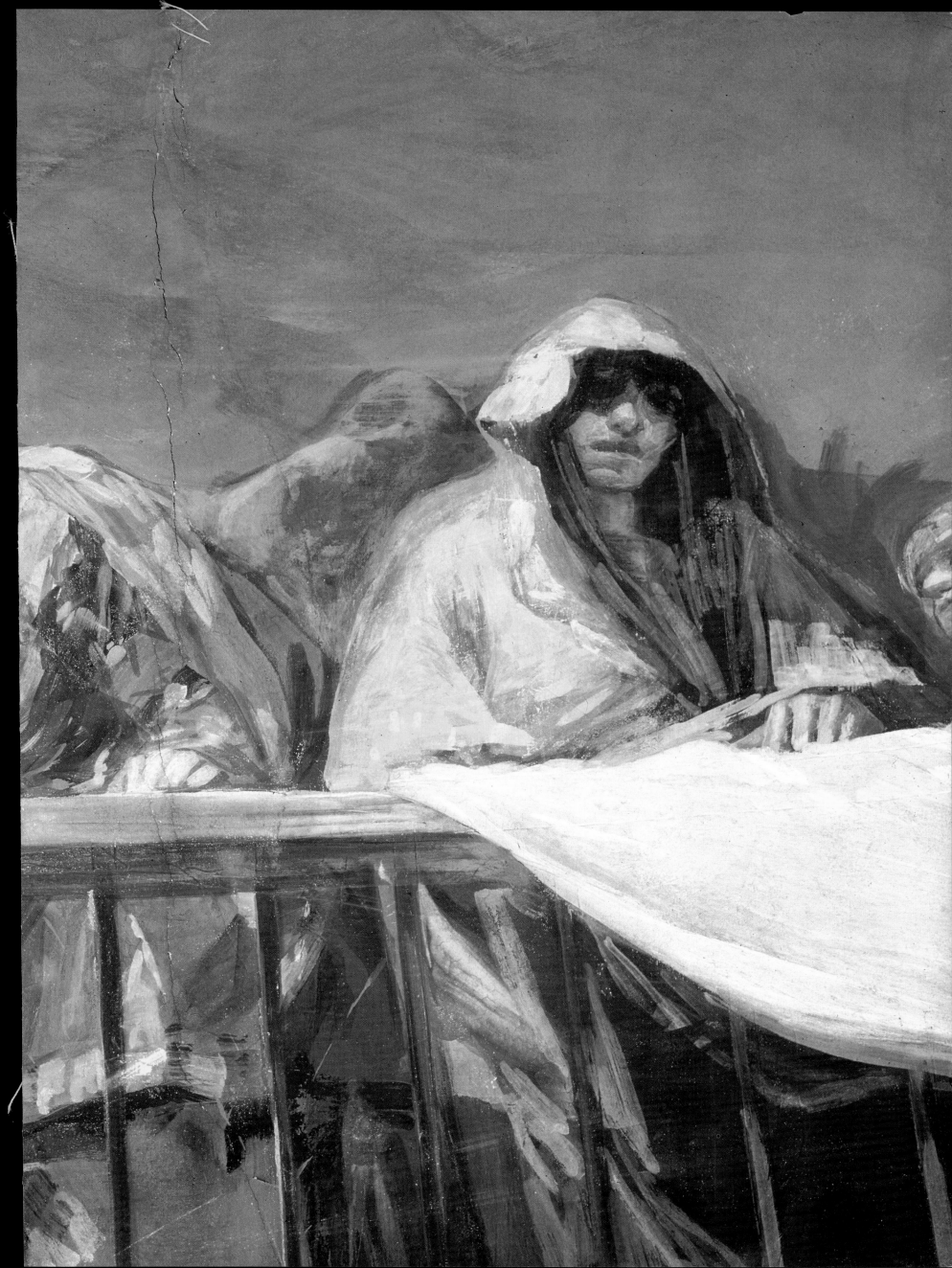

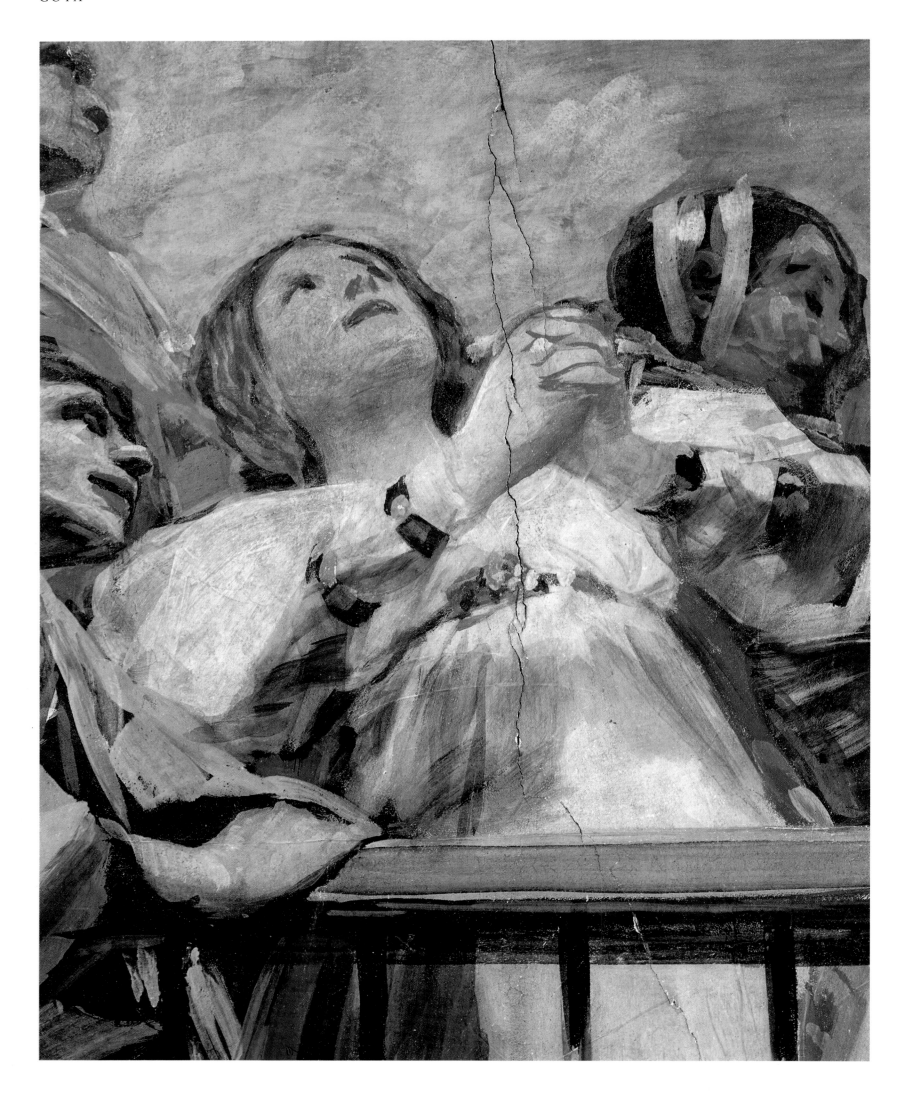

ABOVE

The Miracle of St Antony *(detail)*, 1798
Frescoed dome, 236 inches (600 cm) diameter
San Antonio de la Florida, Madrid

RIGHT

The Arrest of Christ, 1798
Oil on canvas, 118 × 79 inches (300 × 200 cm)
Sacristy of Toledo Cathedral

56

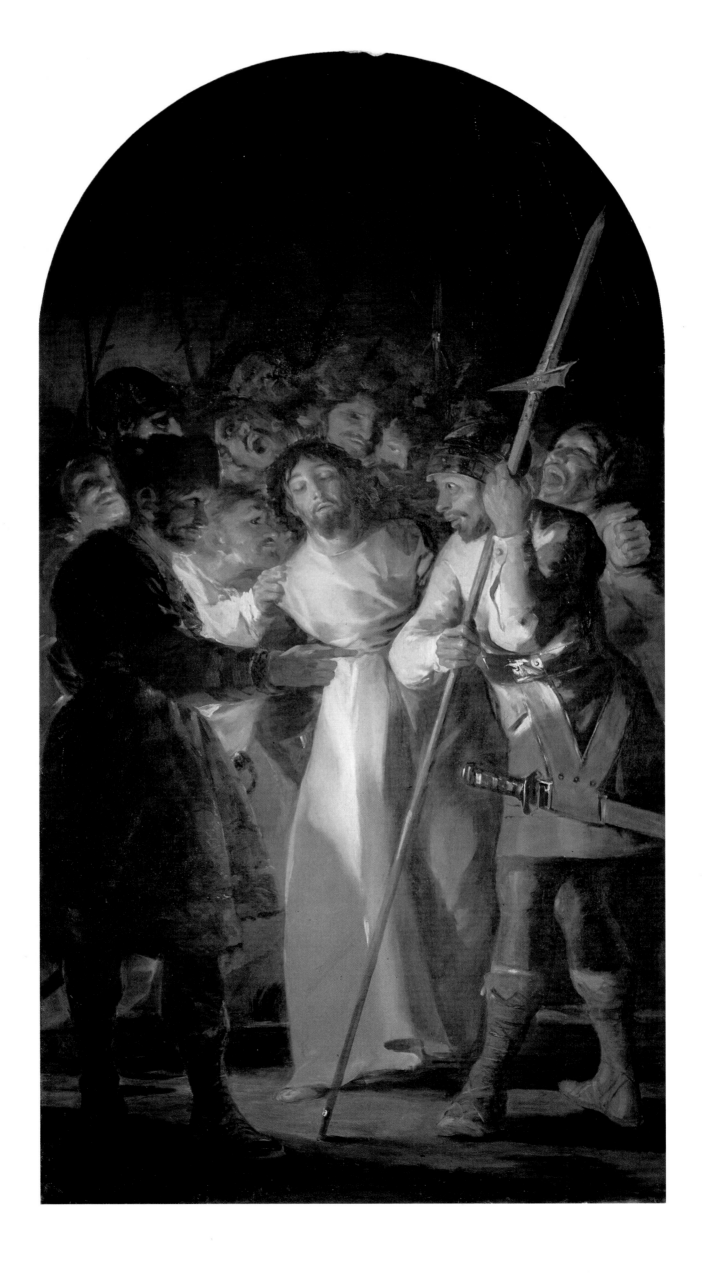

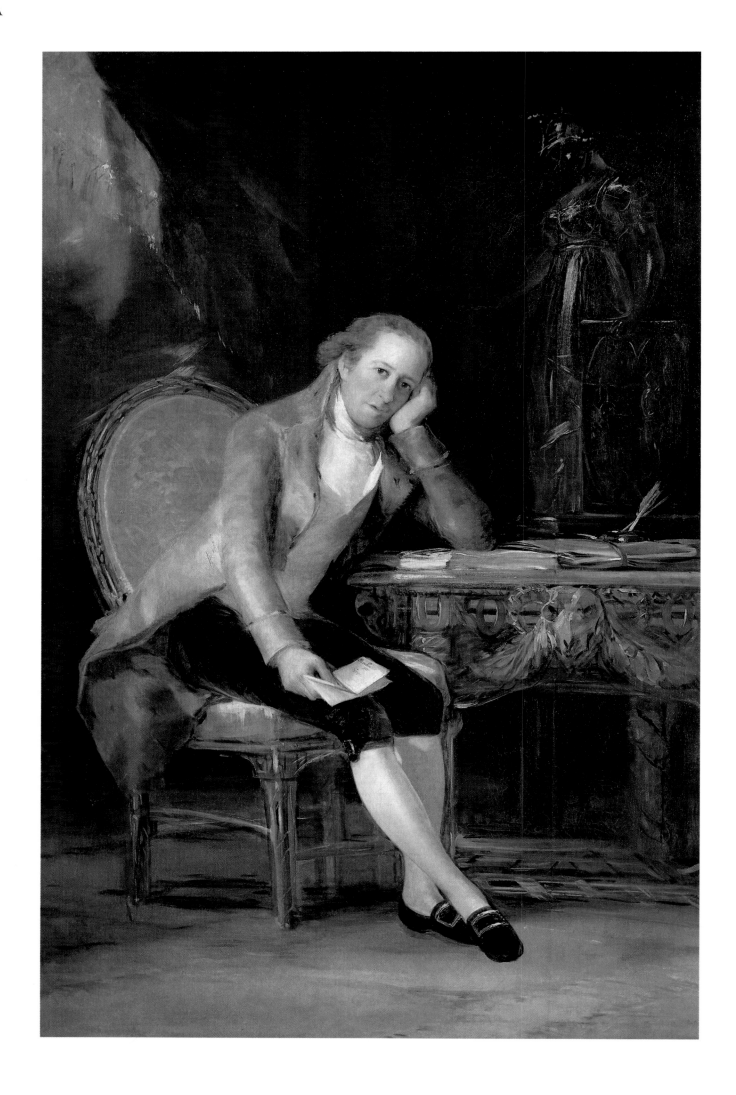

ABOVE
Gasper Melchor de Jovellanos, 1798
Oil on canvas, 81 × 52 inches (205 × 133 cm)
Museo del Prado, Madrid

RIGHT
Ambassador Ferdinand Guillemardet, 1798
Oil on canvas, 73 × 49 inches (185 × 125 cm)
*Musée du Louvre, Paris,
photo © RMNS*

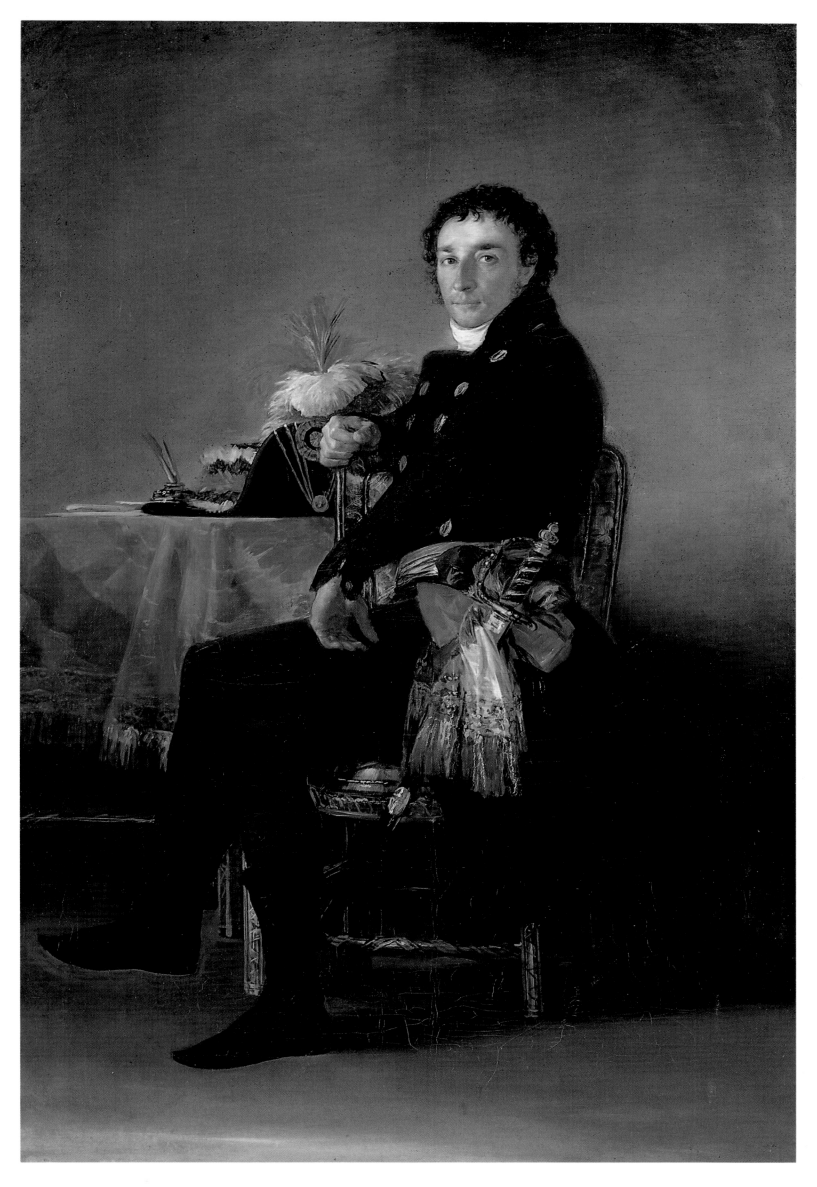

The Maja Clothed, 1798-1800
Oil on canvas, 37 × 75 inches (95 × 190 cm)
Museo del Prado, Madrid

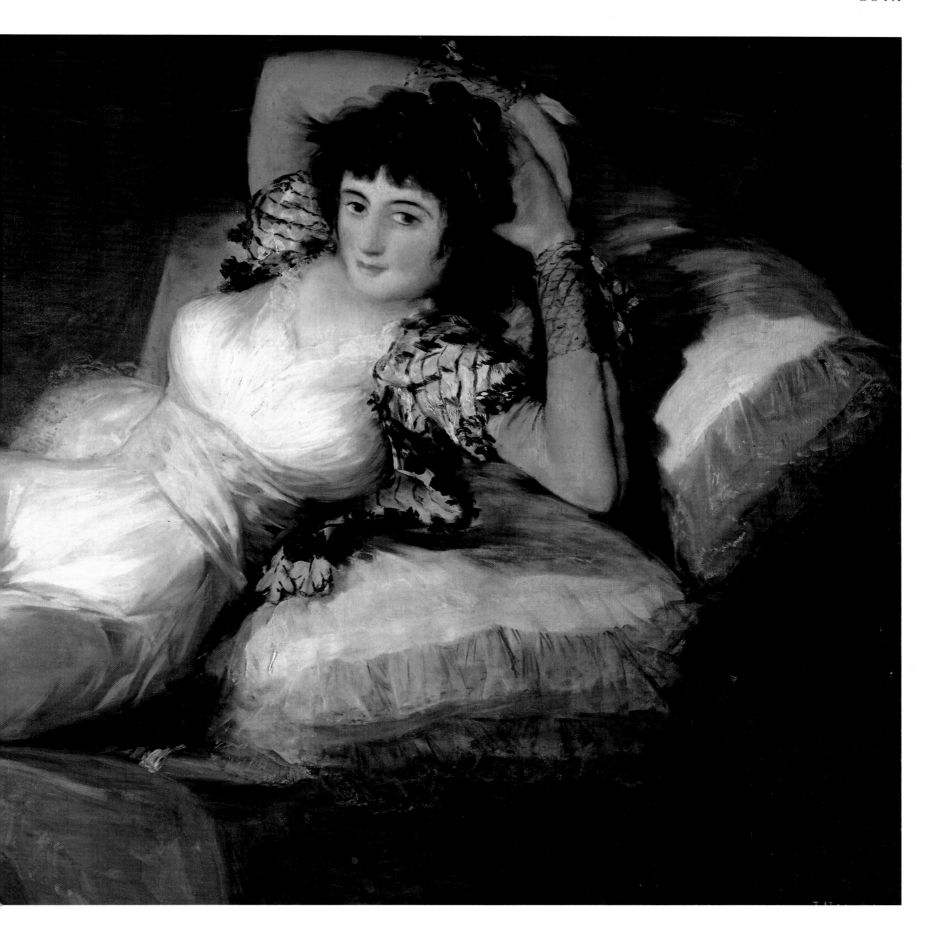

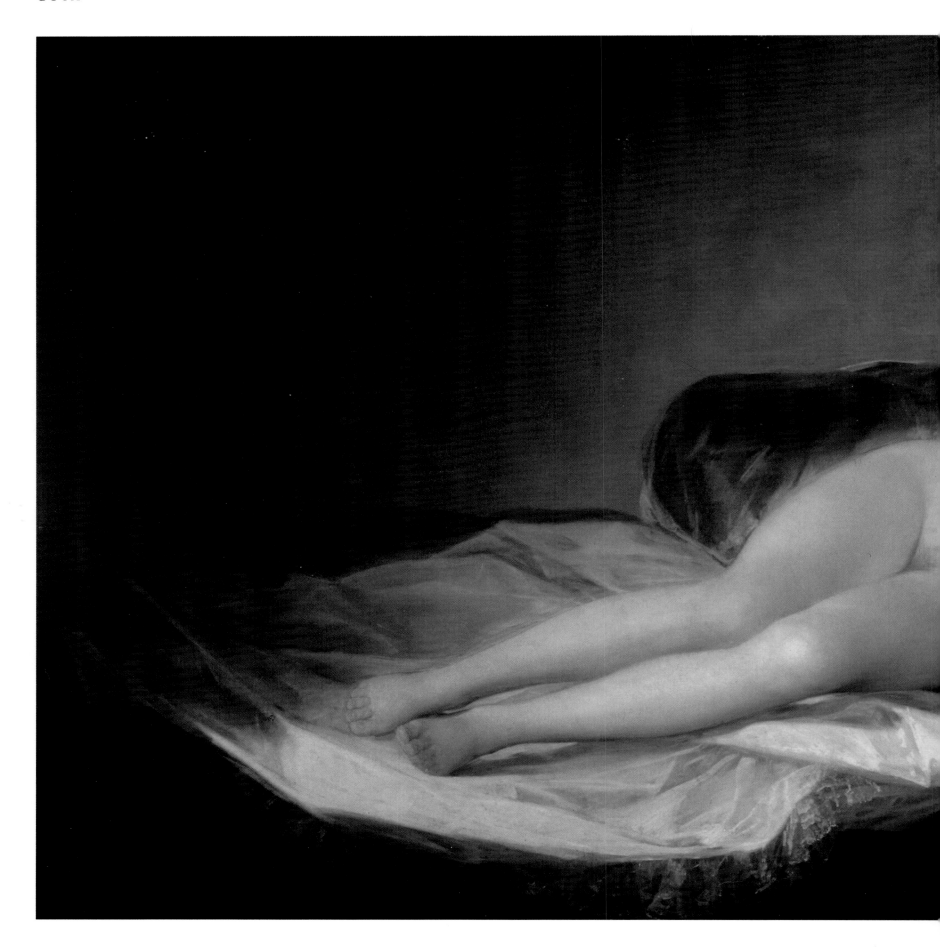

The Maja Naked, 1798-1800
Oil on canvas, 38 × 75 inches (97 × 190 cm)
Museo del Prado, Madrid

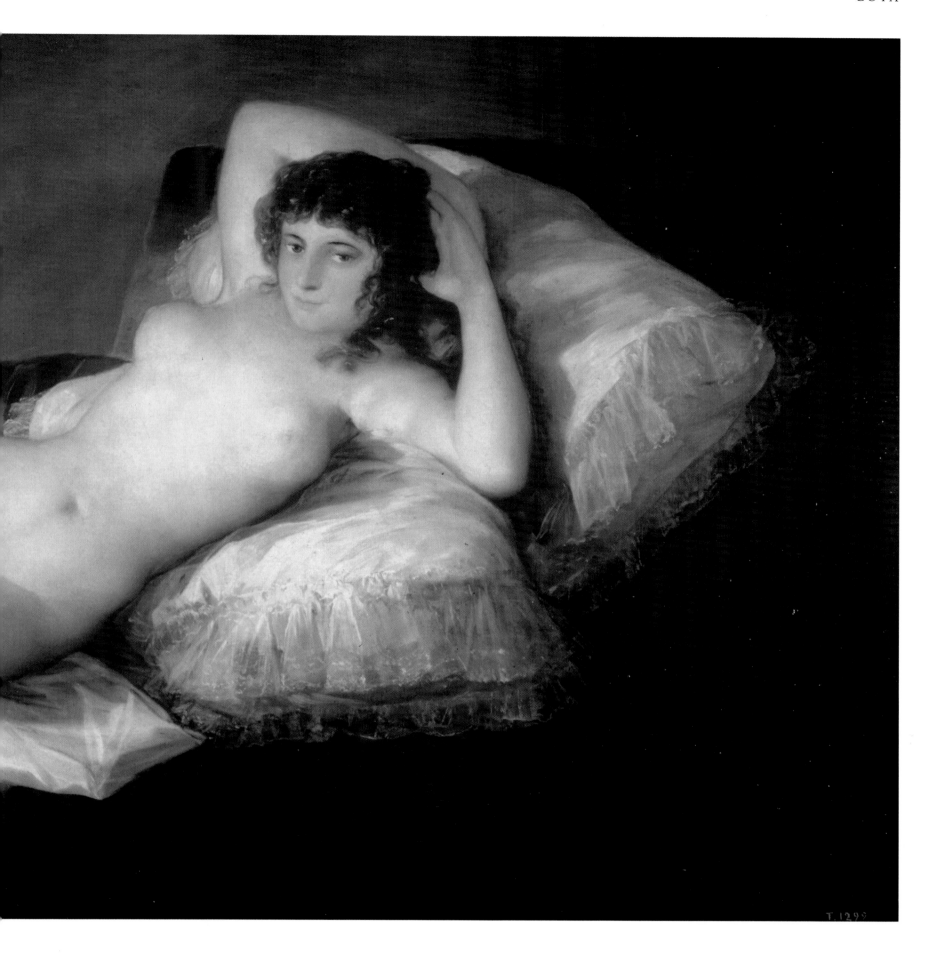

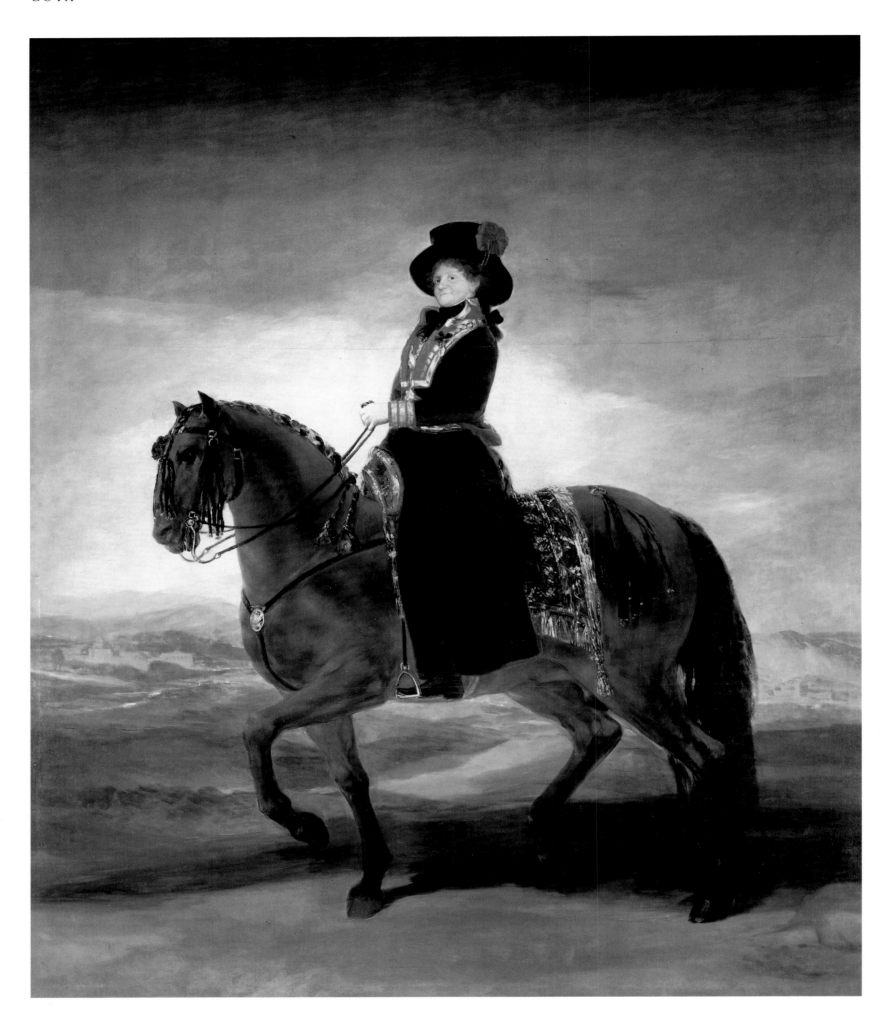

Equestrian Portrait of María Luisa, 1799
Oil on canvas, 132 × 110 inches (335 × 279 cm)
Museo del Prado, Madrid

Charles IV in Hunting Costume, 1799
Oil on canvas, 83 × 51 inches (210 × 130 cm)
Patrimonio Nacional, Palacio Real, Madrid

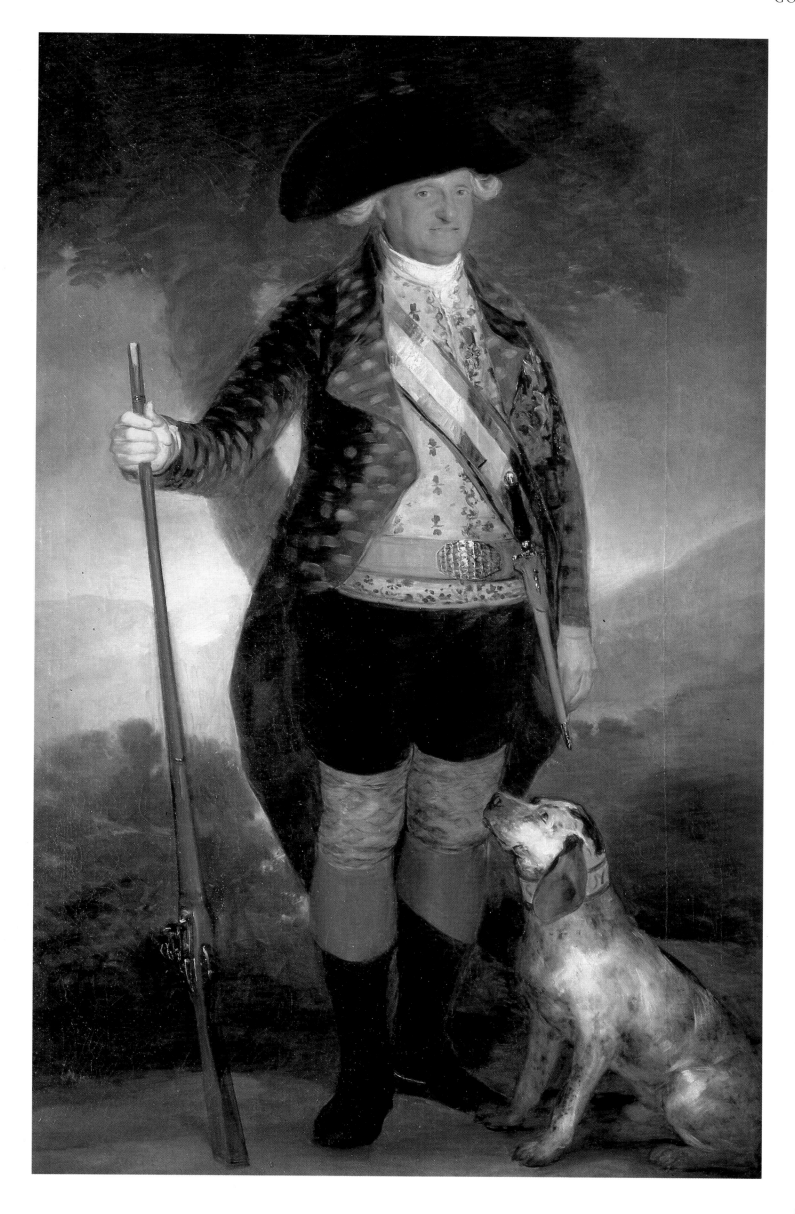

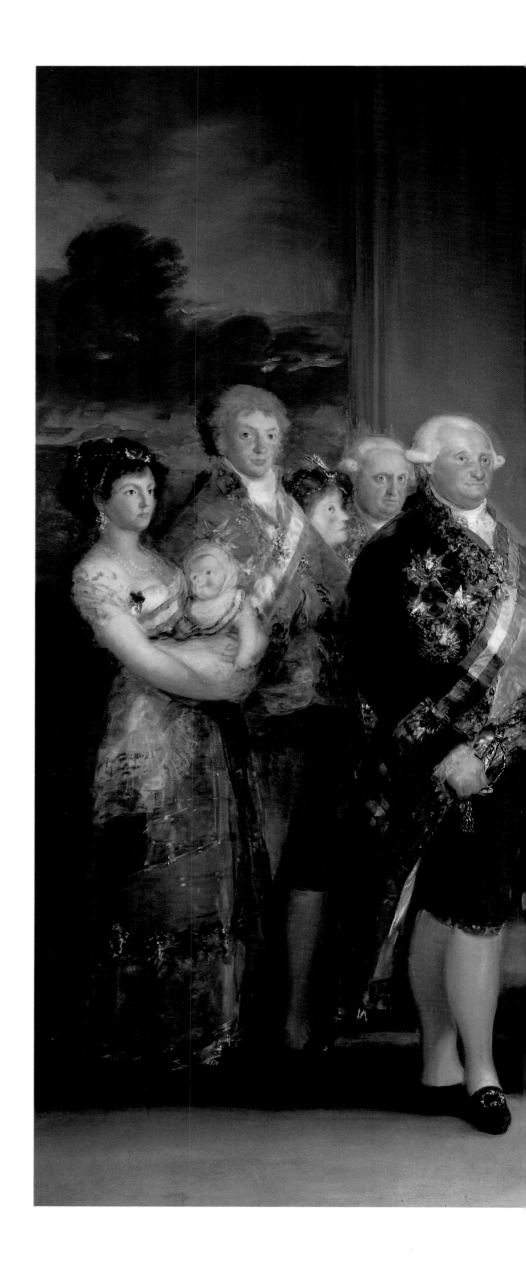

Charles IV and his Family, *c.*1800
Oil on canvas, 110 × 132 inches (280 × 336 cm)
Museo del Prado, Madrid

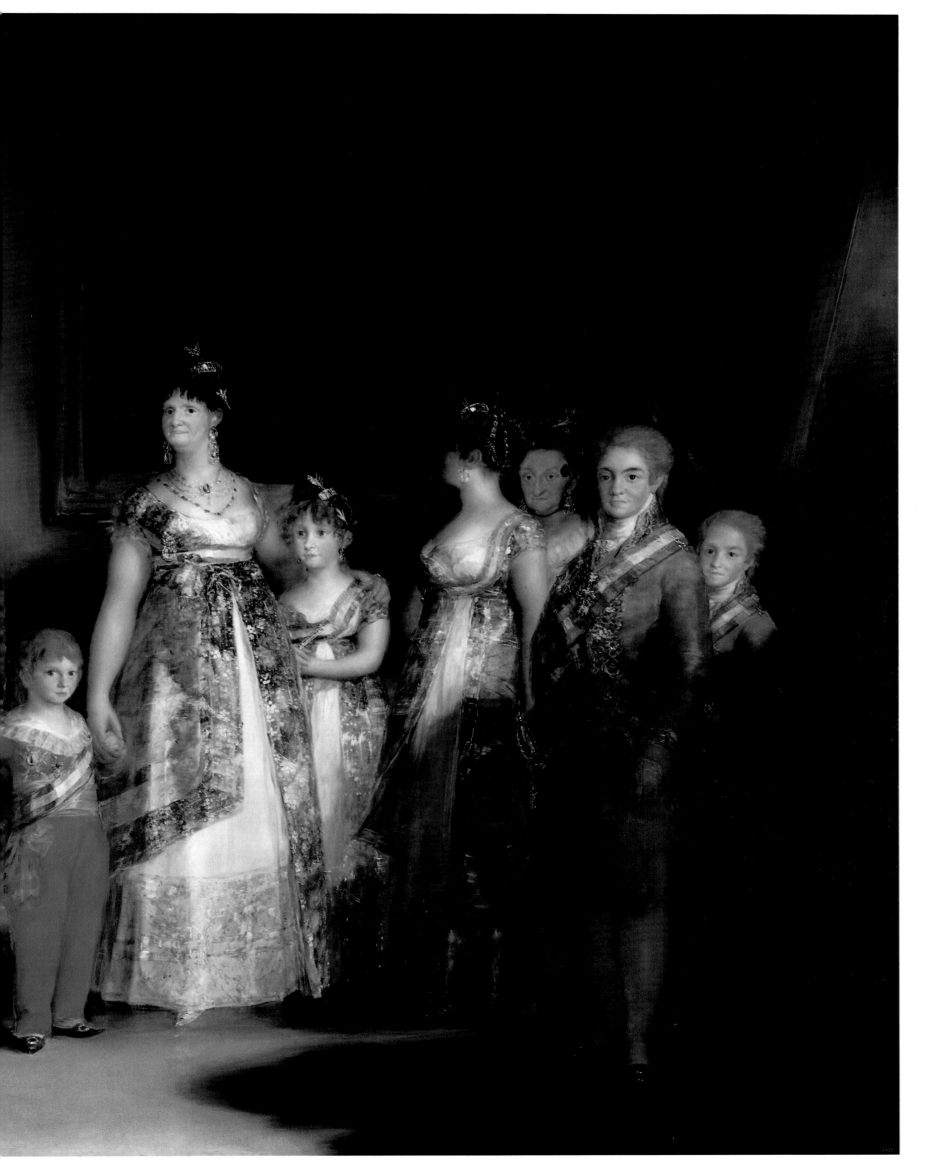

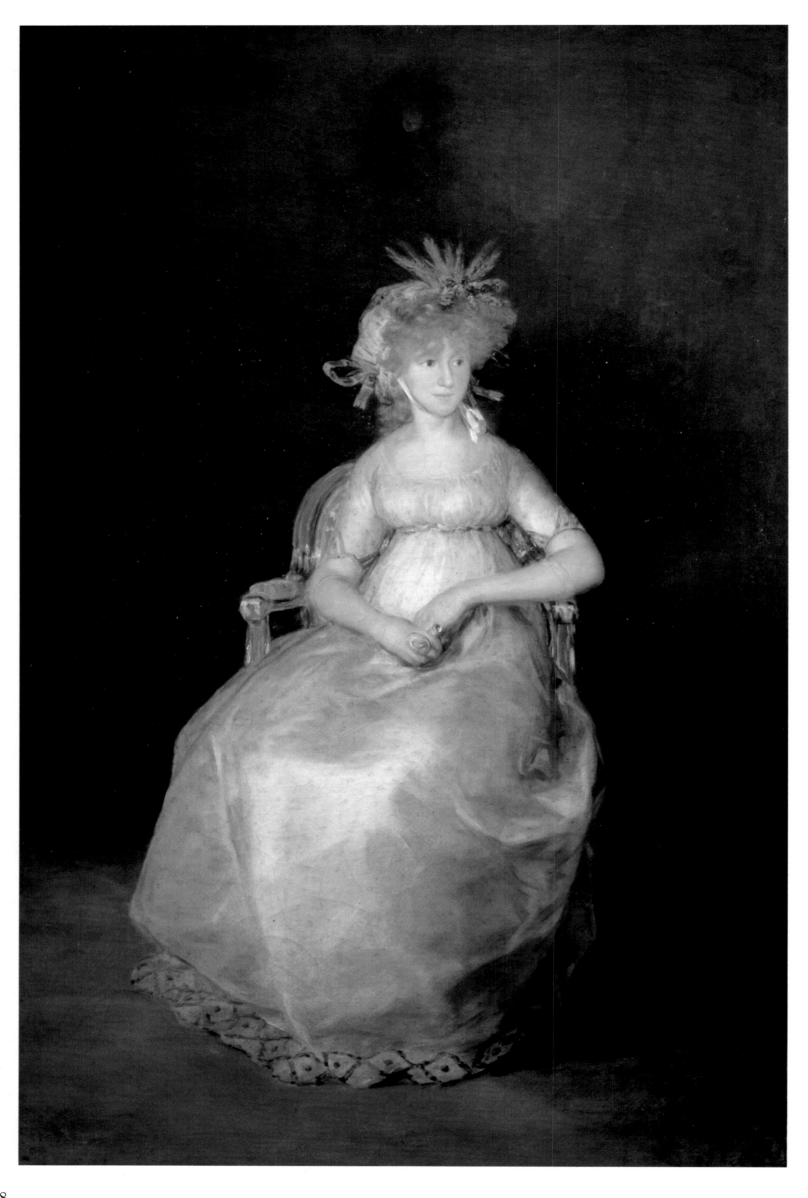

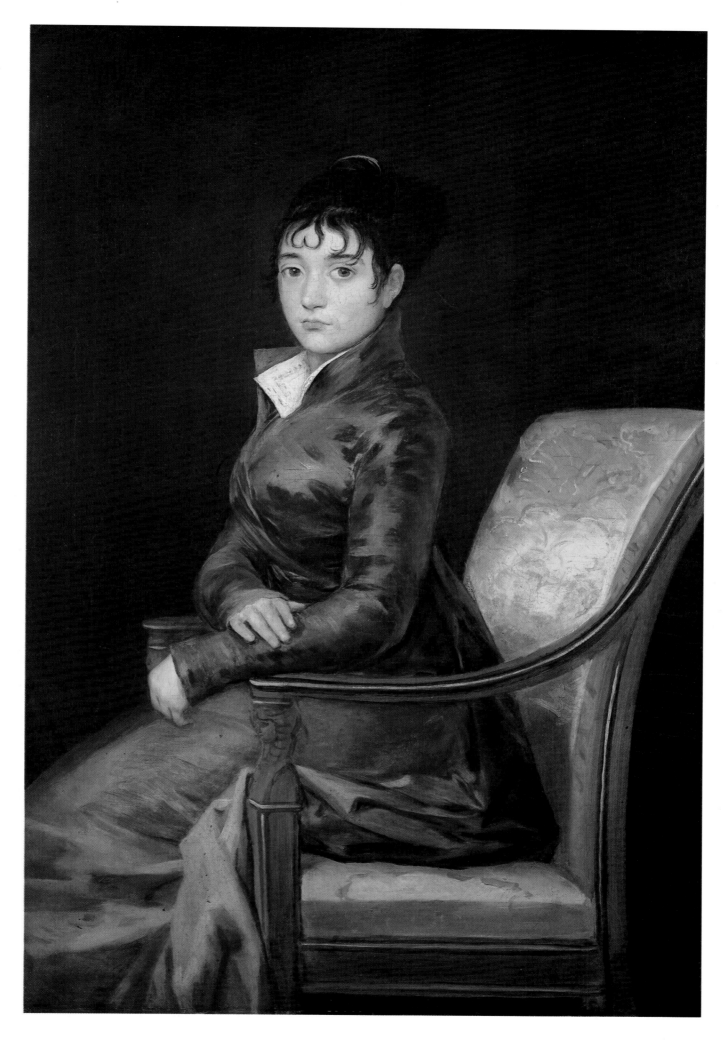

Thérèse Louise de Sureda, 1803/4
Oil on canvas, 47⅛ × 31¼ inches (119.7 × 79.4 cm)
© 1995 Board of Trustees, National Gallery of Art, Washington, D.C.
Gift of Mr. and Mrs. P.H.B. Frelinghuysen
in memory of her father and mother,
Mr. and Mrs. H.O. Havemeyer
[1942.3.1]

The Countess of Chinchón, c.1800
Oil on canvas, 85 × 57 inches (216 × 144 cm)
Private Collection, Madrid

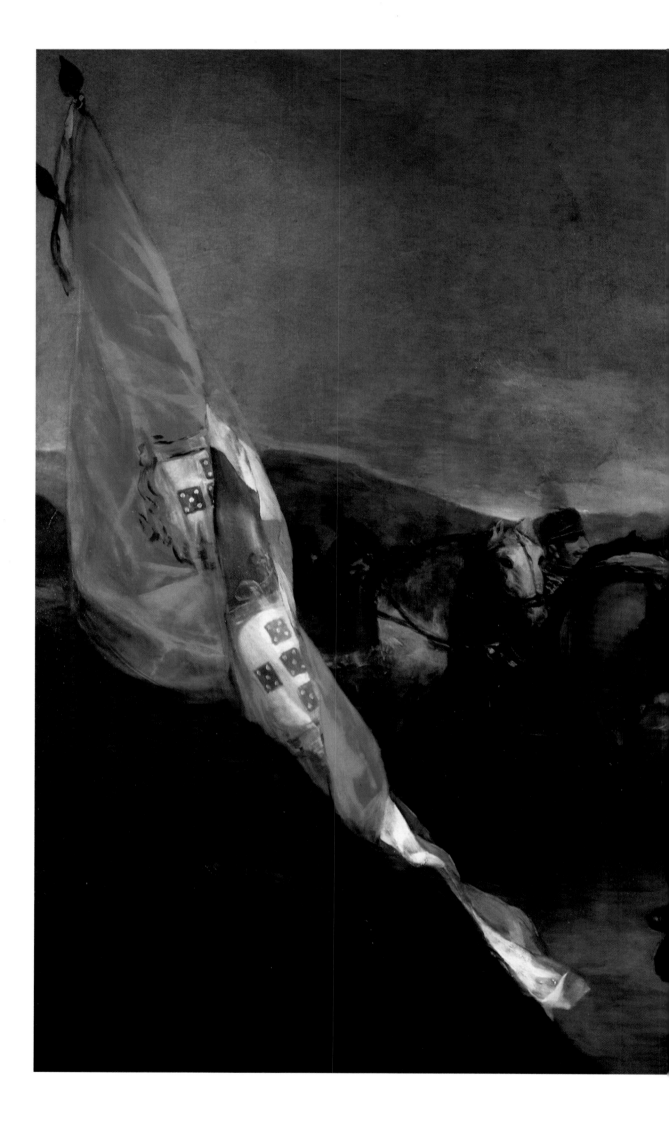

Don Manuel Godoy, 1801
Oil on canvas, 71 × 105 inches (180 × 267 cm)
Real Academia de Bellas Artes
de San Fernando, Madrid

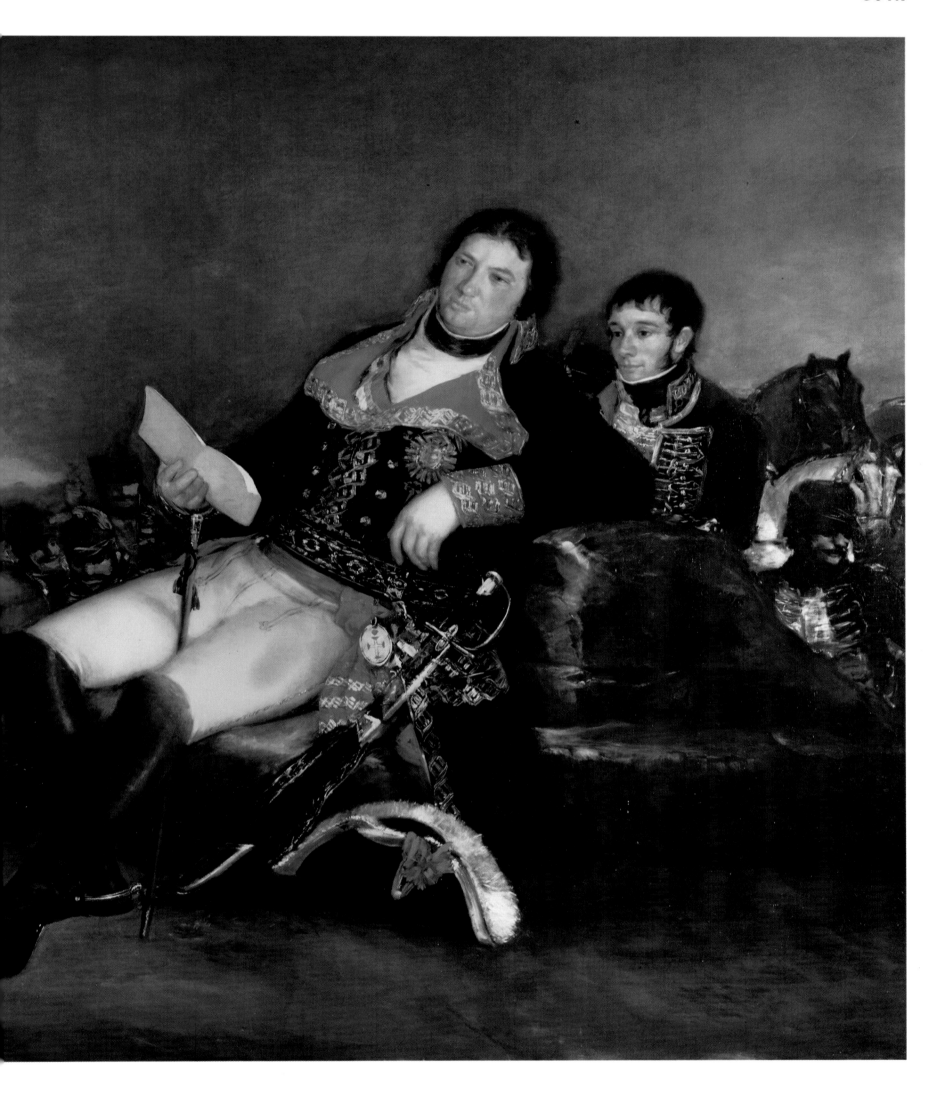

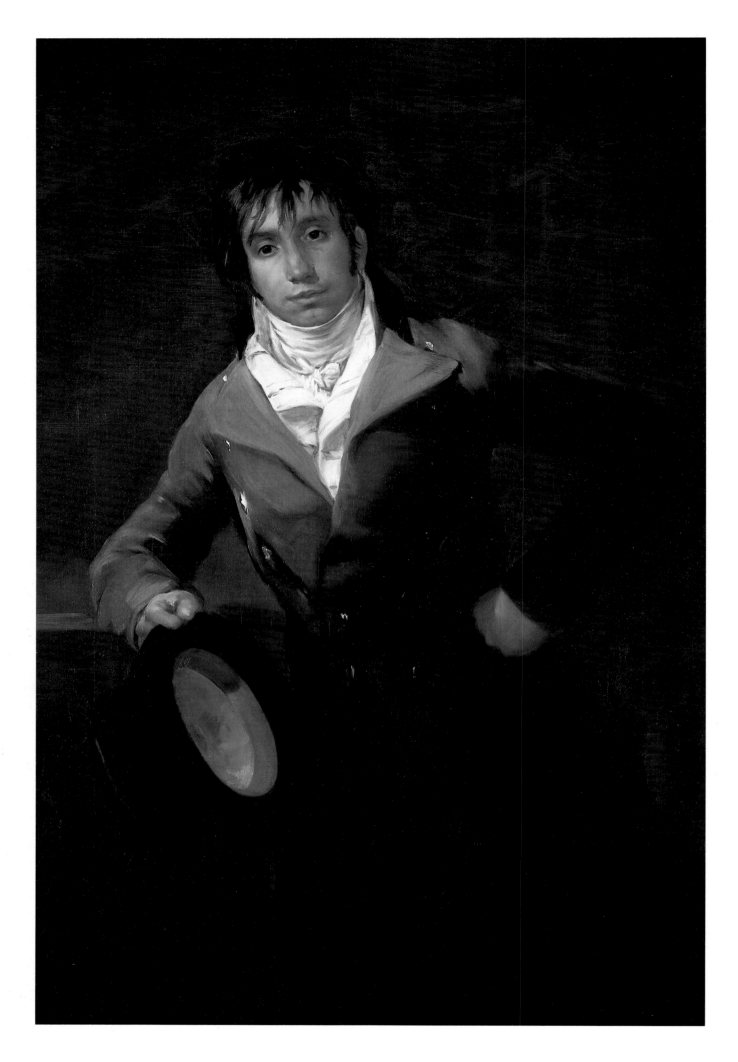

Bartolomé Sureda y Miserol, *c.*1803/4
Oil on canvas, 54¼ × 38¾ inches (119.7 × 79.3 cm)
© *1995 Board of Trustees, National Gallery of Art, Washington, D.C.*
Gift of Mr. and Mrs. P.H.B. Frelinghuysen
in memory of her father and mother,
Mr. and Mrs. H.O. Havemeyer
(1941.10.1)

Doña Isobel de Porcel, 1805
Oil on canvas, 32 × 21½ inches (82 × 55 cm)
National Gallery, London

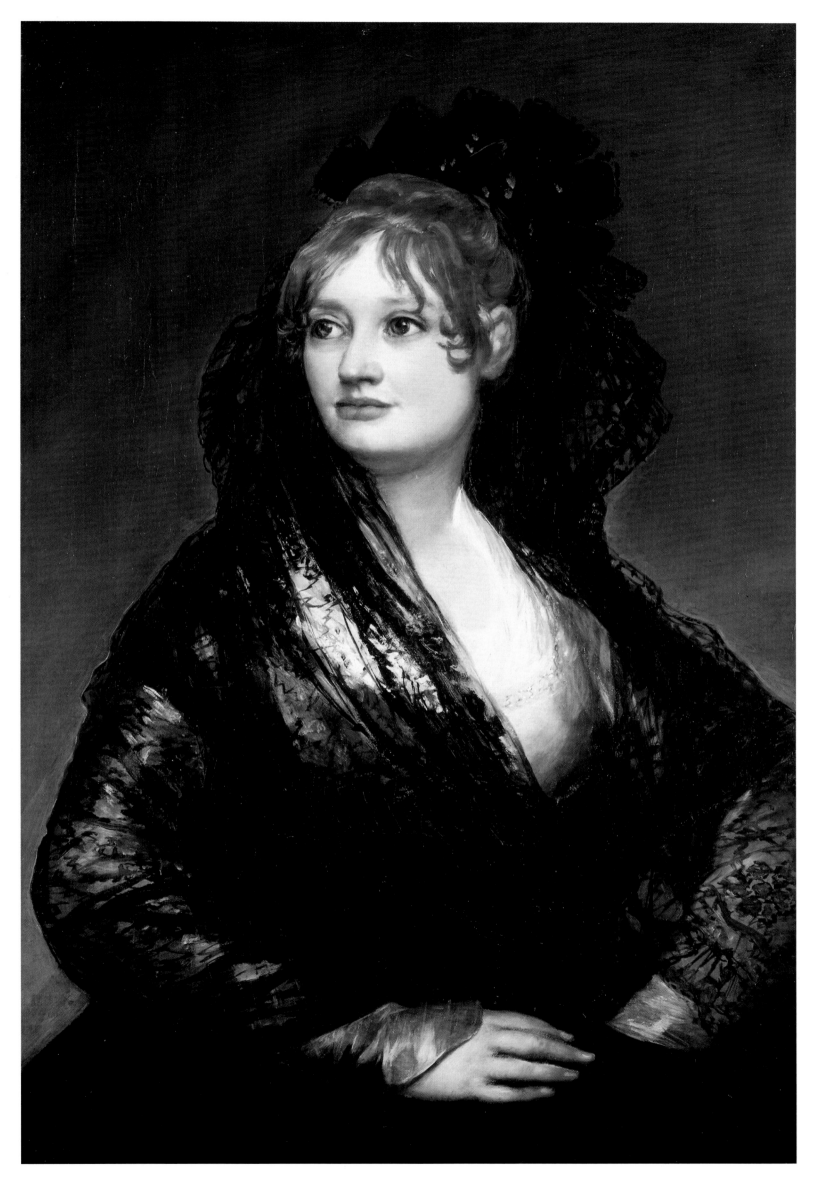

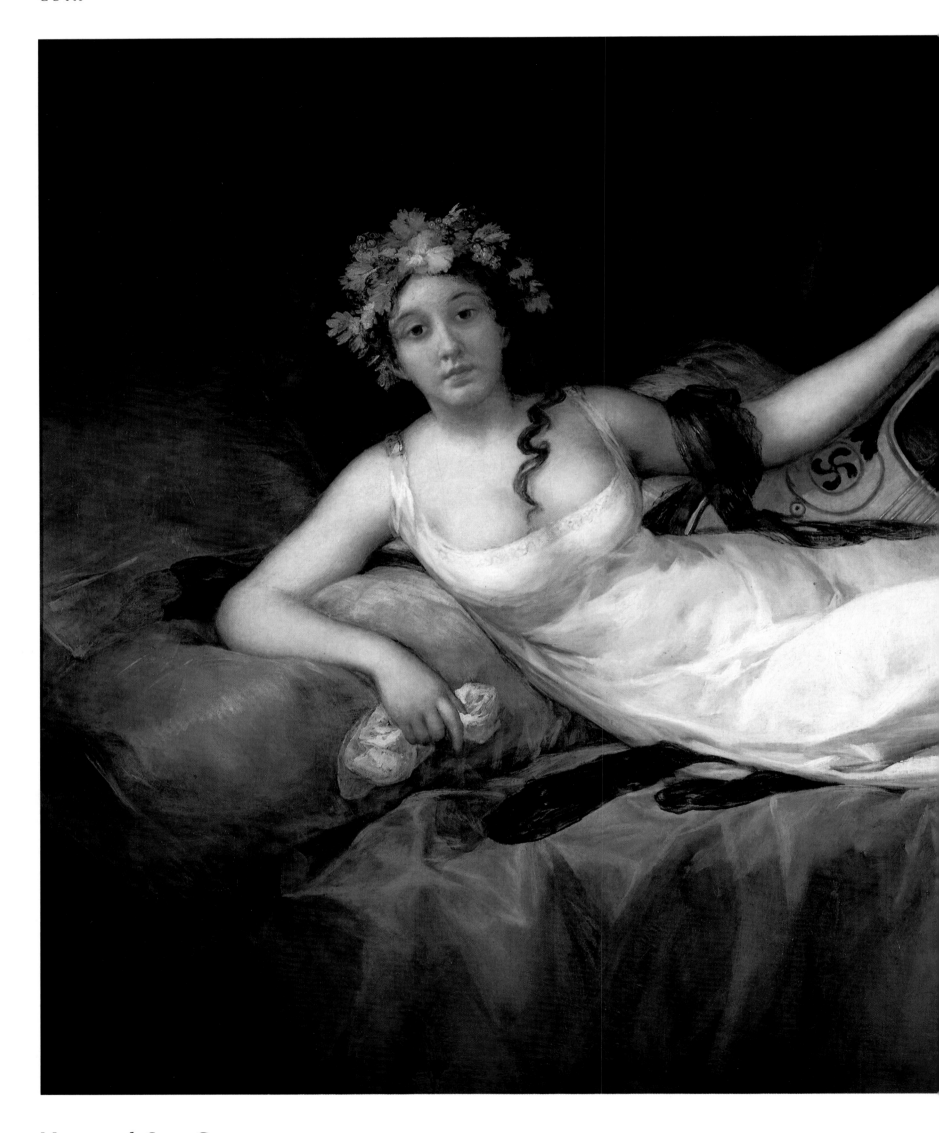

Marquesa de Santa Cruz, 1805
Oil on canvas, 51 × 83 inches (130 × 210 cm)
Museo del Prado, Madrid

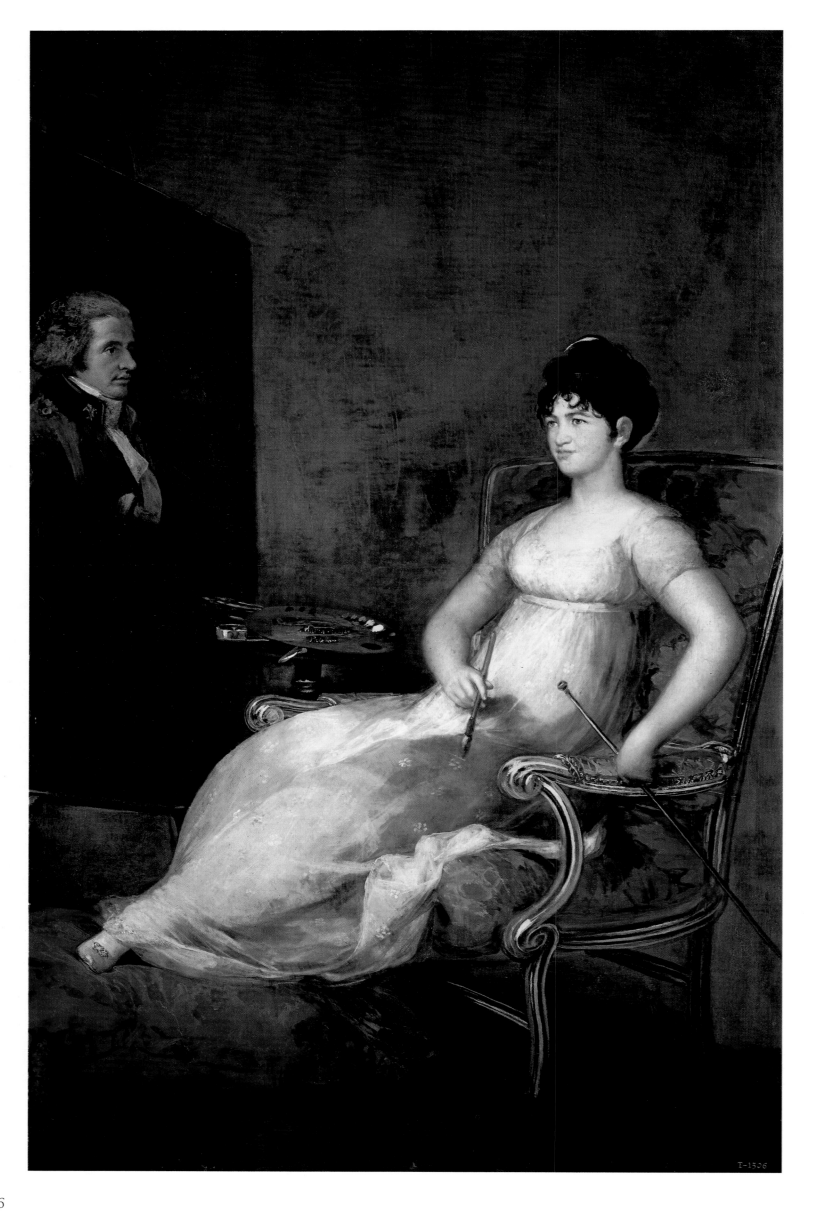

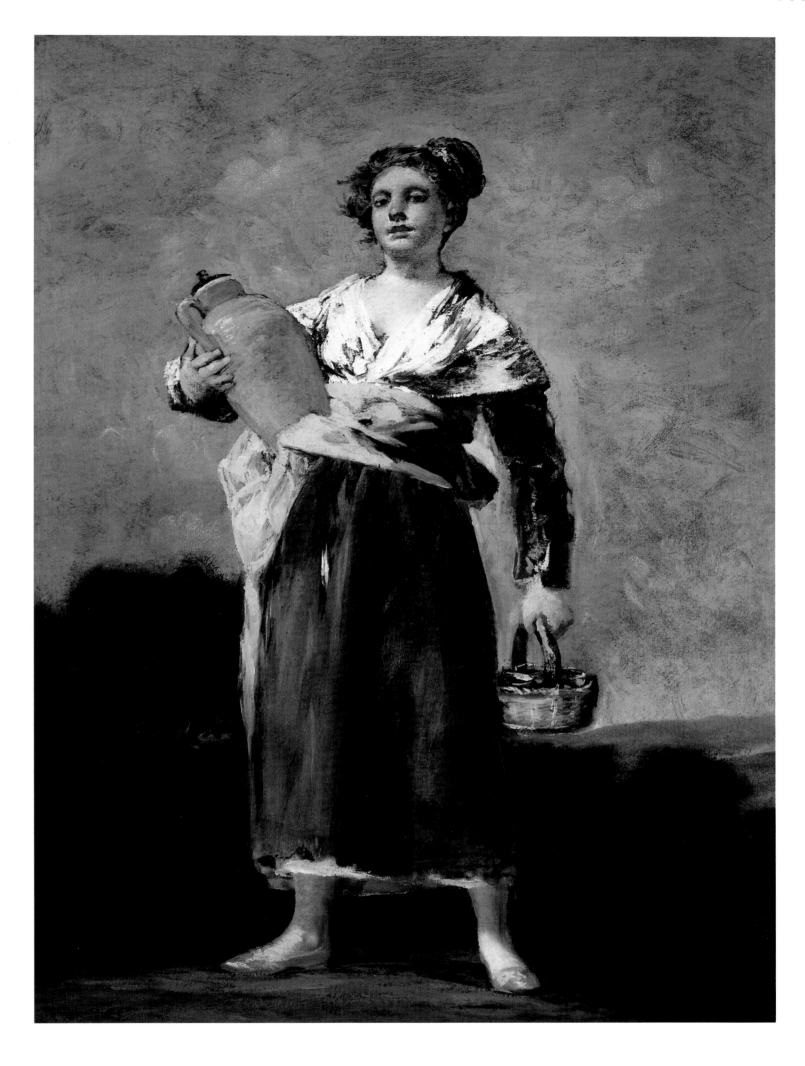

LEFT
Marquesa de Vilafranca, 1805
Oil on canvas, 77 × 50 inches (195 × 126 cm)
Museo del Prado, Madrid

ABOVE
The Water Carrier, 1808-12
Oil on canvas, 27 × 20 inches (68 × 50.5 cm)
Museum of Fine Arts, Budapest

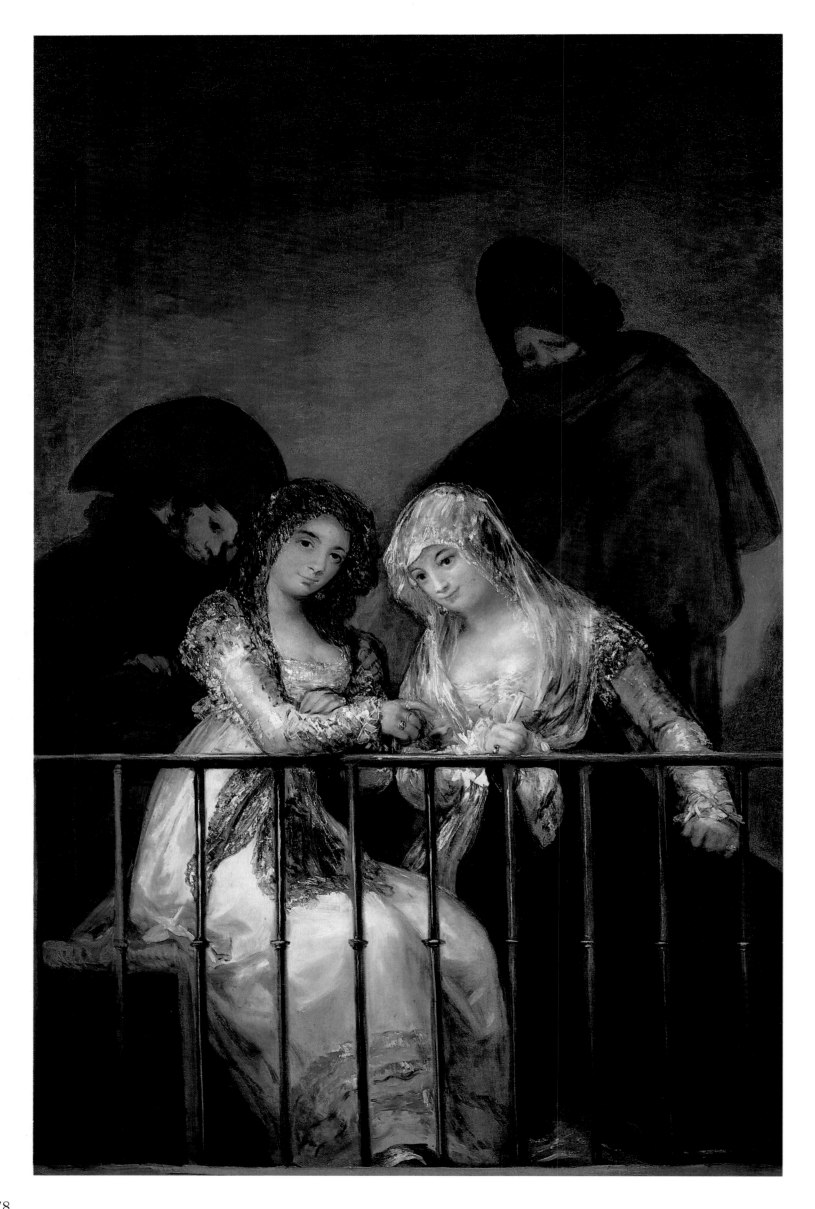

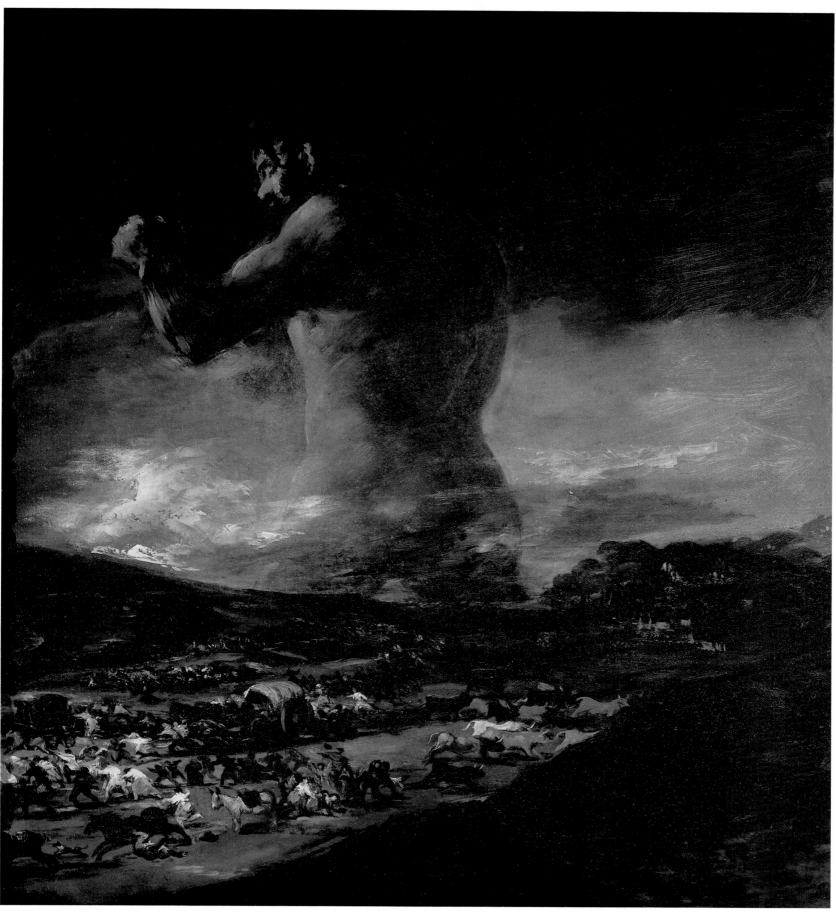

LEFT
Majas on a Balcony, *c.*1808-12
Oil on canvas, 76¾ × 49½ inches (194.8 × 125.7 cm)
The Metropolitan Museum of Art, New York, NY
Bequest of Mrs. H.O. Havemeyer, 1929
The H.O. Havemeyer Collection
(29.100.10)

ABOVE
The Colossus, 1808-12
Oil on canvas, 46 × 41 inches (116 × 105 cm)
Museo del Prado, Madrid

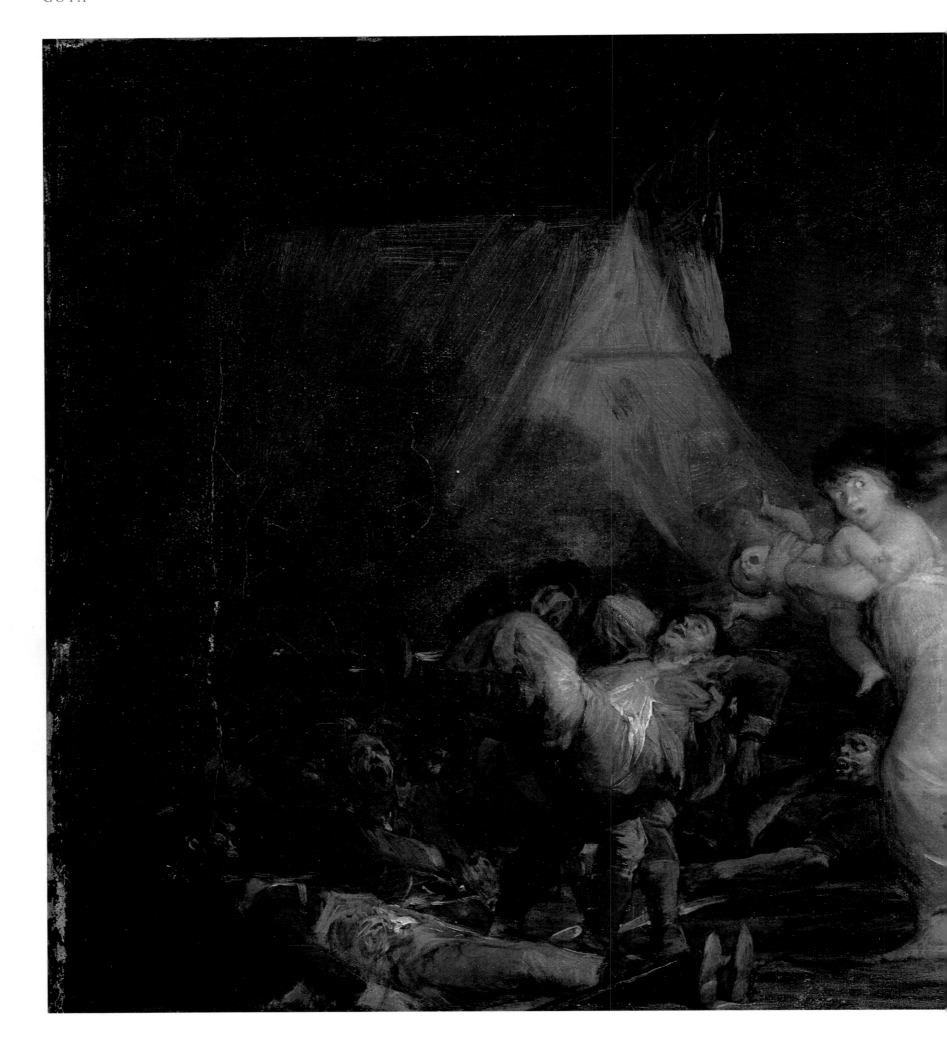

Soldiers Shooting at a Group of Fugitives, 1809-12
Oil on canvas, 12½ × 23 inches (32 × 58 cm)
Private Collection, Madrid

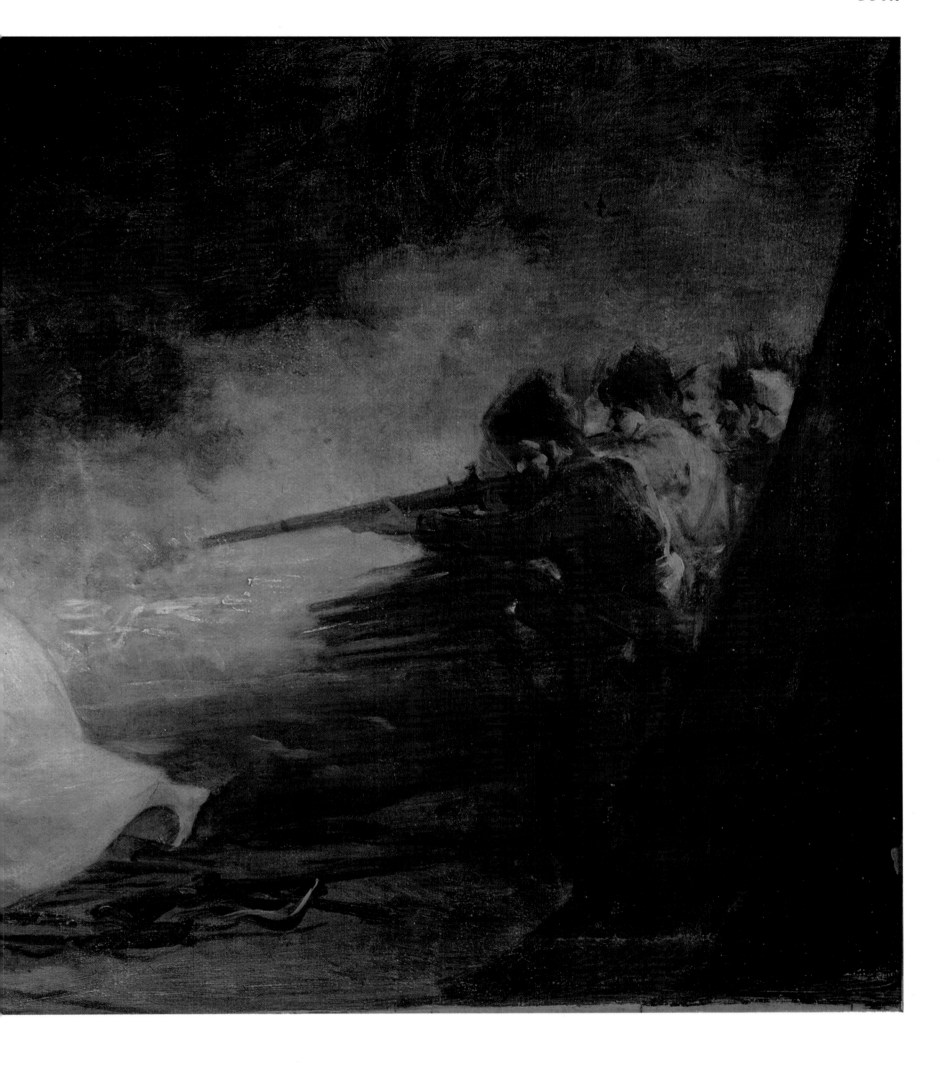

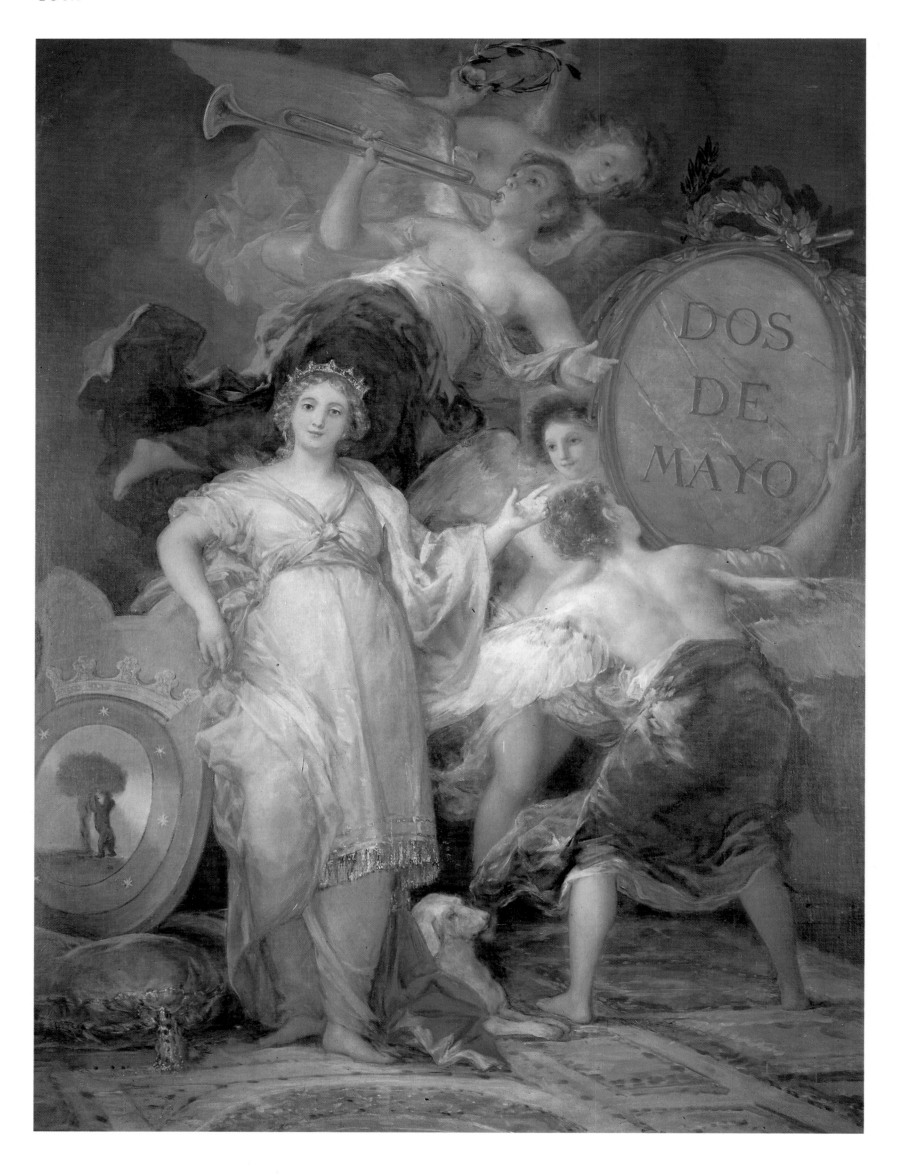

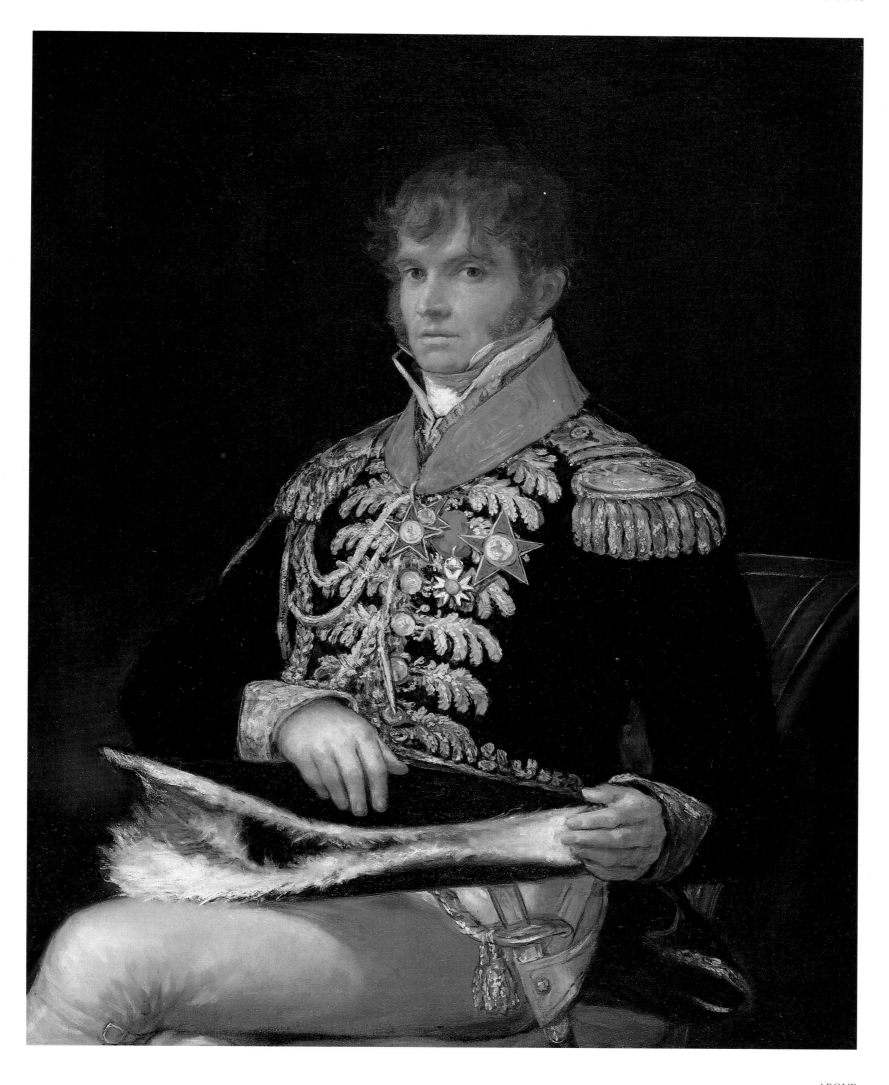

Allegory of the City of Madrid, 1810
Oil on canvas, 102 × 77 inches (260 × 195 cm)
Ayuntamiento, Madrid

ABOVE
General Nicolas Guye, 1810
Oil on canvas, 41¾ × 33⅜ inches (106 × 84.7 cm)
Virginia Museum of Fine Arts, Richmond, VA
Gift of John Lee Pratt
(71.26)

The Bullfight, 1810-20
Oil on canvas, 38¾ × 49¾ inches
(98.4 × 126.3 cm)
The Metropolitan Museum of Art,
New York, NY
Wolfe Fund, 1922
Catharine Lorillard Wolfe Collection
(22.181)

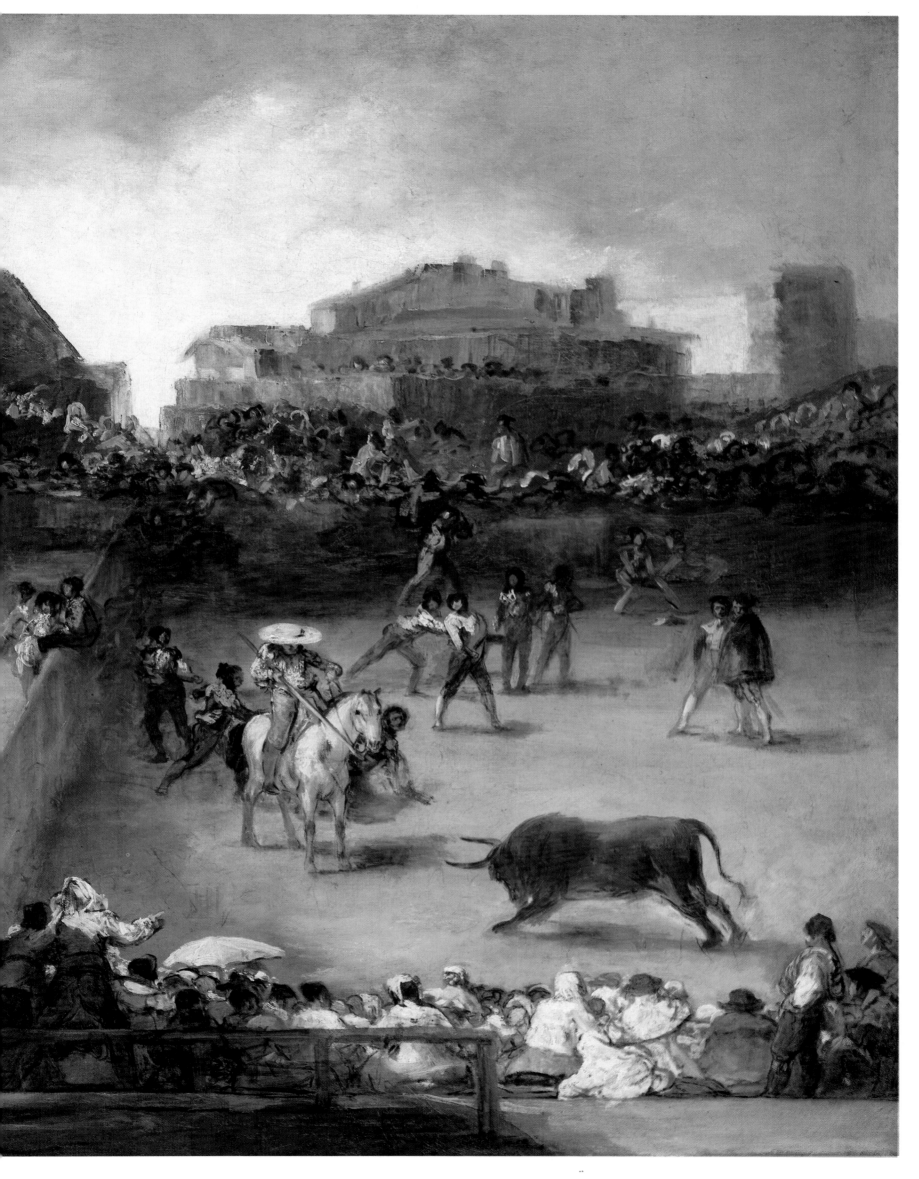

Making Gunpowder, 1812-13
Oil on canvas, 13 × 20½ inches (33 × 52 cm)
Patrimonio Nacional, Palacio Real, Madrid

Making Bullets, 1812-14
Oil on canvas, 13 × 20½ inches (33 × 52 cm)
Patrimonio Nacional, Palacio Real, Madrid

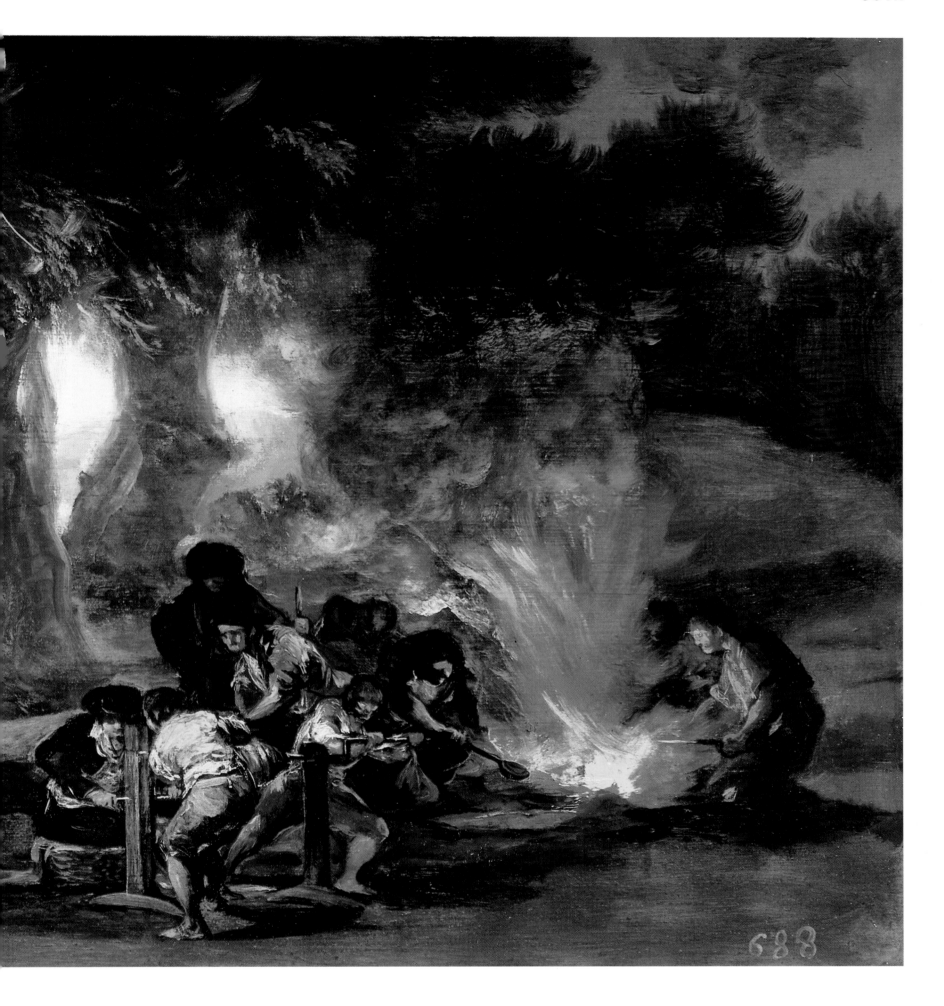

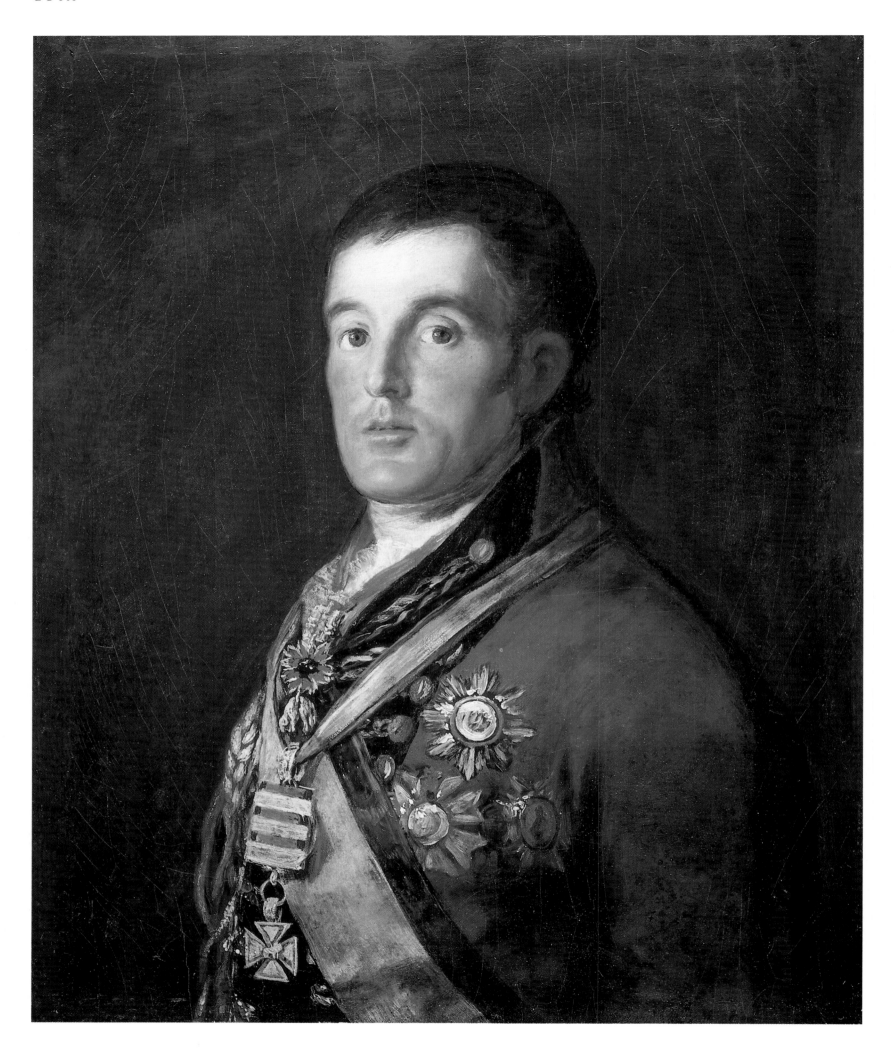

The Duke of Wellington, 1812
Oil on canvas, 25¼ × 33¼ inches (64.3 × 84.7 cm)
National Gallery, London

RIGHT
The Burial of the Sardine, 1812-14
Oil on panel, 33 × 24 inches (83 × 62 cm)
Real Academia de Bellas Artes
de San Fernando, Madrid

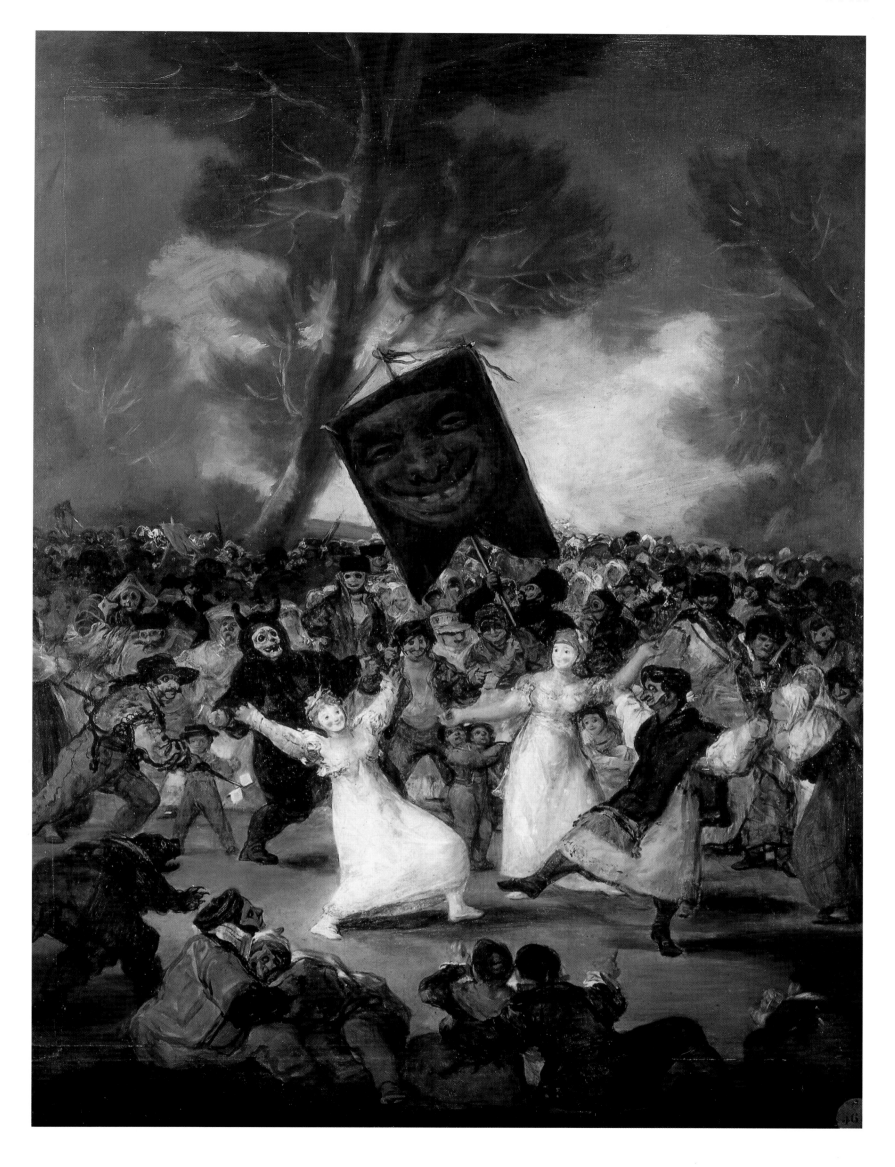

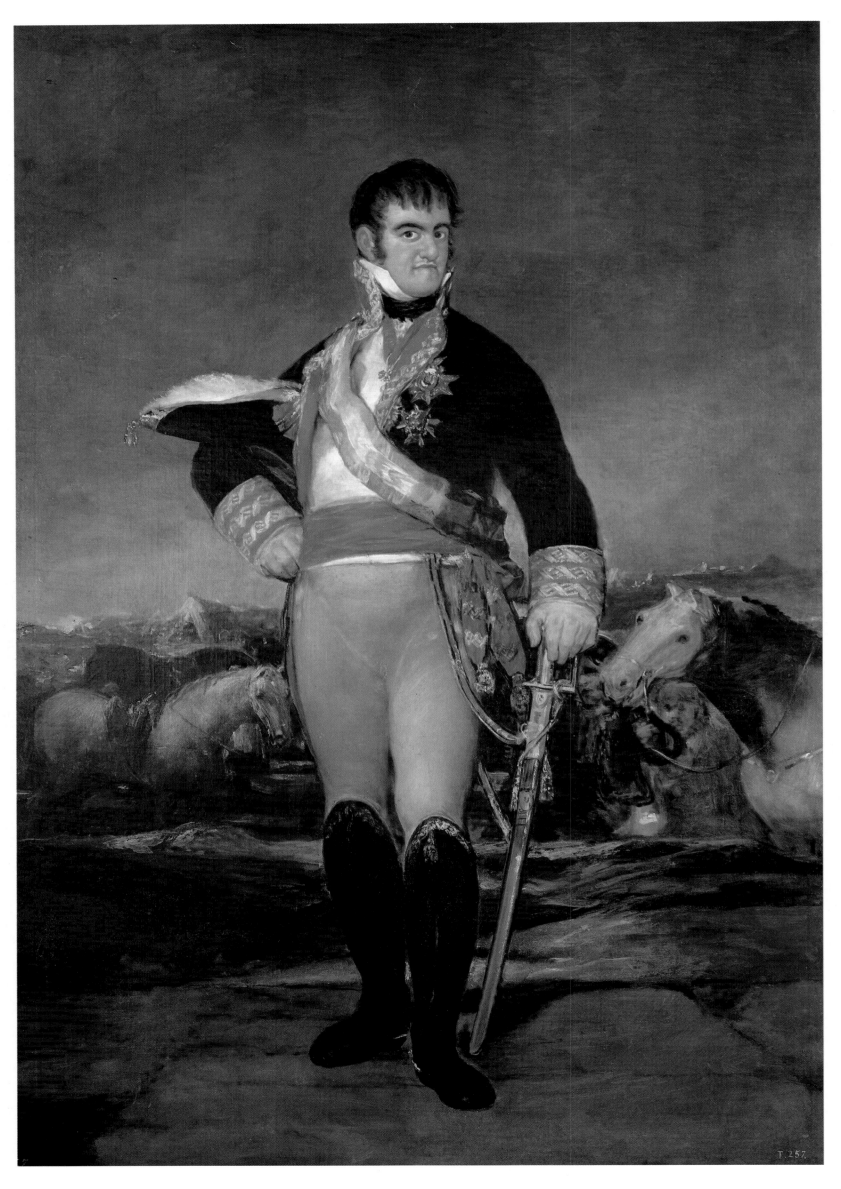

T.257

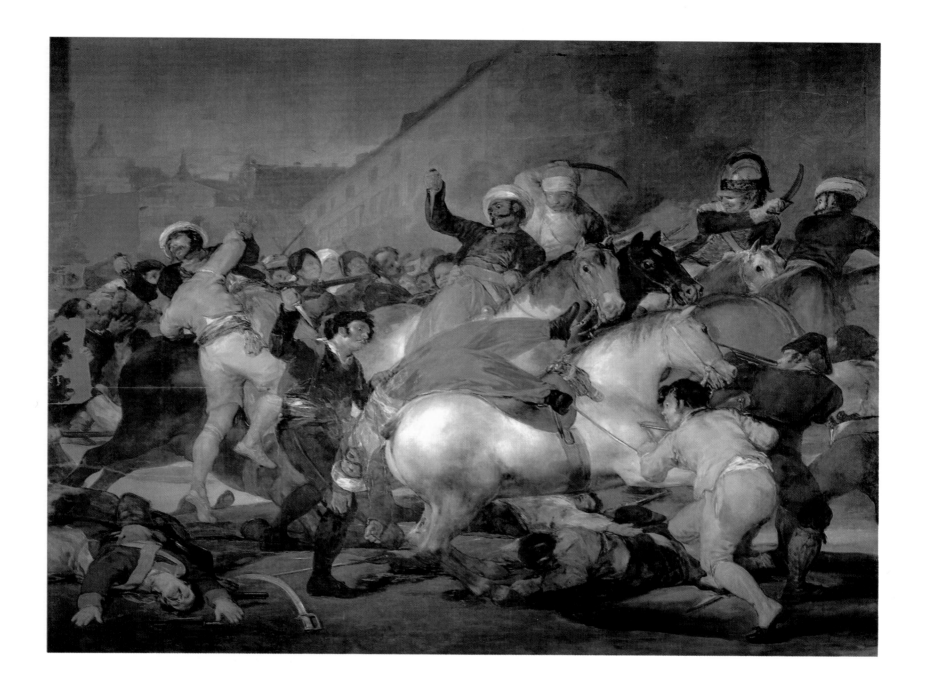

LEFT
Fernando VII in an Encampment, _c._1814
Oil on canvas, 81 × 55 inches (207 × 140 cm)
Museo del Prado, Madrid

ABOVE
The Second of May 1808, 1814
Oil on canvas, 105 × 136 inches (266 × 345 cm)
Museo del Prado, Madrid

93

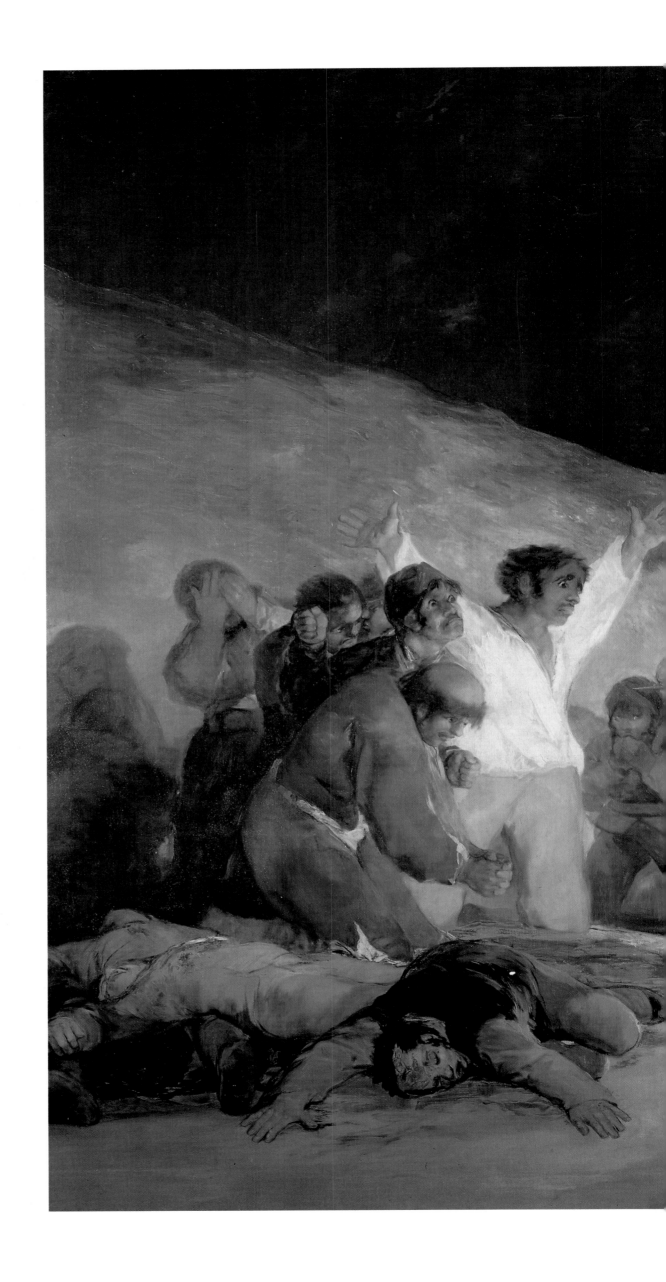

The Third of May 1808, 1814
Oil on canvas, 105 × 136 inches
(266 × 345 cm)
Museo del Prado, Madrid

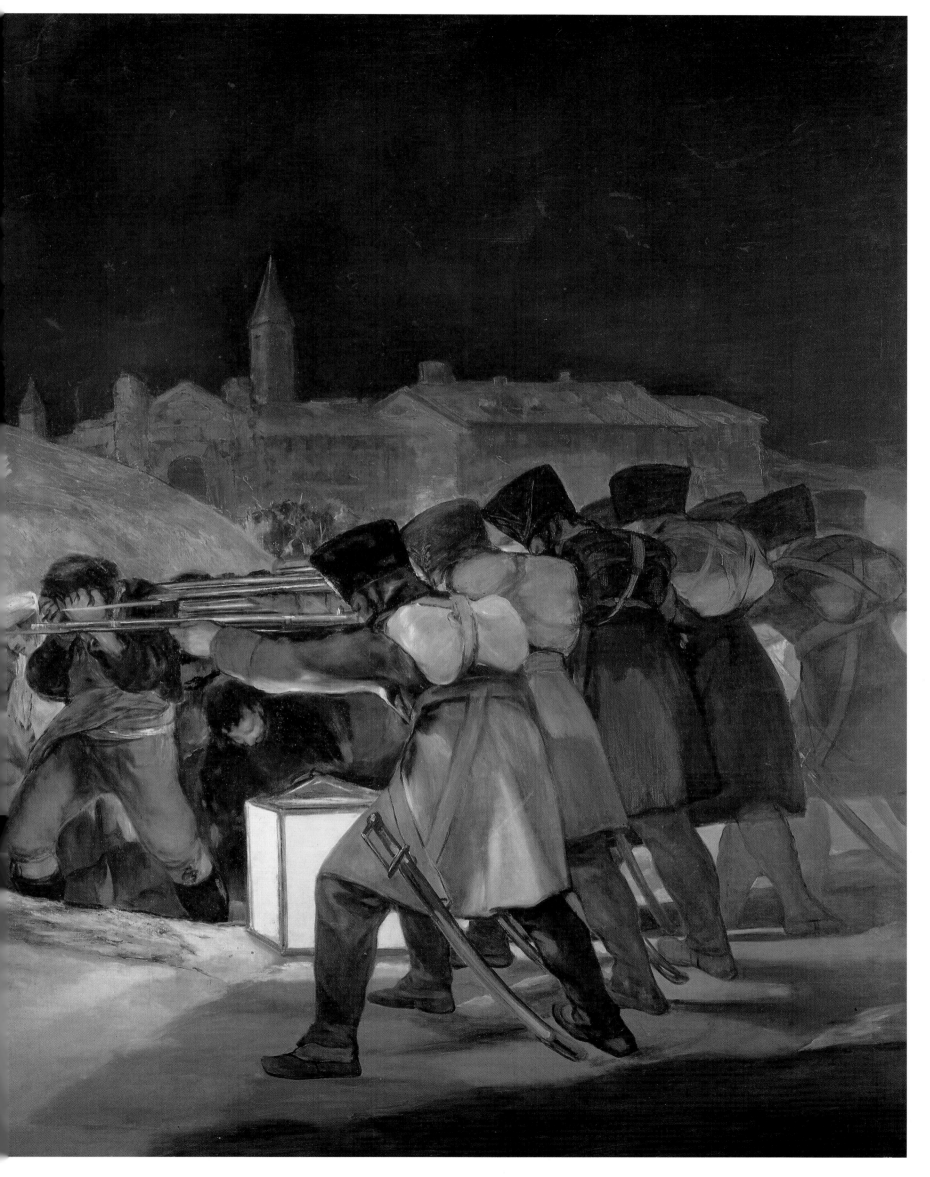

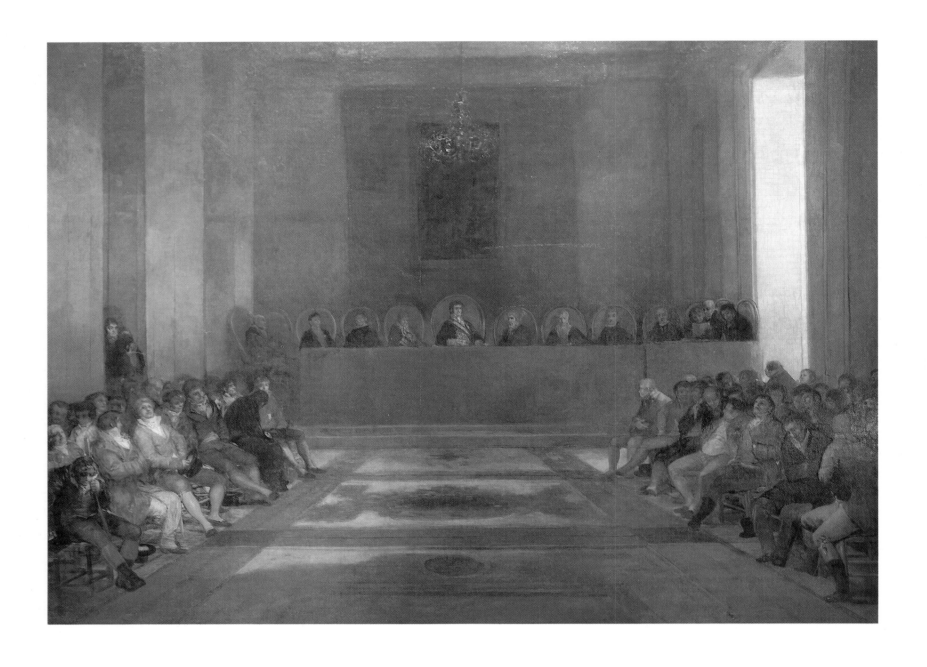

Fernando VII Chairing a Meeting
of the Royal Company of the Philippines, *c.*1815
Oil on canvas, 129 × 164 inches (327 × 417 cm)
Musée Goya, Castres

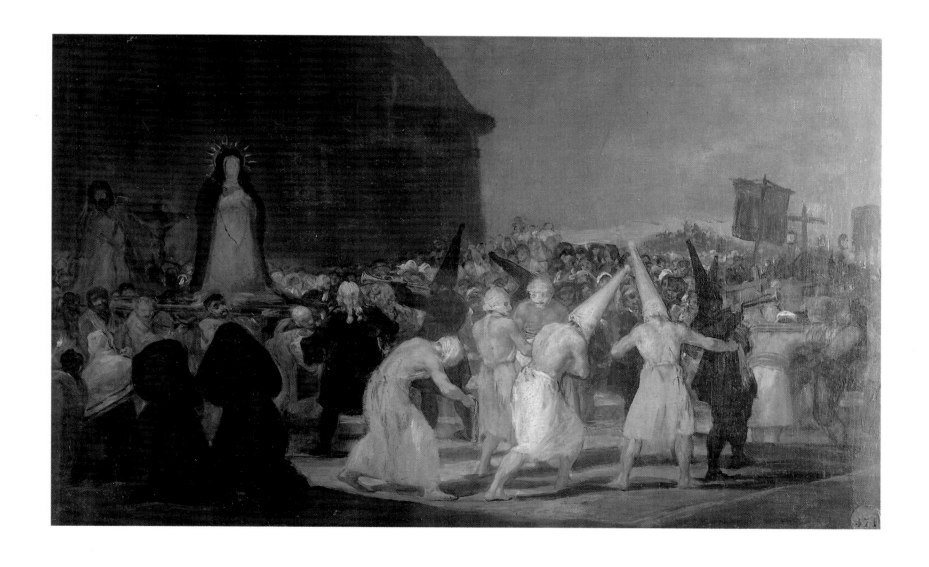

The Procession of the Flagellants, 1815-20
Oil on panel, 18 × 29 inches (46 × 73 cm)
Real Academia de Bellas Artes
de San Fernando, Madrid

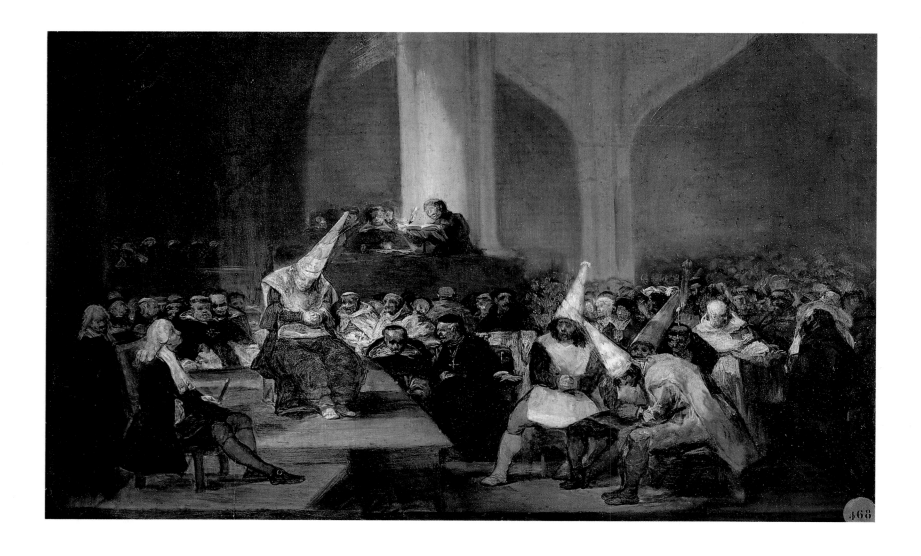

ABOVE
Inquisition Scene, 1815-19
Oil on panel, 18 × 29 inches (46 × 73 cm)
Real Academia de Bellas Artes
de San Fernando, Madrid

RIGHT
Old Women Looking in a Mirror, 1817-19
Oil on canvas, 71 × 49 inches (181 × 125 cm)
Musée des Beaux-Arts, Lille

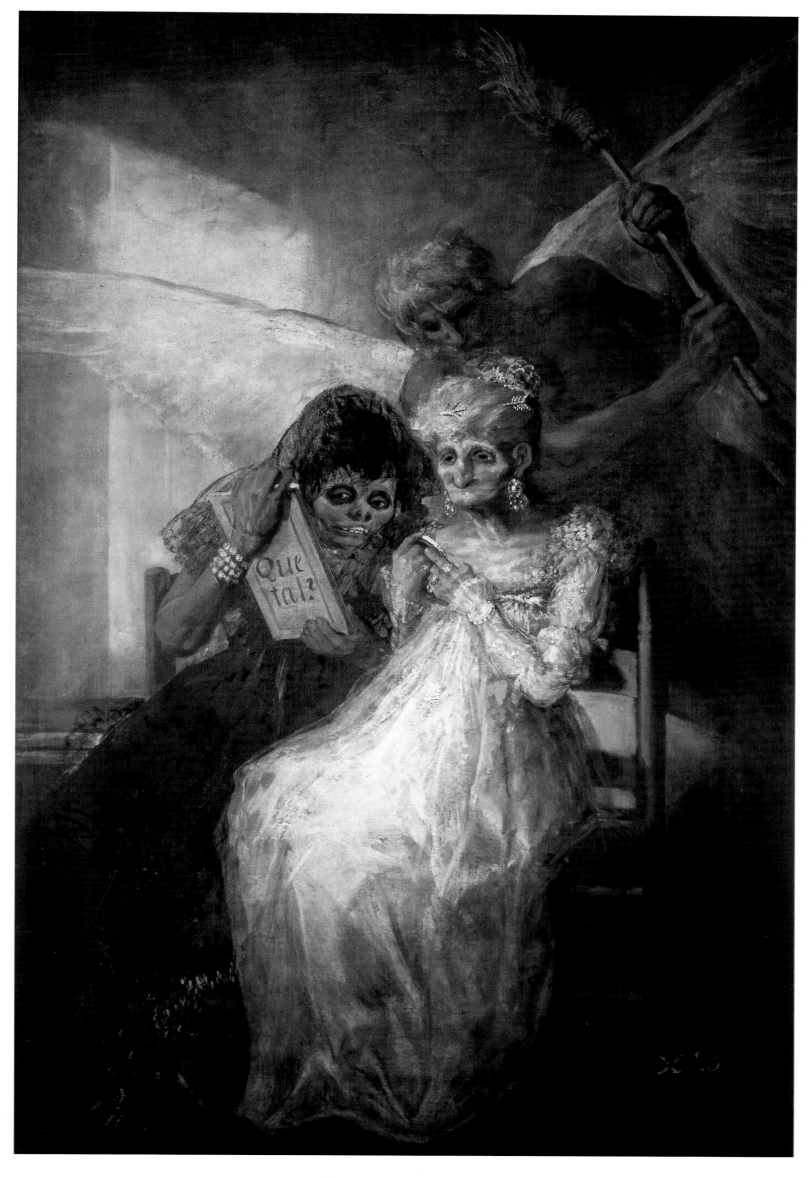

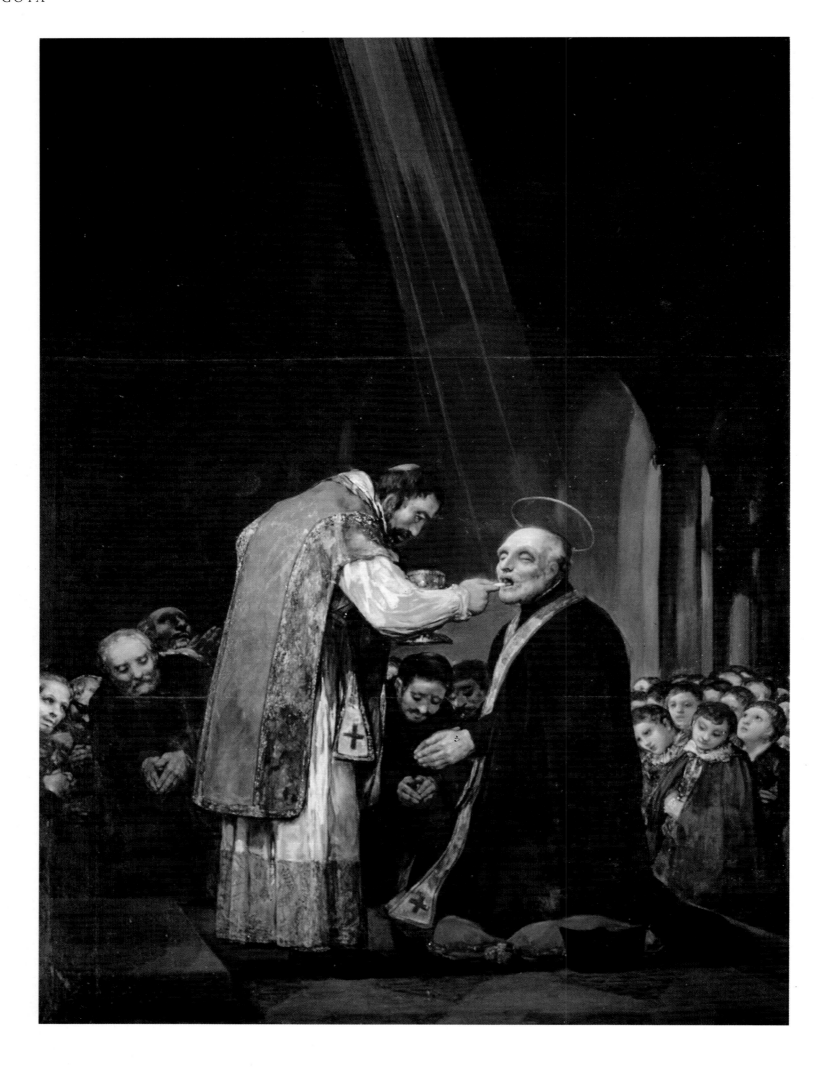

ABOVE
The Last Communion of San José de Calasanz, 1819
Oil on canvas, 98 × 71 inches (250 × 180 cm)
Real Colegio de las Escuelas Pias
de San Antonio Abad, Madrid

RIGHT
Saturn Devouring his Children, 1819-23
Oil on canvas, 57 × 33 inches (146 × 83 cm)
Museo del Prado, Madrid

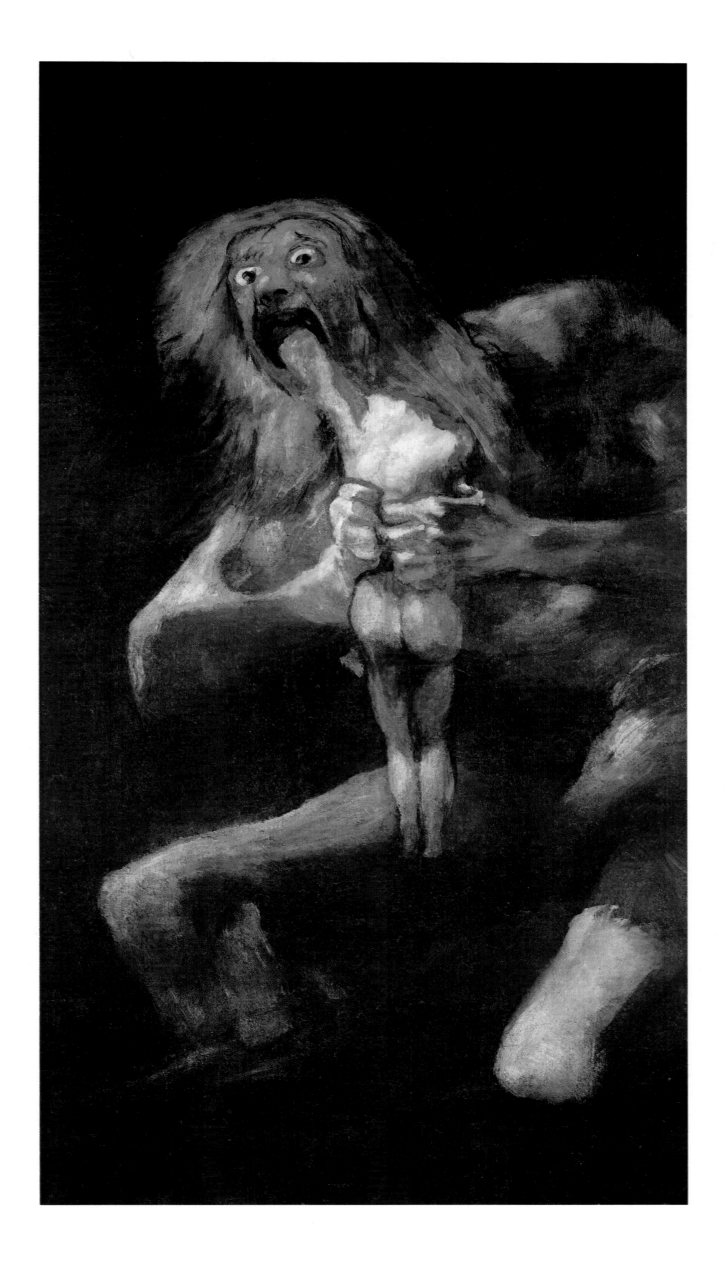

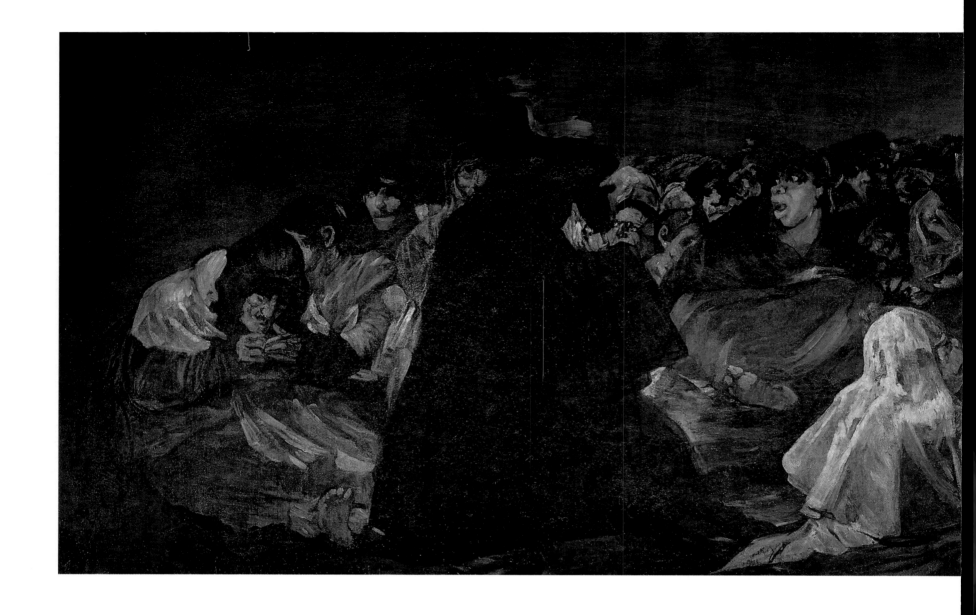

The Witches' Sabbath, 1819-23
Mural transferred to canvas, 55⅛ × 172½ inches (140 × 438 cm)
Museo del Prado, Madrid

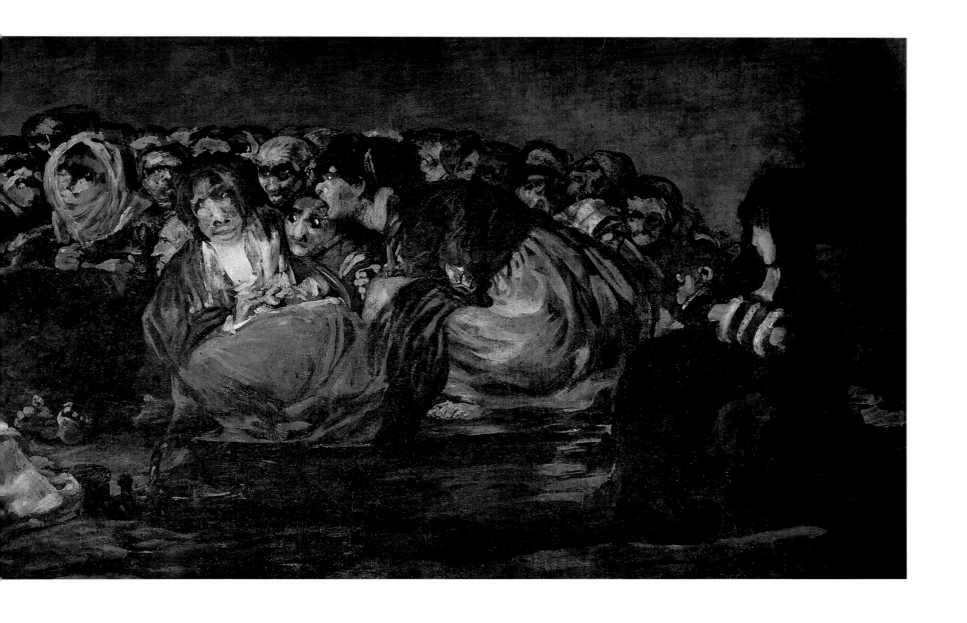

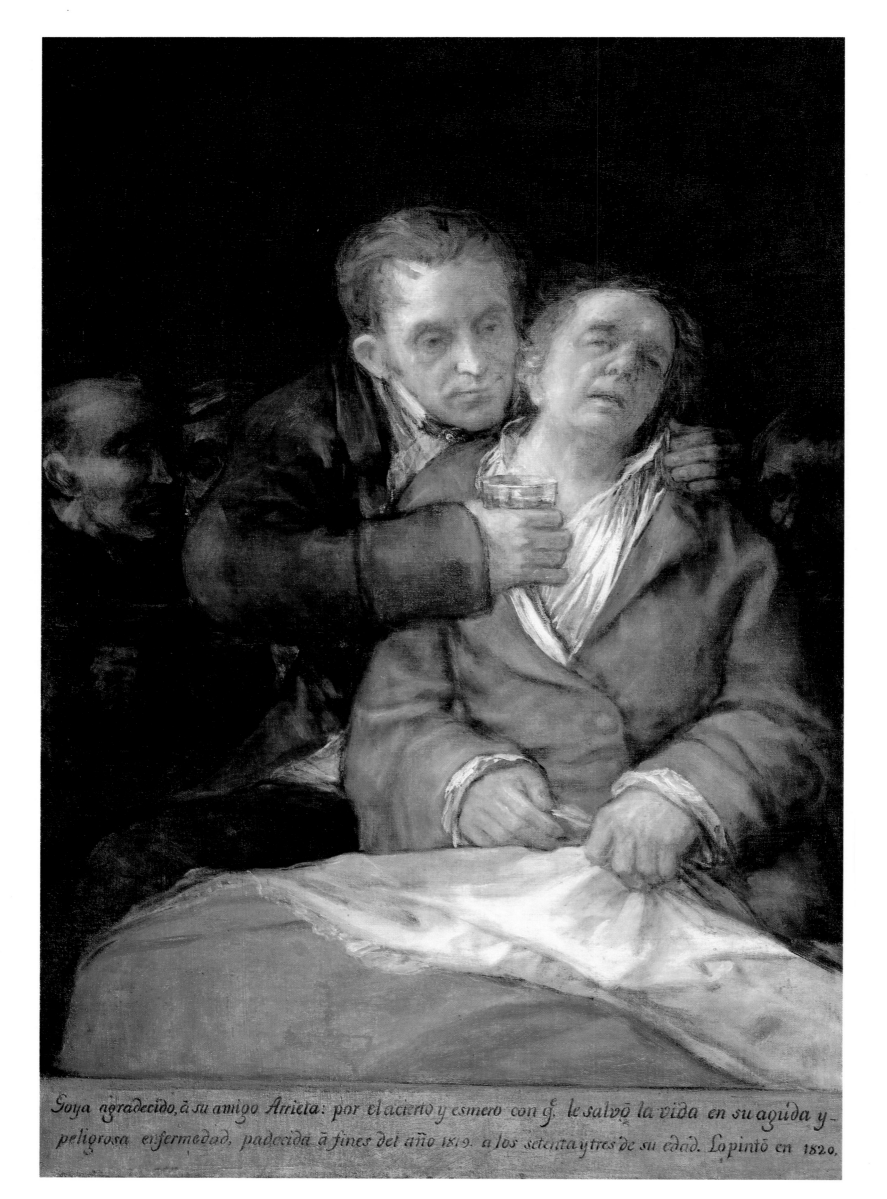

Goya agradecido, à su amigo Arrieta: por el acierto y esmero con q.ᵉ le salvó la vida en su aguda y
peligrosa enfermedad, padecida à fines del año 1819. a los setenta y tres de su edad. Lo pintó en 1820.

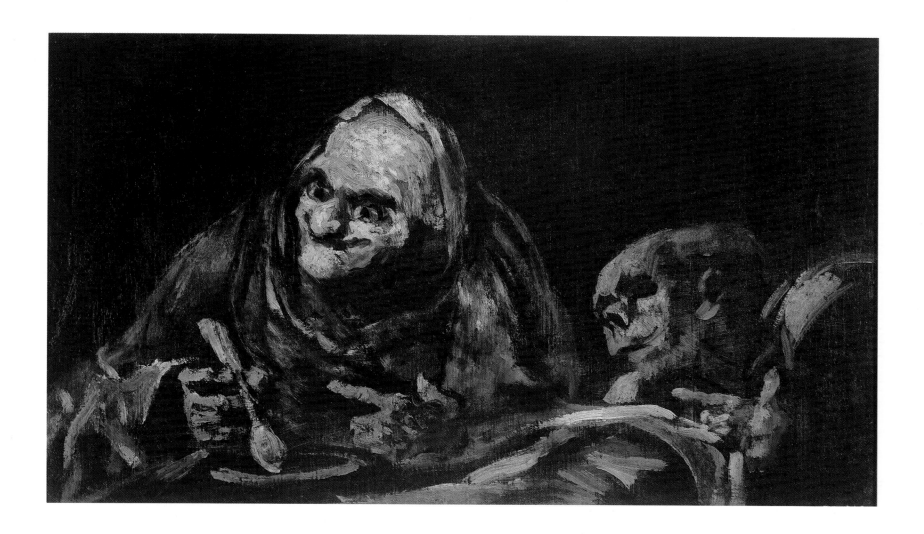

Self-Portrait with Doctor Arrieta, 1820
Oil on canvas, 45½ × 31⅛ inches (117 × 79 cm)
The Minneapolis Institute of Arts, MN
The Ethel Morrison Van Derlip Fund

Two Old Men Eating, 1820-23
Mural transferred to canvas, 21 × 34 inches (53 × 85 cm)
Museo del Prado, Madrid

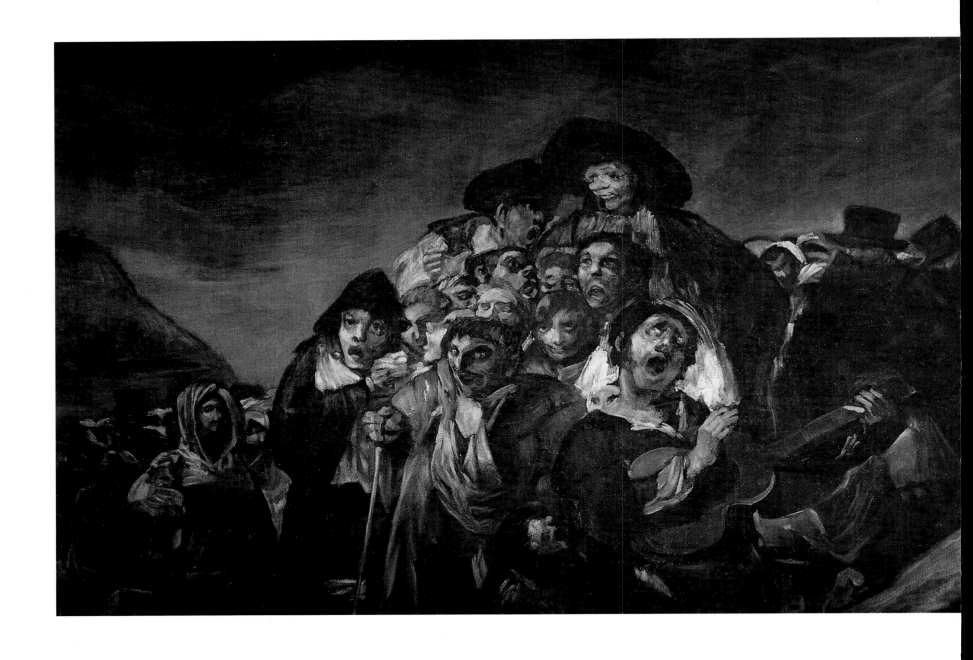

Saint Isidore's Day, 1821-23
Oil on canvas, 55 × 172 inches (140 × 438 cm)
Museo del Prado, Madrid

106

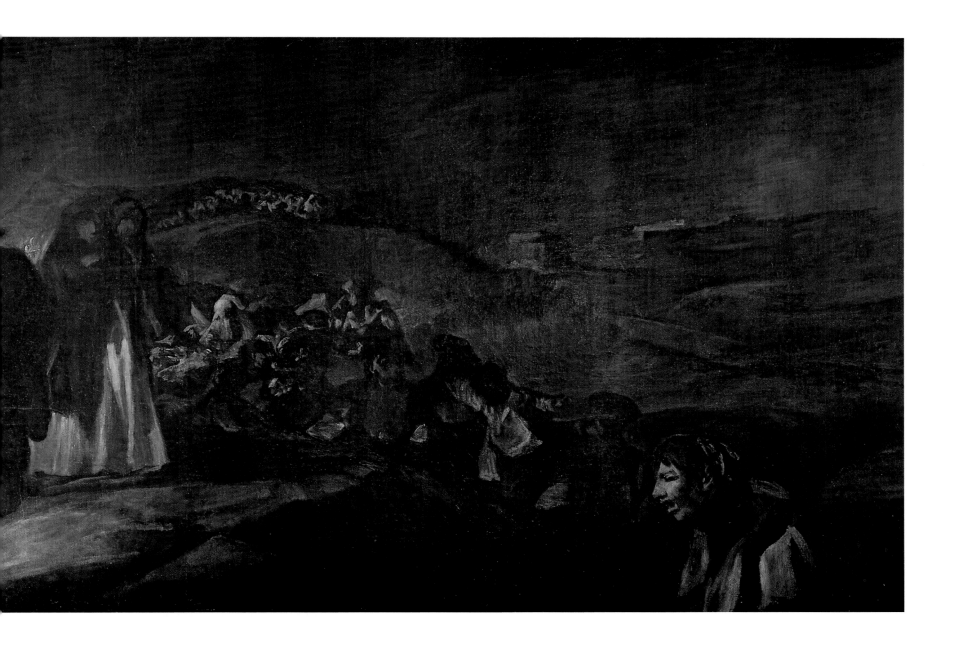

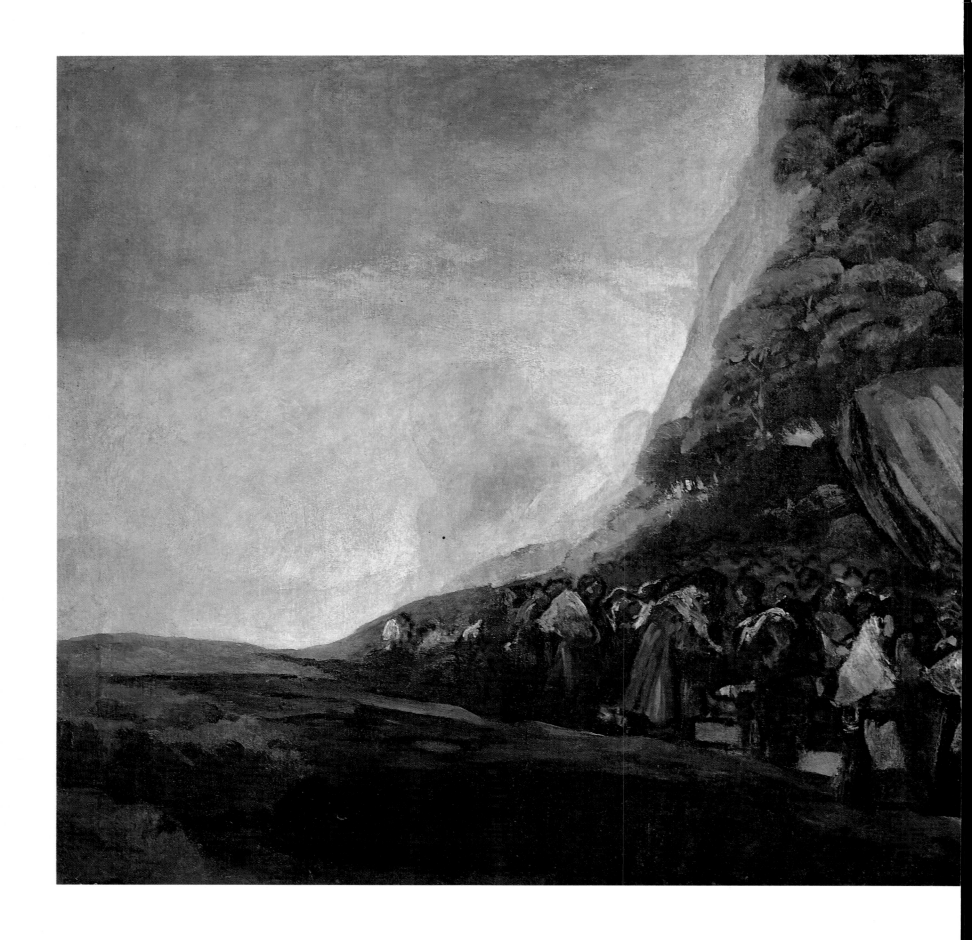

Pilgrimage to the Well of Saint Isidore, 1822
Mural transferred to canvas, 48 × 89 inches (123 × 226 cm)
Museo del Prado, Madrid

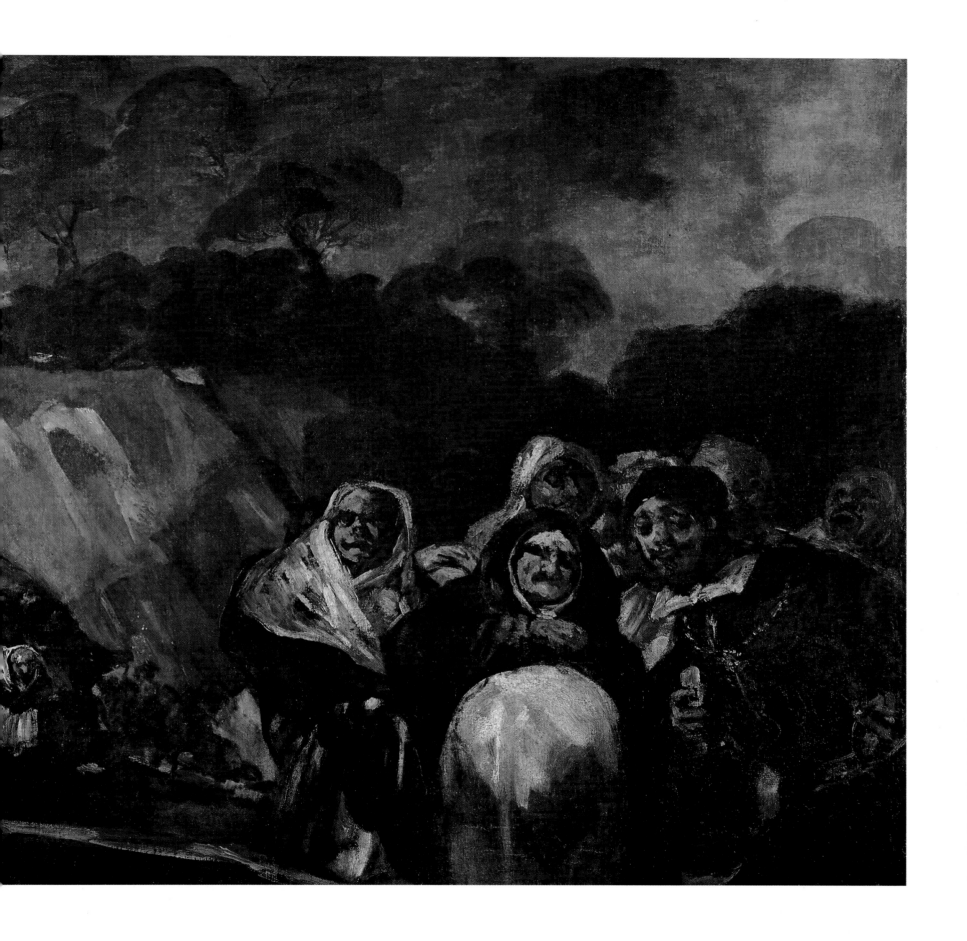

Goya 1824

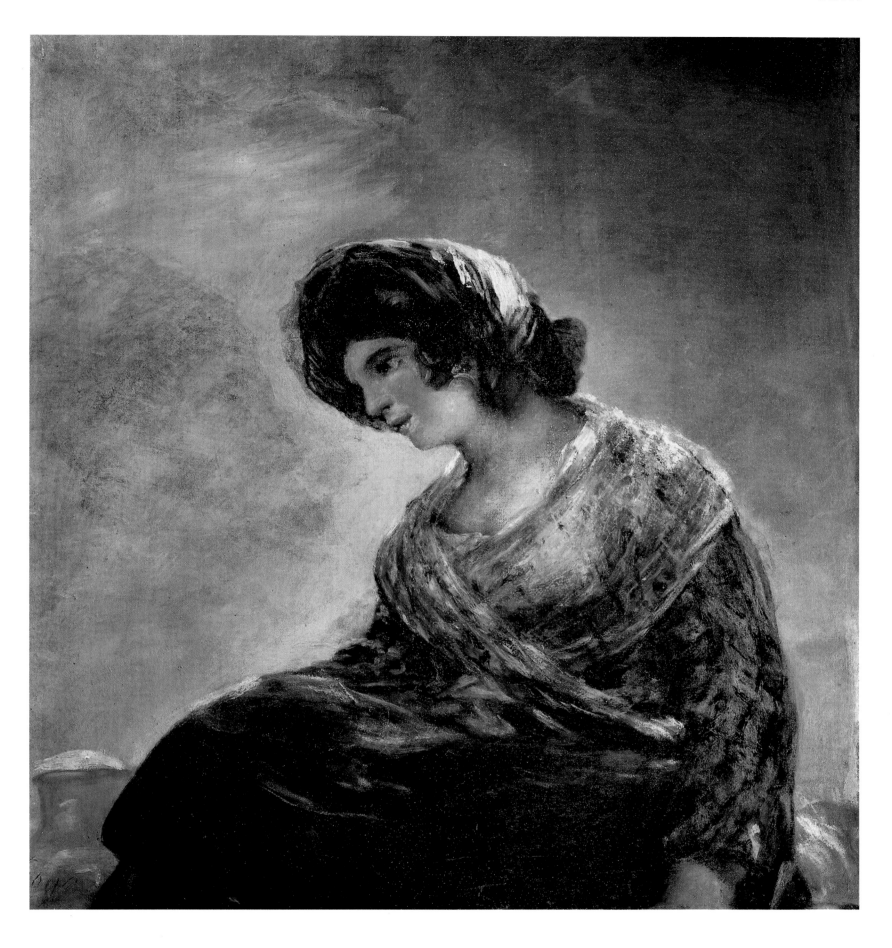

Doña María Martinez de Puga, 1824
Oil on canvas, 32 × 23 inches (80 × 58 cm)
The Frick Collection, New York

The Bordeaux Milkmaid, 1827
Oil on canvas, 34 × 29 inches (86 × 74 cm)
Museo del Prado, Madrid

Select Bibliography

Bareau, Juliet Wilson, *Goya's Prints*, London, British Museum, 1981

Bareau, Juliet Wilson, and Mena Marqués, Manuela B, *Goya, Truth and Fantasy*, Chicago, The Art Institute, 1994

Baticle, Jeannine, *Goya, Painter of Terrible Splendor*, New York, 1994

Canton, Sanchez, *The Life and Works of Goya*, Madrid, 1964

Clark, Kenneth, *The Romantic Rebellion*, London, 1973

Harris, Enriqueta, *Goya*, London, 1969

Harris, Enriqueta and Bull, Duncan, *Goya's Majas*, London, National Gallery, 1990

Holland, Vyvyan, *Goya*, London, 1961

Hughes, Robert, *Nothing if not Critical*, London, 1990

Klingender, F.D., *Goya in the Democratic Tradition*, London, 1948

Licht, Fred, *Goya in Perspective*, New Jersey, 1973

Perez Sanchez, Alfonso E and Sayre, Eleanor A, *Goya and the Spirit of the Enlightenment*, New York, Metropolitan Museum of Art, 1989

Symmons, Sarah, *Goya*, London, 1977

Symmons, Sarah, *Goya in Pursuit of Patronage*, London 1988

Tomlinson, Janis A, *Francisco Goya: The Tapestry Cartoons and Early Career at the Court of Madrid*, Cambridge, England, 1989

Acknowledgments

The publisher would like to thank designer Martin Bristow, picture researchers Suzanne O'Farrell and Sara E. Dunphy, production manager Simon Shelmerdine, and editor Jessica Hodge. We would also like to thank the following institutions and agencies for supplying illustrative material.

Banco de España, Madrid: pagees 33, 43

Board of Trustees of the National Museums and Galleries on Merseyside, Walker Art Gallery, Liverpool: page 11 top

The British Library, London: pages 10 bottom, 16 both, 18

The British Museum, London: pages 6 top, 14 three, 15, 19, 20, 22, 25

The Frick Collection, New York, NY: page 110

Giraudon/Bridgeman Art Library, London: page 99

The Hispanic Society of America, New York, NY: pages 12 bottom, 48

Kimbell Art Museum, Fort Worth, TX: page 49

MAS, Barcelona: pages 2, 6 bottom, 10 top, 26/7, 32, 37, 44, 51, 52, 53, 54/5, 56, 57, 68, 80/1, 82, 100

Meadows Museum, Southern Methodist University, Dallas, TX: page 46

Metropolitan Museum of Art, New York, NY: pages 78, 84/5

Minneapolis Institute of Arts, MN: page 104

Musée Goya, Castres, Tarn: page 96

Musée du Louvre, Paris, photo © RMN: page 59

Museo de Zaragoza, Aragon: page 8

Museo Lazaro Galdiano, Madrid: page 50

Museum of Fine Arts, Budapest: page 77

National Gallery, London: pages 11, 73, 90

National Gallery of Art, Washington, D.C.: pages 11 bottom (Samuel H. Kress Collection), 40, 69, 72

National Museum, Stockholm: page 36

Patrimonio Nacional, Palacio Real, Madrid: pages 65, 86/7, 88/9

Prado Museum, Madrid: pages 7, 12 top, 13, 17, 21, 24 top, 28, 29, 30, 31, 38/9, 41, 42, 45, 58, 60/1, 62/3, 64, 66/7, 74/5, 76, 77, 92, 93, 94/5, 101, 102/3, 105, 106/7, 107/8, 111

Real Academia de Bellas Artes de San Fernando, Madrid: pages 1, 46, 70/1, 91, 97, 98

Roger-Viollet, Paris: page 24 bottom

Scala, Florence: page 34/5

Staatliche Museen zu Berlin, Preussischer Kulturbesitz Kupferstichkabinett: page 23

Virginia Museum of Fine Arts, Richmond, VA: page 83